8 FOREWORD
 ELISSA TENNY, ROBERT ZIMMER

12 PREFACE: OTHER WORLDS
 BILL BROWN

15 PREFACE: MEASURE TWICE
 JONATHAN SOLOMON

ON DIMENSIONS OF CITIZENSHIP 26
NIALL ATKINSON, ANN LUI, MIMI ZEIGER

CITIZEN 36
THRIVAL GEOGRAPHIES (IN MY MIND I SEE A LINE) 40
AMANDA WILLIAMS AND ANDRES L. HERNANDEZ
WITH SHANI CROWE
ARCHITECTURES OF HABIT 46
ADRIENNE BROWN

CIVITAS 58
STONE STORIES 62
STUDIO GANG
SPACE OF CO-LIBERATION 68
ANA MARÍA LEÓN

REGION 80
ECOLOGICAL CITIZENS 84
SCAPE
ON THE POLITICS OF REGION 90
IMRE SZEMAN

102 **NATION**
106 **MEXUS**
ESTUDIO TEDDY CRUZ + FONNA FORMAN
112 **ALMA MATER**
DAN HANDEL

122 **GLOBE**
126 **IN PLAIN SIGHT**
DILLER SCOFIDIO + RENFRO,
LAURA KURGAN, ROBERT GERARD PIETRUSKO
132 **SMELTING POT**
JENNIFER SCAPPETTONE

172 **NETWORK**
176 **MANY**
KELLER EASTERLING WITH MANY
182 **EFFORTLESS SLIPPAGE**
INGRID BURRINGTON

200 **COSMOS**
204 **COSMORAMA**
DESIGN EARTH
210 **KOSMOS**
NICHOLAS DE MONCHAUX

TRANSIT SCREENING LOUNGE

236

AFRONAUTS
FRANCES BODOMO

238

EXODUS
MANDANA MOGHADDAM

240

DARK FIBER
DAVID RUETER, MARISSA LEE BENEDICT

242

COSMIC GENERATOR
MIKA ROTTENBERG

244

WHERE THE CITY CAN'T SEE
LIAM YOUNG

246

BIOGRAPHIES 250
PAVILION CREDITS 258
ACKNOWLEDGMENTS 259
IMAGE CREDITS 260
SPONSORS 262

FOREWORD

ELISSA TENNY
PRESIDENT
SCHOOL OF THE ART INSTITUTE
OF CHICAGO

ROBERT ZIMMER
PRESIDENT
UNIVERSITY OF CHICAGO

The School of the Art Institute of Chicago and the
University of Chicago are honored to be the commis-
sioners of the United States Pavilion at the 2018 Venice
Architectural Biennale. The curators of this year's
Biennale, Yvonne Farrell and Shelley McNamara, have
titled the overarching exhibition *Freespace*, a concept
with which they intend to encourage "reviewing ways
of thinking, new ways of seeing the world, of inventing
solutions where architecture provides for the wellbeing
and dignity of each citizen." This forum provides a
unique opportunity for a truly international and
interdisciplinary exploration of the evolving nature of
citizenship and its impact on nations, communities,
and individuals around the globe.

The US Pavilion exhibition, entitled *Dimensions
of Citizenship*, explores the role of architects, artists,
scholars, designers, community organizers, and cultural
critics in shaping, responding to, and mapping the
forces that control and envision the meaning of citizen-
ship in today's world. Curated by Niall Atkinson, Ann
Lui, and Mimi Zeiger, this exhibition configures the

US Pavilion as seven spatial scales, expanding outward from the human body to the cosmos, engaging the multifaceted nature of citizenship. The rigid boundaries that have traditionally defined citizenship are now shifting and fluid, as forces such as globalization, digital technology, and geopolitical transformation challenge conventional notions of what being a citizen means and inform new modes of belonging.

The School of the Art Institute of Chicago—a leader in educating the world's most influential artists, designers, and scholars since its founding in 1866—and the University of Chicago—one of the world's preeminent research institutions with an established tradition of rigorous scholarship and objective analysis that dates back to its founding in 1890—have an entwined history and enjoy an enduring partnership. Although very different in mission and approach, our institutions share a commitment to meaningful interdisciplinary discourse, innovative and impactful scholarship, and a deep connection to the city of Chicago and the diverse array of communities and individuals who live there. Our institutions fulfill our long-standing commitment to the public good collaboratively when the School partners with various aspects of the University, including sponsoring intercollegiate student projects through Art, Science + Culture Graduate Collaborative Grants; collaborating with the Polsky Center for Entrepreneurship and Innovation; and undertaking joint efforts with the City of Chicago, such as a National Science Foundation-funded project with the Urban Center for Computation and Data. Each institution also addresses the public good in ways central to their respective missions.

School of the Art Institute of Chicago artists, designers, architects, and scholars use their practices as the basis for curricular innovation, believing that

art flourishes in recognition of the essential role it has played throughout human existence. The School's early investment in art education, an interdisciplinary art and design curriculum, and the leading role it has taken in shaping discourse about artists' responsibilities as public intellectuals and citizens, exemplify this public approach to art and design. Public programming and exhibitions, collaborations with civic, charitable, and cultural organizations, and SAIC at Homan Square— a satellite campus featuring complimentary courses and projects designed in collaboration with residents— expand this public orientation.

University of Chicago scholars engage with notions of citizenship from a multiplicity of perspectives, driving innovations in public policy, law, urban scholarship, community arts and engagement, and scientific breakthroughs that improve the quality of human life. The study of architecture is a growing area at the University, drawing upon a long tradition of social sciences research, with initiatives such as Arts + Public Life investing in community-facing urban transformation through artistic practice. Similarly, the UChicago Urban Labs, the Energy Policy Institute at Chicago (EPIC), and the Mansueto Institute for Urban Innovation bring together scholars from diverse fields to address complex issues relating to urban growth and development at the local, national, and global level.

As the presidents of these two great Chicago institutions, we recognize that our city has been home to some of the world's greatest architectural innovations, but it has also been the site of many historical and contemporary challenges associated with urban life. Our institutions are committed to working together in partnership with the city and its people to address these challenges, and it is our hope that the US Pavilion's exhibition at the Biennale and its associated programs

will reflect this commitment. We hope that it generates energetic discussion about the intersection between citizenship and architecture, inspiring new ideas within, and engagement with, architectural practice and scholarship, and that it compels the recognition that a complex understanding of the dimensions of citizenship can increase our sense of belonging to, and responsibility for, one another.

PREFACE
OTHER WORLDS

BILL BROWN
SENIOR ADVISOR TO THE PROVOST FOR ARTS
AND KARLA SCHERER DISTINGUISHED SERVICE PROFESSOR
IN AMERICAN CULTURE IN THE DEPARTMENTS OF ENGLISH,
VISUAL ARTS, AND THE COLLEGE, THE UNIVERSITY OF CHICAGO

Architecture is a worldly art. Of course, it can also be otherworldly. Otherworldly in the sense of offering utopian, surrealist, or fantastic vision. But otherworldly, too, in the more quotidian sense of aspiring to make another world—materially, aesthetically, and socially. Insofar as design makes a spatial proposition, it prods the collective imagination to rethink the built environment: to recast the impossible as the merely improbable (or the unlikely as the necessary) and to envision life newly lived within and among new material forms.

The Venice Architecture Biennale commits itself to such propositions while the field transforms— through computational design and representation strategies, the rapid evolution in building materials and systems, and the intensifying recognition that design, when it changes the world, also changes the earth. The US Pavilion in 2018 certainly manifests such transformation and such commitment. Moreover, commissioned by two Chicago institutions, the Pavilion appears as a nexus between a global city whose Gothic architecture became the source for John Ruskin's passionate critique of modernity, and a global city,

in the American Midwest, whose modern architecture renders the city itself a great museum of modernism. Our remarkable curatorial team raises the stakes of the US exhibition by asking: How might architecture (the spatial proposition of design) apprehend the abstraction of citizenship? How can it confront materializations of that abstraction, past and present? How does it understand the state of being-apart, the state of being-together, within or beyond the nation-state?

Whereas Walter Benjamin considered architecture to be the paradigmatic instance of an art absorbed collectively and unconsciously, *Dimensions of Citizenship* means to bring unconscious modes of separation and incorporation into collective consciousness. Buildings are not laws; a public square does not itself constitute the commons; bridges are not treaties. But spaces have been designed to enforce or overcome exclusion; to embed signification in structure; to script narrative through site. Architectural aspiration, however unanticipated or untoward, can de-rigidify structure, actual and virtual, cognitive and affective, and provide a glimpse of other space, other worlds, in multiple dimensions.

Even as this curatorial team asks architecture to engage the question of citizenship, so too it asks any thinking about citizenship to engage the question of built space. As a Commissioner of the US Pavilion, the University of Chicago has seized the opportunity to consider how the field of design, itself dependent on so many areas of expertise, can become integral to the University's interdisciplinary inquiry, and how that inquiry can contribute to the field. The University is renowned for the extent and intensity of its urban research—from public policy to the material sciences, from anthropology to cinema and media studies, from economics to art history, from the Urban Energy and Environment Lab to artists who work in and on the

urban fabric. This broad reach positions the institution to develop new research and pedagogical agendas wherein design questions and urban scholarship inform one another. The University's commitment to the Biennale project has and will include events both in Venice and in Chicago (also Delhi and Hong Kong) where international questions of citizenship and space are addressed from many perspectives—law, political theory, and sociology, but also architecture, landscape architecture, and urban design.

The University's dedication to ambitious architecture appears in the work of iconic modernists on our campus—Eero Saarinen, Mies van der Rohe, and Walter Netsch—and of such contemporaries as Ricardo Legorreta, Tod Williams and Billie Tsien, Helmut Jahn, Rafael Viñoly, Studio Gang, and Diller Scofidio + Renfro. The recently inaugurated Mansueto Institute for Urban Innovation will house the new center for architecture and urban design at the University of Chicago. The Center's mission is to be a forum to discuss and create the future of urban design and architecture, in light of the present trend for worldwide urbanization, a shift towards human-centered design and a universal set of objectives for cities as places for human sustainable development. The University's commitment to the Venice Biennale marks a special moment of reinvigorated global engagement, committed to the deeper understanding of the fundamental processes that shape cities everywhere, and the development of innovative practices of spatial design that advance citizenship and quality of life for all.

PREFACE
MEASURE TWICE
THE CITIZENSHIP OF DIMENSIONS

JONATHAN SOLOMON
ASSOCIATE PROFESSOR AND DIRECTOR OF THE DEPARTMENT OF
ARCHITECTURE, INTERIOR ARCHITECTURE, AND DESIGNED OBJECTS,
SCHOOL OF THE ART INSTITUTE OF CHICAGO

"Measure twice, cut once," the architect's adage goes, encapsulating both the expertise that defines the profession and the judiciousness with which we exercise it.

Times change. There is now an app for drawing a plan of your apartment and a 3D printer for erecting your house, if you don't want to wait to grow it from mycelium. In a moment when the democratization of information, communication, and production is upending institutions built on expertise, architects are increasingly moving into new territories at new scales to deploy their expertise and define their value.

The School of the Art Institute of Chicago, a place where expertise has long floated freely between disciplines and discourses, is a natural place for these kinds of migrations. As a school of "citizen artists and designers" who recognize that our work in the classroom is not separate from our work in society, we teach students to learn who they are measuring for; and that wielding a knife is knowing not just what is being cut, but what is being cut out.

As co-commissioners of the exhibition *Dimensions of Citizenship*, SAIC has made a creative and critical project out of our support, organizing curricula and programming in response to the theme and providing structures for student-driven interest in citizenship to produce new work. Seeking to best embody the curators' project, we ask: What role does the School have in a future where architects and designers expand their value to include the interconnected impacts of measurement on culture, society, and politics? Can we teach the citizenship of dimensions? Surely this requires understanding the actors taking measure, and the worlds they imagine and define.

The politics of measurement are pervasive. They are embedded in our buildings, from the simple demarcation of a bathroom by gender, to the complex ways in which the design of housing limits diverse family structures, to how the layout of an office plan effects hierarchy in a corporation. From the legacies of red-lining to the impacts of present day gerrymandering, measuring lines on a map and cutting access and inclusion determines the distribution of resources, limits the influence of voices, and defines belonging across our society. The arbitrary cruelty of walls between nations scales up to global barriers between the north and south, while the networks of exchange at this scale both cast out and fence in.

Citizen artists, designers, and architects have a responsibility to take a position in this context.

Measurement is part of the professional service that architects provide, but it is also where the profession has its agency. At SAIC, when we teach students to draw a plan or to research a building code, we do not stop at their responsibilities to their client alone. We teach students that these are the tools to shape, respond to, or imagine increasingly complex and shifting modes of belonging.

With *Dimensions of Citizenship*, we show how architectural expertise, the care and facility with which we approach measurement, can have the same agency at the scale of the city and region. How can measurement be more equitable, more transparent, and more informed? At the scale of how we define the edge of nations or the relationships between them, how can measurement be more compassionate and more collaborative?

At SAIC, we teach that measurement, at a variety of scales, is significant. We should measure many times, and in different ways, both to address the demands of the profession and to hold ourselves responsible to its breadth and agency.

ONLY BY
HAVING
CLEAR
AND VITAL
IMAGES

OF THE
MANY
ALTERNATIVES,

GOOD
AND
BAD,

OF WHERE
ONE CAN GO,

TOMORROW WILL BRING ALL TOO QUICKLY.

SAMUEL R. DELANY
"THE NECESSITY OF TOMORROWS"

ON DIMENSIONS OF CITIZENSHIP

NIALL ATKINSON
ANN LUI
MIMI ZEIGER

Without an image of tomorrow, one is trapped by blind history, economics, and politics beyond our control. One is tied up in a web, in a net, with no way to struggle free. Only by having clear and vital images of the many alternatives, good and bad, of where one can go, will we have any control over the way we may actually get there in a reality tomorrow will bring all too quickly.
—Samuel R. Delany, "The Necessity of Tomorrows"

To watch the news in the United States in 2018—that is, to follow streams of media inputs across various haptic devices, from various time zones—is to observe a nation actively reckoning with what it means to be a citizen. The question of belonging, of who should be included and how, is asked with every athlete taking a knee, every #metoo, every presidential tweet, and every protest sign or fist raised. Today, as transnational flows of capital, digital technologies, and geopolitical transformations expand, they undermine conventional notions

of citizenship. It isn't any monumental allegiance to flag and country that newly shapes the denotation and connotations of the term; rather, it is the intimate yet complex relation between ourselves and the actual and virtual spaces we inhabit—and the future worlds of which we dream.

Those gulfs between an individual citizen and a nation, and, parallel anthropogenic gulfs between nationalism, globalism, and cosmicism, are territories in which to explore the critical question: How might architecture respond to, shape, and express changing ideas of citizenship? This is not an obvious question to ask, nor an easy question to answer, but it is nonetheless requisite for architecture and architects, design and designers to assume any agency in visualizing the many alternatives, good and bad, of tomorrow.

We begin by defining citizenship as a cluster of rights, responsibilities, and attachments, and by positing their link to the built environment. Of course architectural examples of this affiliation— formal articulations of inclusion and exclusion—can seem limited and rote. The US-Mexico border wall ("The Wall," to use common parlance) dominates the cultural imagination. As an architecture of estrangement, especially when expressed as monolithic prototypes staked in the San Diego-Tijuana landscape, the border wall privileges the rhetorical security of nationhood above all other definitions of citizenship—over the individuals, ecologies, economies, and communities in the region. And yet, as political theorist Wendy Brown points out, The Wall, like its many counterparts globally, is inherently fraught as both a physical infrastructure and a nationalist myth, ultimately racked by its own contradictions and paradoxes.

Calling border walls across the world "an ad hoc global landscape of flows and barriers," Brown writes of the paradoxes that riddle any effort to distinguish the nation as a singular, cohesive form: "[O]ne irony of late modern walling is that a structure taken to mark and enforce an inside/outside distinction—a boundary between 'us' and 'them' and between friend and enemy—appears precisely the opposite when grasped as part of a complex of eroding lines between the police and the military, subject and *patria*, vigilante and state, law and lawlessness."[1] While 2018 is a moment when ideologies are most vociferously cast in binary rhetoric, the lived experience of citizenship today is rhizomic, overlapping, and distributed. A person may belong and feel rights and responsibilities to a neighborhood, a voting district, remain a part of an immigrant diaspora even after moving away from their home country, or find affliation on an online platform. In 2017, Blizzard Entertainment, the maker of *World of Warcraft*, reported a user community of 46 million people across their international server network. Thus, today it is increasingly possible to simultaneously occupy multiple spaces of citizenship independent from the delineation of a formal boundary.

Conflict often makes visible emergent spaces of citizenship, as highlighted by recent acts both legislative and grassroots. Gendered bathrooms act as renewed sites of civil rights debate. Airports illustrate the thresholds of national control enacted by the recent Muslim bans. Such clashes uncover old scar tissue, violent histories and geographies of spaces. The advance of the Keystone XL pipeline across South Dakota, for

1 Wendy Brown, *Waning Sovereignty, Walled Democracy* (New York: Zone Books, 2010), 24–25.

example, brought the fight for indigenous sover-
eignty to the fore.

If citizenship itself designates a kind of border
and the networks that traverse and ultimately
elude such borders, then what kind of architecture
might *Dimensions of Citizenship* offer in lieu of
The Wall? What designed object, building, or space
might speak to the heart of what and how it means
to belong today? The participants in the United
States Pavilion offer several of the clear and vital
alternatives deemed so necessary by Samuel
R. Delany: The Cobblestone. The Space Station.
The Watershed.

Dimensions of Citizenship argues that citizen-
ship is indissociable from the built environment,
which is exactly why that relationship can be the
source for generating or supporting new forms
of belonging. These new forms may be more
mutable and ephemeral, but no less meaning-
ful and even, perhaps, ultimately more equitable.
Through commissioned projects, and through film,
video artworks, and responsive texts, *Dimensions
of Citizenship* exhibits the ways that architects,
landscape architects, designers, artists, and writ-
ers explore the changing form of citizenship: the
different dimensions it can assume (legal, social,
emotional) and the different dimensions (both
actual and virtual) in which citizenship takes place.
The works are valuably enigmatic, wide-ranging,
even elusive in their interpretations, which is
what contemporary conditions seem to demand.
More often than not, the spaces of citizenship
under investigation here are marked by histories
of inequality and the violence imposed on people,
non-human actors, ecologies. Our exhibition fea-
tures spaces and individuals that aim to manifest

the democratic ideals of inclusion against the grain of broader systems: new forms of "sharing economy" platforms, the legacies of the Underground Railroad, tenuous cross-national alliances at the border region, or the seemingly Sisyphean task of buttressing coastline topologies against the rising tides.

Certainly, the troublesome ebb and flow of the United States' immigration policy past and present continues to thwart any utopian quest for an architecture of sanctuary. And no conversation on contemporary citizenship can occur without confronting the current set of mass migrations and expulsions leaving so many stateless. This is why *Dimensions of Citizenship* presents experiences and spaces of belonging that defy, transgress, or undermine conventional boundaries. These are experiences and spaces that are not defined by enclosure, but by movement, transition, and the attendant frictions and detours of moving from point A to point B.

In *Expulsions*, sociologist Saskia Sassen argues that often, today, complex systems—social, economic, political—in divergent contexts often produce the same simple brutalities: the expulsion of people from where they once belonged. Across different dimensions of crisis—from home foreclosures during the recession to mass incarceration in the United States, from international industries of extraction to global environmental calamity—today's lived experience has become precarious, if not perilous for more and more people. In this way, changing forms of citizenship, notably mass migration, can also be read as manifestations of seemingly impenetrable systems—such as market derivatives and climate predictions, now beyond

any collective understanding and control—and act as lenses to evaluate their effects, ethics, and suggest tomorrow's interventions.

"[W]hat are the spaces of the expelled?" Sassen asks. Her conclusion advocates for recognition of these "conceptually subterranean" conditions. "They are," she writes, "potentially the new spaces for making—making local economies, new histories, and new modes of membership."[2] *Dimensions of Citizenship* means to add the making of new architectures and new methodologies for architectural practice. The exhibit is in part an act of rendering visible these temporally defined spaces, harder to draw than a red line on a map. Ultimately, with visibility comes the formalization of the previously informal and, subsequently, a space for design.

Architecture, urbanism, and the built environment—these form a crucial lens through which we come to understand better what, perhaps, we all already know: that citizenship is more than a legal status, ultimately evoking the many different ways that people come together— or are kept apart—over similarities in geography, economy, or identity.

When investigating the spatial relationships between architecture and citizenship, it is tempting to ascribe a pressing temporality to our own heated moment. Yet even shadowed by the gut-punch headlines so common in this particular political climate, the questions are much larger and much older than any single administration provokes. Politics only sheds light on existing conditions. A broader point of view transcends those conditions and

2 Saskia Sassen, *Expulsions: Brutality and Complexity in the Global Economy* (Cambridge, MA: Harvard University Press, 2014), 222.

frames them within a context of both longer-term
and wider-reaching struggles and ambitions.

A historical point of view suggests that while
questions about citizenship are urgent, they are also
timeworn. Our accelerationist blip on the radar of
history is just a couple ticks away from the seem-
ingly democratic armatures of ancient Greece or the
ideal cities of the Renaissance—two examples that
come with accompanying architectures of inclusion
and exclusion. In looking back, we are reminded
that there has never been (nor likely will there be) a
golden age of citizenship. It isn't a stable condition,
but rather a continuing site of contention, despite
attempts try to idealize, formalize, and fix it in place.

As a city-state the Republic of Venice, for
example, used to orchestrate an efficient, brutal,
and complex system of trade and cultural exchange
in its pre-modern heyday; now it is a site where
several elements of the global cultural economy
converge: film, art, architecture, and mass tour-
ism. Local bonds of identity, critical to unifying the
far flung empire of the past, barely register in the
lucrative exchanges transacted in the city. The city's
current inhabitants—migrants, refugees, temporary
workers, and long-time residents—operate in a
condition of seeming statelessness: demoted to
second tier citizens in the cities they call home. The
architectures that make up Venice's famed urban
fabric are increasingly subject to foreign-owned,
empty residences and short-term rentals. Its ship-
ping lanes are rerouted for passing cruise ships
whose scales of size and population dwarf the city's
sinking foundations.

It is here in the realities of the invisible city
described by Marco Polo to Kubla Khan that we find
the uncomfortable conflation of the local and the

global. Parsing such slippery, subjective territory prompts another paradox: the understanding of the self as "citizen" and the other as "stranger" is constructed by, even as it constructs, the built environment. As scholar Engin F. Isin, writes in *Being Political: Genealogies of Citizenship*, "[G]roups cannot materialize themselves as real without realizing themselves in space, without creating configurations of buildings, patterns, and arrangements, and symbolic representations of these arrangements."[3] This is the need to materialize, to render visible structures of belonging.

Our goal with *Dimensions of Citizenship* is to reflect contemporary configuration of belonging as they operate across a series of points from the individual body to heavenly bodies. For example, in the shared etymologies of the words citizen, civitas, and city, we read that acts of architecture are also acts of inclusion, and that these manifest across dimensional scales. By organizing the exhibition around seven such spatial parameters—Citizen, Civitas, Region, Nation, Globe, Network, and Cosmos—we pay homage to Charles and Ray Eames' *Powers of Ten* film and the telescopic way that they represented and showed the affinity of the smallest and the largest points of our existence. Leading us to commission seven practices to take on the seven scales, this framework serves as a conceit and means to bring together a diverse set of designers, enabling each team to go deep into one particular area of research and design. If this scalar framework is restrictive, we hope that it forms productive restrictions: boundaries against which the exhibitors can chafe, wrangle, and entangle

3 Engin F. Isin, "City as a Difference Machine," in *Being Political: Genealogies of Citizenship*, (Minneapolis: University of Minnesota Press, 2002), 43.

themselves—bringing the viewer and discourse along with them.

We are aware that this framework emerges from a decidedly humanistic position. In accepting concepts drawn from Renaissance thinking about the ideal city and the social armatures (both religious and secular) that have led to particular developments of inclusion and exclusion, we also bear the weight of certain embedded biases. In a recent *Artforum* interview, architect and scholar Mabel Wilson calls on architects to ask what are the other, more diverse kinds of subjectivity that don't fall within humanist thinking or discourse. "Architecture has always propped up Man with a capital M, whether we're talking about the Vitruvian Man in classical antiquity or Le Corbusier's Modulor Man in the twentieth century, and architecture has always excluded other ways of being human," says Wilson.[4]

Alternative methodologies lead to alternative futures. Ideas drawn from cinema, Afrofuturism, agonism, and speculative design undergird the new works on display and run through the films and videos shown in what we call the Transit Screening Lounge. Works draw on the violent lineage of slavery and fugitivity in black history and culture, yet find liberatory spatial practices; represent the ways in which stateless people endure and risk potentially fatal exodus in search of asylum; and document alternative ecological geographies against the growing spector of transnational corporate power and neo-nationalisms.

It should come as little surprise that issues of citizenship in the so-called Anthropocene emerged as a recurring sub-theme

4 Mabel O. Wilson and Julian Rose, "Changing the Subject: Race and Public Space," *Artforum*, Summer 2017.

in the exhibition, with the recognition that citizenry might extend to non-human actors. While Sassen tracks the conditions in which environmental crisis has led to human migration, *homo sapiens* are only one agent of the global ecosystems— who happen to have, in some situations, mobility— other citizens from microbe to mammal must bear the impact *in situ*.

Dimensions of Citizenship does not solve or fully untangle the complex relationships of governance, affinity, and circumstance that bind us, citizen to stranger, self to other. Instead, it uses design—spatial research and speculation, drawing and dreaming—as a means to engage and visualize the legal, cultural, and ecological ties that bind.

Because citizenship is comprised in part by our actions in the public realm, by our voicings of discontent, desires, or demands, *Dimensions of Citizenship* stakes out a crucial agency within the architectural discipline. We posit this exhibition as a necessary framework for future conversations about the conditions, methodologies, and interventions of inclusion and exclusion that impact all of us. Our intent is to render visible paradoxes and formulations of belonging. Only when these new understandings of citizenship are in sight might we struggle free from antiquated definitions, forms, or bureaucracies and activate potent spaces for new design possibilities.

Dimensions of Citizenship begins at the
scale of the individual—at the threshold
of the self and the collective. Our contem-
porary moment reminds us that citizenship
is not a neutral or assumed mantel. It is
an active construction of identity, one
that comes with inherent spatial concerns.
To be a citizen is to both embrace the
rights and assume the responsibilities of
membership within the *polis*, a larger
political community. In celebrating that
definition, we must also accept that conven-
ing individuals into an "us"—the "we" in
We the People—is contingent on a construc-
tion of "them"—the other, the stranger,
the non-conforming body.

It is the tensions between the indivi-
dual and society, us and them, public
and private that drives questions into the
built environment. Acts of inclusion and
exclusion take place on suburban front
lawns and on the University of Virginia's
neoclassical Lawn; in protests at football

stadiums and airports; and in the everyday
gestures of alliance and solidarity on side-
walks and subways. But what does it mean
to architecturally embody citizenship?

Amanda Williams and Andres L.
Hernandez's work at this scale not only
asks how architecture mediates the body
with the bodies of others, it demands that
we recognize the bodies past and present
that have been structurally and deliberately
denied the easy appellation of Citizen.
To represent those who cannot actualize
the full rights and benefits of US citizen-
ship, Williams and Hernandez turn to
black spatial practices in which collective
architectures are defined not by heroic
expression but by transgressive tactics
and fugitivity.

THRIVAL GEOGRAPHIES (IN MY MIND I SEE A LINE)

AMANDA WILLIAMS + ANDRES L. HERNANDEZ

IN COLLABORATION WITH SHANI CROWE

I seemed to see a line, and on the other side of that line were green fields, and lovely flowers, and beautiful white ladies, who stretched out their arms to me over the line, but I couldn't reach them no-how. I always fell before I got to the line.[1]
—Harriet Tubman

I learned to see freedom as always and intimately linked to the issue of transforming space.[2]
—bell hooks

The assumption that all people are able to actu-alize the rights, benefits, and responsibilities of citizenship within the built environment is mis-leading. Much like other oppressed communities

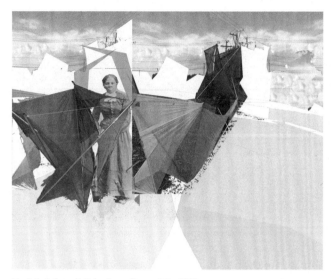

Harriet's Refuge, digital collage, dim. variable, 2017.

in the United States, including lesbians, gay men, bisexuals, and transgender people, undocumented immigrants, and the disabled, African Americans' access to space is largely prescribed, "as they are historically and routinely rendered visually transparent, peripheral, part of the landscape, ready to be moved, cleared and discarded for spatial use and improvement."[3] African Americans' ownership of property and use of public space for personal enjoyment has been historically perceived as transgressive behavior, and often met with punitive legal action, violence, and, at times, death. Given

1 Sarah Hopkins Bradford, *Scenes in the Life of Harriet Tubman* (Auburn, NY: W.J. Moses, 1896).

2 bell hooks, Julie Eizenberg, and Hank Koning, "House, 20 June 1994," in *Assemblage: A Critical Journal of Architecture and Design Culture* 24 (August 1994): 22–29.

3 David Theo Goldberg, *Racist Culture: Philosophy and the Politics of Meaning* (Cambridge, UK: Blackwell Publishers, 1993).

Thrival Geographies (study_v1), digital collage, dim. variable, 2017.

this context, the ability of African Americans to successfully navigate and shape the physical spaces within their lives has amounted to de facto *survival* strategies.

Addressing this fraught social-spatial condition and its impact at the scale of the citizen, *Thrival Geographies (In My Mind I See a Line)*, an intervention in the courtyard of the US Pavilion, is rooted in the historical spatial practices of African Americans, yet speculates upon new spatial strategies that support the most precarious of populations. We foreground these practices as manifestations of civic agency and freedom that move all citizens beyond mere survival toward thrival and full participation in the democratic ideal. Superimposing an alternative or rival geography[4] of movement across the full site, the intervention originates within the forecourt of the pavilion,

4 Stephanie M.H. Camp, *Closer to Freedom: Enslaved Women and Everyday Resistance in the Plantation South* (Chapel Hill: University of North Carolina Press, 2004).

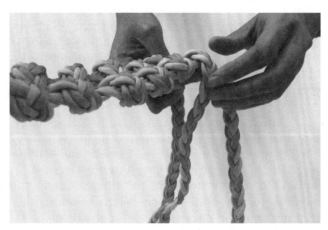

Shani Crowe braid study, 2017.

weaving within and rising up the portico of the main
entrance, and stretching beyond the visible to the
rear terrain of the building. Evoking clandestine
routes charted and navigated by African Americans
seeking both temporary escape and permanent
freedom from the institution of slavery, our inter-
vention strategically shifts orientation in its steady
movement toward, and its shaping of, thrival spaces.

The work highlights the unique ways in which
black women have historically navigated and
shaped space in order to advance their position in
American society and takes the African American
historical figures Harriet Jacobs and Harriet Tubman
as muses. Harriet Jacobs sought a
peculiar freedom within her loop-
hole of retreat,[5] confining herself
for seven years to the liminal
space of the garret of her owner's
house. Harriet Tubman found
emancipation for herself and

5 Harriet Jacobs,
*Incidents in the Life of
a Slave Girl: Written by
Herself*, Jean Fagan
Yellin, ed. (Cambridge,
MA and London:
Harvard University
Press, 1987 [1861]).

others through the network of safe houses and sup-porters from the southern to the northern US states and Canada known as the Underground Railroad. Although relative and precarious, the autonomy of the two Harriets was predicated on their ability to utilize tactics of fugitivity and duplicity in order to navigate the social and spatial landscapes of slavery.

With the persistence and evolution of spatial injustice within the United States, the black female body continues to be (mis)read as being *out of line*. As such, the actions of African American women within the built environment are still perceived as transgressive, and are increasingly countered by emotional and physical violence, and death. In embracing the mantra BLACK WOMAN SPACE MATTERS, Williams and Hernandez tackle questions of citizenship status, gender, and race at the intersection of history, theory, and practice of architecture.

Lead Artists
Amanda Williams +
Andres L. Hernandez

Collaborating Artist
Shani Crowe

Studio Team
Nina Cackovic
Taylor Chan

Bianca Marks
Korynn Newville
Amanda Wills

Structural Consulting
Skidmore, Owings
& Merrill
William Baker
David Horos
Christian Hartz

Fabricators
Active Alloys

Sponsors
The Joyce Foundation

Special Thanks
Paul Levy and the
Bridgeport Art Center

Formal studies, copper wire mesh, dim. variable, 2017.

ARCHITECTURES OF HABIT

ADRIENNE BROWN

[Citizenship] is an ordinary space of activity
that many people occupy without thinking much
about it.
—Lauren Berlant[1]

Even the distracted person can form habits.
—Walter Benjamin[2]

In "The Work of Art in the Age of Its Technological
Reproducibility," Walter Benjamin insists that we
most often engage architecture in
a state of distraction. In observing
that our perception of architecture
largely takes place through acts
of "casual noticing rather than
attentive observation," Benjamin
does not intend to produce yet
another indictment of our oversat-
urated perceptual faculties—a move
we might expect today given the
cyclical attention-panic accompa-
nying the broad adoption of each
new gadget, app, or digital network.
Rather, by claiming architecture
to be the first form of mass media,

1 Lauren Berlant,
"Citizenship," in *Keywords
for American Cultural
Studies*, eds. Bruce Burgett
and Glenn Hendler (New
York and London: New
York University Press,
2014).

2 Walter Benjamin,
"Work of Art in the
Age of its Technological
Reproducibility," trans.
Edmund Jephcott et al. in
*Selected Writings Volume 4:
1938–1940*, eds. Howard
Eiland and Michael W.
Jennings (Cambridge,
MA and London: The
Belknap Press of Harvard
University Press, 2003).

Benjamin insists that studying how it shapes our perceptual modes can consequently teach us how the masses more broadly learn to perceive and be—through repeated use and the gradual accrual of habits.

Extending Benjamin's thesis about the distracted state through which we perceive the built world and how physical structures shape our habits in ways we aren't always aware of or actively attentive to, let us consider architecture's oblique role in producing habits of citizenship. Citizenship is fundamentally a spatial relationship, naming in its broadest conception one's ability to participate in the civic life of their locale. And yet, as literary critic Lauren Berlant insists, citizenship is best understood not as one form of sovereignty but as a collection (or perhaps a collision) of many different relational forms, pointing to the "constellation of rights, laws, obligations, interests, fantasies, and expectations that shape the modern scene of citizenship." Combining Benjamin's and Berlant's insights, it could be said that architecture shapes the habits of both *perceiving* and *feeling* citizenship.

To attend to how architecture shapes our experience of citizenship, then, is to work against our perceptual proclivity to take in the built environment sideways, through sustained use and in states of distraction. This essay, then, is an attempt to marshal our attention to consider the distracted and circuitous ways architecture scripts our habits of citizenship as well as various attempts to reshape those habits using architecture. What habits of citizenship does architecture produce that accrue through accumulation rather than contemplation? How might architecture generate practices of citizenship obliquely—through what we glimpse from the corner of an eye, brush with an elbow, or sense below our feet? How might the spaces and structures we routinely move through help determine

our relationship to the state and our experience of feeling a part of or apart from it, as the case may be?

Let's begin with a meditation on one the most innocuous and ubiquitous architectures of citizenship—the voting booth. While Benjamin insists that we primarily engage architecture in states of distraction, voting booths are structures designed to force its users to attain a certain amount of focus—or to at least stage the appearance of such—by quarantining us from the rest of the world. On Election Day, access to voting booths generally spans most of the waking day. Voters increasingly have had the option to cast their ballots weeks in advance or by mail, an attempt by many precincts to accommodate those who may not be afforded the time away from work or home to show up to vote. The contestation of extended voting hours in some districts along with efforts to restrict early voting days, however, suggests the concerted efforts by some to limit citizenship to those who can afford to participate. The voting booth, understood as a site where some might form regular habits of use relative to others, belongs to the physical infrastructure of citizenship.

Materially, voting booths are relatively simple structures designed for practical use rather than absorbed contemplation. They are typically constructed of flimsy plastic and perched on tall aluminum legs, offering users just enough stability to be able to scratch a line on a paper ballot or to press a button. Some booths allow users to slide a small curtain closed behind them, more fully producing the sensation of sequester privileged by modern voting. These temporary structures are typically set up inside of other forms of architecture, being lined up in rows once or twice a year within local civic spaces such as firehouses, elementary school gymnasiums, or open apartment building lobbies. Their purpose is to carve out private space within larger public spaces.

The process of voting begins for most by traveling to an assigned polling station, where one proceeds to cordon herself off from the civic space she has just entered and reckon with a ballot containing names of people the voter has generally never met. The booth separates the voter from the general public as she seeks a more abstract form of intimacy with the group. The scale of the booth marks voting as the work of private individuals, presenting it as an act you do alone—for yourself and by yourself. The material experience of these spaces can be somewhat awkward— the flimsiness of the booth's construction makes you feel its impermanency, which may variously serve to heighten the distinctiveness of the occasion or mark its formal abnormality. The space available for the body to take up in most voting booths, moreover, is fairly narrow, signaling that voting is an act designed for those who can fit themselves into measurable civic space.

But the plastic private voting booth of today is a far cry from the scenes and structures of voting for much of US history. Before the second half of the nineteenth century, voting was a noisy and viscerally public affair where watching others voice their decisions was part of the process. The point was to be in public and occupy civic space rather than to portion it off for individual contemplation. By the middle of the nineteenth century, however, most states had moved toward a ballot system ensconcing private voting. As literary critic Elaine Hadley notes of the similar shift taking place in nineteenth-century Britain, private voting "mass produce[d] a new abstract space of privacy, or rather, mass-produce[d] two abstract spaces of privacy—the booth itself and the evanescent liberal citizen, constituted by his cognitive abstraction, who was momentarily capable of embodying his citizenship

through an abstracted interest in the national or imperial good."[3] The architecture of the voting booth carves up local social space in order to make room for voters to temporarily become national subjects.

Visual artist Lonnie Holley's 2016 art installation *In the Grip of Power* modifies the voting booth to emphasize voting as an embodied act. The booth Holley presents viewers in the gallery space seems at first glance like any other—a simple plastic and aluminum structure that one would bend down and lean into in order to fill out a ballot semi-privately. However, if you stand back from the booth or approach it from the right side, you notice that when the user bends down to use the booth, their head becomes level with the muzzle of a handgun affixed to the outside of the booth and pointed directly into its interior. Holley describes *In the Grip of Power* as providing viewers with a stark reminder of how un-habitual the process of voting has been for many in the US. Commemorating "those that got killed along the way, literally got blown to pieces" in seeking the vote, Holley describes "the trail to vote" as simultaneously "a trail of tears." To be in the grip of power, Holley's work suggests, is to potentially inhabit a position of power and agency, but it can also mean being at the mercy of another. His installation reminds us of the physicality that voting demands—requiring some to literally risk their bodies in order to occupy the sovereign space of the abstract and generalized citizen. Holley's alterations to the voting booth makes visible the differential habits of citizenship this architecture has historically accommodated and encouraged.

While modern voting is largely treated as a private act done by the individual subject acting for themselves and by themselves,

3 Elaine Hadley, *Living Liberalism: Practical Citizenship in Mid-Victorian Britain* (Chicago and London: University of Chicago Press, 2010), 180–81.

the desire to relocate civic participation to the public square and redefine citizenship as a social act of collective demand and public voice endures. The different kinds of occupations within the planned and makeshift civic squares of Zuccotti Park, Ferguson, and Charlottesville mark the desires of publics of various sorts and merits to exceed the physical, social, and affective scales of the individual booth on state-sanctioned election days. If voting booths secure a space for the lone voter to abstract themselves from their embedded situation within the local to become vague state subjects, physical occupations of civic space insist upon the immediate presence of people in real space. The physicality of occupation gains even more significance in the wake of rulings like Citizens United that protect the political speech of legal entities like corporations that have no corporeality. Physical occupations remind us that no matter how much we treat corporations like people, granting them free speech and the power of political participation, they can't physically occupy space—even as they purchase and privatize it.

In the case of the Charlottesville protests of the summer of 2017, the built environment of the public square not only contained competing masses but magnetized their divergent vision of publicness. What united both the white supremacists converging in Charlottesville to defend and protect the statue of Confederate General Robert E. Lee with the protestors seeking to rebuke these efforts and deny them a public mandate was their shared sense that the built environment matters and that citizenship's scale is local, inhabitable, and contestable. Monuments are material instantiations of competing fantasies of citizenship as well as active sites for shaping its habits. Recent conversation about the work of monuments in

the past year asks us in some ways to recall Benjamin's insistence in 1936 that architecture works on us in states of distractions.[4] When we turn our full attention to the structures that surround us, we find that memorialization—how we commemorate the past—can never be fully untangled from how we form habits in the present.

Of course, occupation as a form of protest is an old form indeed. The recent occupations of the past few years were preceded by the Bonus Army's summer encampment of 1932 on the muddy banks of the Anacostia River in Washington DC where they demanded payments owed to them by the federal government for their military service. We might also look to the Poor People's March and accompanying occupation of the National Mall during the winter and spring of 1968 planned by Martin Luther King Jr. and led by Ralph Abernathy gathering a range of Americans fighting for economic justice. If the voting booth relies on a scale of sequester, these mass occupations of the past and recent present not only seek to take up existing space to produce a broader scale of civic participation but also remake the architecture of the spaces they inhabit. In almost all of these cases, the occupied space is remade in some way, with makeshift structures produced in order to sustain the occupiers in practical and poetic ways, if only temporarily. However, this is not to say occupation is either inherently utopian or repressive, but that it possesses varying potentiality— a fact which both the colonizing function of occupation as well as the various causes and forces that have adopted occupation as a tactic reminds us.

Between the scale of the open civic square and the individual voting booth are, unquestionably, many other scales that induce different habits of citizenship and their varying states of attention.

4 Benjamin, "Work of Art."

The residential neighborhood is one such scale. If, as Benedict Anderson has argued, nations are imagined communities, then neighborhoods constitute a different version of belonging that, while still being organized according to borders, is also held together by visible shared habits.[5] A neighborhood is both an imagined community and the product of everyday routines often undertaken in varying states of distraction within communal space—walking the dog, taking the trash to the curb, moving one's car, catching the bus, etc. But like all scales of citizenship, the neighborhood is organized by both collectivity and exclusion; for those who have been shuttled into spaces abandoned by resources and attention, neighborhood borders can prove quite difficult to transgress. As sociologist Robert Sampson has argued, despite our increasing enmeshment within global and virtual scales citizenship, life is still decisively shaped by where you physically live.[6]

And yet, for all of the ways that neighborhoods form and shape the outcomes of its residents, it is often the architecture that is closest to us that we fail to pay attention to. Whereas the voting booth channels our focus to become abstract, the spaces we most commonly inhabit shape our civic life in more oblique ways. How might we cut through our perceptual distraction in order to more precisely tune into these spaces that have escaped attention—attention that may be visual, social, economic, haptic, civic, aesthetic, or political in nature? We might look to architect Marshall Brown's 2012–17 plans for rethinking the vacancies endemic to Chicago's Washington Park neighborhood as one model. His plan approaches open lots not

5 Benedict Anderson, *Imagined Communities: Reflections on the Origin and Spread of Nationalism* (New York and London: Verso, 1983).

6 Robert J. Sampson, *Great American City: Chicago and the Enduring Neighborhood Effect* (Chicago and London: University of Chicago Press, 2012).

as a problem to be fixed, but as a possibility for continued inhabitation. Instead of seeking to remake existing urban grids so as to attract new residents or to plug in the holes left behind by the neighborhood's declining population numbers, Brown insists on rebuilding the streetscape around the paths and patterns crafted by the residents who have remained there. "The absence of growth," Brown insists, "must no longer be an obstacle to the improvement of neighborhoods." Proposing the bundling of abandoned lots so that they can be cared for by residents without the burden of ownership or homeowner associations, Brown proposes we look

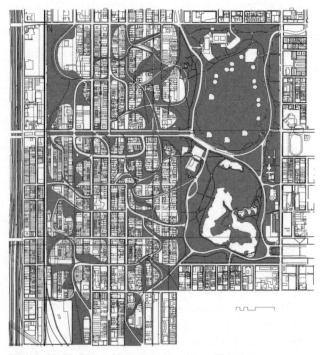

Site plan of Marshall Brown Projects, Inc., *Smooth Growth®*, 2012–17.

closer at what exists before leaping to remake or
renew neighborhoods—actions which have historically
helped to displace existing residents rather than
improve how they live. Nestled within Brown's spatial
plan for Washington Park is an attempt to rethink the
scale of citizenship by promoting an understanding

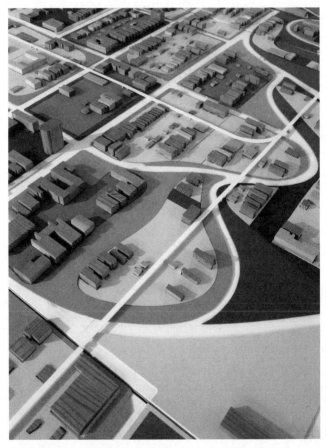

Model photograph of Marshall Brown Projects, Inc., *Smooth Growth*®, 2012–17.

of the civic as rooted through inhabitants rather than the state and informed by the present rather than an ever-deferred futurity.

If we have focused on the ways architecture obliquely shapes our habits of citizenship as well as how various forms of occupation—in art, protest, and planning—both work within and against states of distraction mediating our routine perception of the built environment, I want to end with a brief meditation on a building type that asks us to explicitly attend to its staging of citizenship—the national pavilion. Nations have used architecture to demonstrate their strength and solidity since the walled city-state. But the emergence of the state pavilion as a global form for mass display at the 1893 Columbian Exhibition in Chicago marked a new phase of statecraft that explicitly wielded architecture's ideological clout. Whereas the city wall demonstrated a nation's hard power by marking its ability to defend itself, the state pavilion designed to reflect a distinctive national style marks architecture's increasing soft power within a global network of power and prestige.

State pavilions also tend to reflect who is considered central to a nation's conception of citizenship in often blunt ways. Take, for instance, the absence of African Americans from the exhibits hosted by the American pavilion built for the Paris World's Exhibition of 1900. While African American intellectual W. E. B. Du Bois helped to curate the Exhibit of American Negroes, which was funded by the US Congress, it was housed not within the American pavilion, but within the Palace of Social Economy and Congresses. Yet as we've learned from citizenship's varying scales, vacancy is not necessarily a marker of deficiency, but of the possibility for making and enduring. And Du Bois' exhibit demonstrates just this: while few can recall the

neo-classical state building that officially represented the US, he produced an exhibit of photography and avant-garde info-graphs that continue to circulate and captivate audiences over a hundred years later. If the American pavilion at the Paris World's Fair represented the state's vision of citizenship as statically neo-classical, Du Bois' exhibit offers a counter-vision of citizenship that asks us to toggle between other scales, viewpoints, and mediums in order to bring other forms of participation into view. If the scale of citizenship epitomized by the modern-day voting booth validates the individual citizen, we find other archi-tectures large and small, temporary and permanent, imagined and real, being wielded in ways that challenge this singular scale and its attendant habits. Rather than periodic sequester, the built environment holds the power within it to reframe citizenship as a practice of spatial, social, and perceptual expansion that demands new forms of attention.

The term "civitas" describes a social body of
citizens bound by law. Yet in that dry defini-
tion lies something more poetic: the dream
that we are greater than the sum of our con-
stituent parts. How can we, as citizens and
as collective individuals, be more than we
are alone? Applied to the built environment,
to architecture, public space proves to be the
site for the same question. Public space is
the medium through which we often argue
if there is a place, today, for the promise of
the democratic commons, as well as where
we unpack attendant crises of privatization
and governance.

 Even while spaces such as the city
square or civic plaza have become increas-
ingly regulated and exclusive, in recent
years they have notably been fertile sites
for collective voicings of dissent. From the
transformation of streets by the Black Lives
Matter and Occupy movements, we are
reminded of philosophers Hannah Arendt's
and Jürgen Habermas' respective arguments

that public space is constructed by our public actions: the "where" that is formed when we voice to others our once private desires and demands. Take, for example, today's movements to remove or contextualize Confederate monuments in the United States. This momentum shows how communities' reckonings with conflicted sites is a powerful exercise of citizenship, forming a public discourse more monumental than the statues themselves. Civitas—or public space—might emerge anywhere: on the streets of Ferguson, in a town hall meeting, or over Thanksgiving dinner. Civitas is an active polemic: formed by agonistic conversation about the ways we come together.

Studio Gang's practice is unique in its work with civic assets in divergent cities in the United States. Using a toolkit drawn from architecture, urban planning, and participatory processes, they engage local communities while reckoning with complex histories and stakeholder interests.

STONE STORIES

CIVIC MEMORY AND PUBLIC SPACE IN MEMPHIS, TENNESSEE

STUDIO GANG

The city of Memphis, Tennessee, is a place where competing urban histories are actively debated in public space, sometimes pitching the past against the present. It is here, along the banks of the Mississippi River, that citizens and city government organized to remove the city's two Confederate monuments in December 2017. Both located in public parks, the statues came down due to the combined pressure of citizen action and creative legal maneuvers that surmounted bureaucratic hurdles placed by state authorities. This successful exercise of community power over public space now opens up the question: what sort of civic monuments might citizens desire today? *Stone Stories* explores how one overlooked yet important public site in Memphis—a cobblestone landing dating back to the nineteenth-century—might be refashioned into a place of inclusive civic memory that reflects and elevates the history, values, and aspirations of all Memphians.

 Memphis Landing is a cobblestone-paved landing along the Mississippi River. It served as

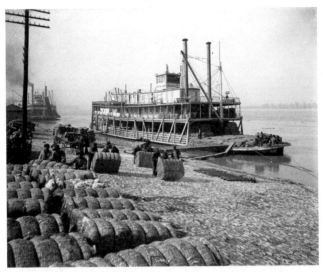

Originally completed in 1861, Memphis Landing was a critical piece of civic
infrastructure. Accommodating the dramatic rise and fall of the Mississippi River,
its simple paved slope was ideal for facilitating nineteenth-century commerce.
Here workers are shown unloading cotton at the Landing, ca. 1900.

the city's main port from its construction in 1861
through the 1930s, until the growth of railroads,
highways, and air freight rendered it largely
obsolete. As the city's historic "front door" and
commercial hub, the Landing's eight acres, which
stretch 600 yards along the water's edge, served
Memphis' early economy—whose cornerstone
was cotton production and trade, which relied on
slave labor. Forever linked to this legacy, the
Landing has remained an underused site for nearly
a century despite its location adjacent to the
center of downtown. An architectural artifact of
a former economy, use, and technology, the paved
Landing is a vast heterogeneous mosaic of nine
types of stone and is subject to the daily rise and

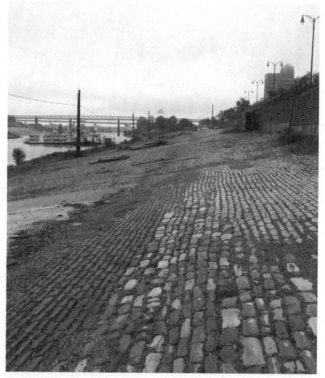

Memphis Landing in 2017 is a mosaic of nine different types of stone that speaks directly and indirectly to the city's history. These physical qualities, as well as its central location and ambiguous cultural meaning, make it an important site of civic memory waiting to be revealed and shared.

fall of the river. For *Stone Stories*, hundreds of cobblestones from the Memphis riverbank were transported to Venice as part of a larger effort to open up a new chapter for this civic material and the citizens to whom it belongs.

 A once active waterfront space, the Landing and its complex history has long lay dormant, waiting to play a new role in civic life. *Stone Stories*

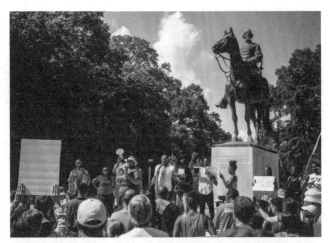

As part of a larger movement calling for the removal of Memphis' two Confederate monuments, protestors gathered in in August 2017 at the city's statue of Nathan Bedford Forrest—a Confederate general, slave trader, and an early leader of the Ku Klux Klan. The rally was organized by the Memphis group #TakeEmDown901.

builds on Studio Gang's ongoing work in Memphis to uncover the many stories embedded in the Landing and to explore how design can help communities imagine a more meaningful future for their public realm. By addressing the latent opportunity in one overlooked civic site, the project demonstrates how citizens everywhere can claim a place in their city's history and exercise citizenship through engaging the public spaces they own in common.

Studio Gang's early proposal for Memphis Landing, developed for their Memphis Riverfront Concept (2017), imagined the site's transformation beginning with a community tree planting event that would bring shade and softness to its hardscape. For *Dimensions of Citizenship*, the Studio is working in greater depth with Memphis residents to explore how the Landing can become a meaningful site of civic memory for all Memphians.

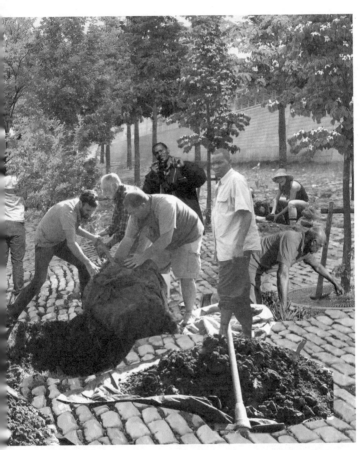

Studio Gang
Project Team
Jeanne Gang
Mark Schendel
Alissa Anderson
Abraham Bendheim
Gia Biagi
Claire Cahan
Jonathan Izen
Lydia Meyer
Schuyler Smith
Heinz von Eckartsberg

Project Advisors and
Collaborators
William Baker, Kevin
Chang, and David Horos,
Skidmore, Owings
& Merrill
Carol Coletta, The
Kresge Foundation
Benny Lendermon,
Riverfront Development
Corporation
Eric Robertson,

Community LIFT
Maria Viteri and Stan
Kulasik, International
Masonry Institute
Adam Goss, RedMike
Marianek, Samantha
Snodgrass, and Ryan
Clark, Spirit of Space

Sponsor
The Kresge Foundation

SPACES OF CO-LIBERATION

ANA MARÍA LEÓN

> From the day of its birth, the anomaly of slavery plagued a nation which asserted the equality of all men, and sought to derive powers of government from the consent of the governed.
> —W.E.B. Du Bois[1]

The Latin term "civitas" is traditionally defined as the social body of citizens united by law.[2] Yet, who gets to be a citizen, and who gets to decide on the law? If the civitas is based on inclusion, who does it exclude? This underlying tension between civitas and difference is a matter of concern to architects in the design of public spaces and services. That is, spaces that are meant to be inclusive, yet operate within a civitas fragmented by relationships of oppression and exclusion. A possible answer to these challenges can be found through the work of two very different thinkers. If philosopher G. W. F. Hegel wrote one of Western thought's best-known meditations on bondage and its consequences on identity, sociologist, historian, and activist W. E. B. Du Bois has

1 William Edward Burghardt Du Bois, *Black Reconstruction: An Essay Toward a History of the Part Which Black Folk Played in the Attempt to Reconstruct Democracy in America, 1860–1880* (New York: Harcourt, Brace and Company, 1935), 3.

2 In Latin: *concilium coetusque hominum jure sociati.* William Smith, "Civitas (Roman)," *A Dictionary of Greek and Roman Antiquities* (London: John Murray, 1875), 291–93.

masterfully disentangled and exposed the role of slavery in the identity of the United States.[3] Reading Hegel with Du Bois can provide crucial insight in thinking about the challenges of the architect within the civitas, and how this challenge informs the design of public space.

Hegel constructs his master-slave dialectic by arguing that every human's deepest desire is to have one's self-consciousness as agency recognized. A hypothetical self encounters another, and each one's desire for recognition leads to a confrontation: a fight to the death. The will that is overpowered by force and chooses not to die becomes the slave, while the triumphant will, the master, forms their identity from the recognition of the slave. But this is a false recognition, for the master is recognized as an entity by someone who they do not recognize back. Philosopher Alexandre Kojève's reading of Hegel stresses this paradox of the master, which he describes as an existential impasse.[4] Ultimately the dialectic is resolved through the labor of the slave, who, by working and changing their environment experiences their own agency in the world, and thus achieves a recognition of their own self. Kojève's stress on empowering of the slave and disqualifying the master gives his reading of the Hegelian dialectic a useful, subversive twist. Incorporating Marxist notions of class struggle, Kojève sees the disenfranchised as the key to a new, higher form of liberation—one that transcends confrontation and subjugation.

The United States is one of many nations that suffer from this existential impasse. The country's long history of colonial practices started through the literal and metaphorical erasures perpetrated by European settlers against the

3 Georg Wilhelm Friedrich Hegel, *Phenomenology of Spirit*, trans. A. V. Miller (Oxford: Clarendon Press, 1977 [1807]); and Du Bois, *Black Reconstruction*.

4 Alexander Kojève, *Introduction to the Reading of Hegel*, trans. James H. Nichols, Jr. (Ithaca and London: Cornell University Press, 1969).

multiple cultural groups that populate the region; it continued as part of the transnational exchange of forced labor, resources, and goods known as the triangle trade. Settler colonialism turned human bodies and land into "natural" resources occupying territory, incrementally expanding these political boundaries by purchase or war, and finally superseding them into a global system—a pattern that reverberates to this day.[5] Once constituted as a nation, this system was covered within claims for liberty, civilization, and democracy, a contradiction that has been exposed by Du Bois in his magisterial work, *Black Reconstruction*.[6]

Du Bois explains two processes by which the United States specifically has been mired in this problem from its conception and which are of interest here: the production of a global system of capital built on racialized, forced labor, and the effects of this system at a human scale, in the construction of racism. In his examination of the plantation system leading up to the Civil War, Du Bois notes that "the real modern labor problem" stems from the fact that slavery does not originate from an intrinsic hatred of otherness, but rather from the desire to maximize profit through unremunerated, forced labor. Thus, racism was used to justify slavery in support of capitalism.[7] We might extrapolate this

5 Eve Tuck and K. Wayne Yang, "Decolonization Is Not a metaphor," *Decolonization: Indigeneity, Education & Society* 1, 1 (2012): 1–40.

6 Du Bois, *Black Reconstruction*.

7 There is a large body of research and debate on this matter, which I don't have the space to fully reconstruct here. It is useful here to keep in mind Ruthie Wilson Gilmore's definition of racism as: "... the state-sanctioned or extralegal production and exploitation of group-differentiated vulnerability to premature death." Ruthie Wilson Gilmore, *Golden Gulag: Prisons, Surplus, Crisis, and Opposition in Globalizing California* (Berkeley: University of California Press, 2007), 28. Cedric Robinson specifically ties the development of capitalism to racism in his term "racial capitalism": "The development, organization, and expansion of capitalist society pursued essentially racial directions, so too did social ideology." Cedric Robinson, *Black Marxism: The Making of the Black Radical Tradition* (London: Zed Press, 1983), 2.

pattern to the construction of otherness itself: only by constructing "othered" populations whose lives do not matter can capitalism extract labor from them, generating the necessary surplus value to operate at maximum profit. Reading Du Bois between the lines reveals the ways in which racial bias is produced through a fraught return to the Hegelian struggle for self-recognition. In his first chapters, Du Bois hints at a series of projections and correspondences between the black worker, the white worker, and the planter. In this system, the planter typifies the African worker as barbarous, lazy, ignorant, and wantonly sexual. At the same time, the planter himself embodies these qualities by enforcing a system dependent on violence and abuse (barbarous), leading a luxurious life of idleness (lazy), refusing to innovate or industrialize as it would challenge the chattel system (ignorant), and binding both white and black women within different but detrimental and violent patterns of abuse (wantonly sexual). Therefore, we read a projection of the qualities of the planter into the construction of racial bias towards the black worker.[8] Caught between these two groups, the white worker, steeped in deep poverty, nevertheless aspires to the life of the planter and joins him in the oppression of the black worker.

This production of alterity accompanied the rise of the modern nation-state and its development to our contemporary moment. If Hegel sets up the existential impasse of the master/planter, Du Bois contextualizes this impasse within the system of capitalism and the production of racism. Reading Hegel with Du Bois suggests the master-slave relationship is produced for capital gain, but it imprints the master or planter with negative traits that are then projected onto the oppressed.

8 A careful writer, Du Bois never outspokenly makes this connection, but it is there for the reader to find it.

Architecture, a discipline dependent on power and capital, has traditionally served the master and remains beholden to its existential impasse. Hence, we find traces of this pattern in the history of public spaces, public buildings, and public infrastructure built by the state. The scientific rationality of the 1785 US National Land Ordinance's gridding of newly-acquired territory covers architecture's role in the colonization of occupied land. The modernization impulse behind the expansion of the railroad masks its complicity with the wars against Native Americans defending their soil and their way of life. The neoclassicism incorporated into the burgeoning state's buildings effectively "whitened" the identity of the newly imagined community, ignoring the enslaved labor contained within them. The expansion of modernity itself carried within it a fetishization of otherness and the drive to clear space for the new, facilitating the destruction of struggling, disenfranchised communities. The use of public funding towards the construction of highways and the racialized suburbanization of the United States vacated jobs and capital from urban centers, while keeping people of color within them.[9] These and other histories, which highlight the important role history has to play in our contemporary political moment, are too often absent from the architect's education.[10]

9 Suburbanization also produced oil economies abroad that remain dependent on the fluctuations in the price of oil, just one example of the many transnational repercussions of these policies.

10 We find many of these histories in specialized forums, for instance in journals dedicated to vernacular architecture or cultural studies. In reaction to the events in Charlottesville, VA, of August 2017, I initiated a crowdsourced reading list on how race and racism are constructed with spatial means, and on how in turn space can be shaped by racism. This reading list, collectively produced by over forty architectural historians, is meant primarily as a teaching resource. It's open to the public and available here: https://docs.google.com/document/d/1p-2GvScemyghCaQVkA3fDTs-jqtprk7CPOryZv5-YUTkk/edit?usp=sharing. I have also been involved in reformulating the histories we teach through the Feminist Art and Architecture Collaborative (FAAC). See FAAC, "Counterplanning from the Classroom," *Journal of the Society of Architectural Historians* 76:3 (September 2017): 277–79.

This projection informs a pattern repeated in a long history of segregation policies up to the present. We see projection in the criminalization of African Americans through the prison industrial complex, while large corporations are allowed to evade taxes for increased profits. We see projection in the segregation of gender identities outside heteronormativity under vague sexual allegations of dangerous restrooms or challenges to the family unit, while the #MeToo campaign points clearly to where the real sexual predators can be found. We see projection in the policing of female bodies, their coverage, nourishment, and aging, while any culpability in cases of violence goes to the victim. We see projection in the exclusion of immigrants and refugees under vague notions of terrorism that ignore the mass shootings facilitated by the lack of appropriate gun control regulations. As scholar Ananya Roy has productively pointed out, these and other crimes are often perpetrated legally, when states regularize the illegalities of the powerful and criminalize the infractions of the subaltern and the marginalized.[11]

Thinking about the regulation of difference, political philosopher Iris Marion Young concludes that while the civic necessitates claims to impartiality, this impartial citizen is produced through the loss of others, often resulting in authoritarianism.[12] Operating within systems of differentiation and oppression, supposedly public spaces

11 Ananya Roy, "The City in the Age of Trumpism," a talk at Taubman College (November 17, 2017), https://vimeo.com/246869503. See also Ananya Roy, "The Infrastructure of Assent: Professions in the Age of Trumpism," *The Avery Review* 21 (January 2017).

12 Iris Marion Young, "Impartiality and the Civic Public," in *Feminism as Critique: Essays on the Politics of Gender in Late-Capitalist Societies*, eds. Seyla Benhabib and Drucilla Cornell (Cambridge, UK: Polity, 1987). Hannah Arendt precedes this critique when she finds that attempts to overcome plurality result in the arbitrary domination of others, or an imaginary world where these others do not exist: Hannah Arendt, *The Human Condition* (Chicago: University of Chicago Press, 1998), 234.

can never be truly public—they always are, and have been, spaces of exclusion. Yet those who are excluded—discussed by critical theorist Nancy Fraser as "subaltern counterpublics" and by anthropologist James Holston as "insurgent citizens"—are key to the constitution of a public sphere.[13] Thus while a civitas is defined by conformity with the law, public space can only be produced, and claimed, through the agency and presence of the very populations under threat of exclusion.[14] Thus we have a contradiction between the civic and the public: if one is defined by exclusion, the other is produced by inclusion.

This contradiction begs the question: Who do architects design for when they design civic spaces that are meant for the public? Architects have a fraught relationship with communities struggling against exclusion—disenfranchised groups are mined for information, used as props for public relations, and in many instances, dismissed. Architecture's autonomy anxiety has led the discipline to distance itself from the bodies that alternatively walk through its spaces, breathe the air within them, gaze upon them, and listen to their echoes, even while arguing these very readings might provide some sort of political resistance to the irrelevance of the discipline as it surrenders itself to the forces of real estate and the market.[15]

13 Nancy Fraser, "Rethinking the Public Sphere: A Contribution to the Critique of Actually Existing Democracy," *Social Text* 25/26 (1990): 56–80. James Holston, "Spaces of Insurgent Citizenship," in *Cities and Citizenship*, eds. James Holston and Arjun Appadurai (Durham, NC: Duke University Press, 1996), 37–56.

14 Here I am deliberately eliding more idealized definitions of the public sphere by Jürgen Habermas and Hannah Arendt in favor of a position of inclusion of difference, following Chantal Mouffe, Oskar Negt, and Alexander Kluge, among others. For discussion on some of these positions vis-à-vis public space, see "Agoraphobia," in Rosalyn Deutsche, *Evictions: Art and Spatial Politics* (Cambridge, MA: MIT Press, 1996). See also Reinhold Martin, "Public and Common(s)," *Places Observer* (January 2013): https://places-journal.org/article/public-and-commons/.

Depoliticizing the discipline leads to upholding discriminatory laws, serving predatory capital, and openly discriminating against the disenfranchised—in sum, it leads to collaboration with increasingly totalitarian states. At the root of this relationship between the architect and their constituencies, I argue, is the discipline's existential impasse—the constant and implicit distance between the architect and the communities they design for. This exercise in othering is part of the discipline's Western tradition, which ties the architect in a hierarchical chain of subservience to capital. Thus, depending on their relationship and proximity to power, the architect either plays the metaphorical role of the "master/planter" or that of its aspirational delegate and collaborator, the "white worker." In the case of public space, the master is most often the state—not the bodies that might struggle to access, occupy, and claim those spaces. While serving these states, or the private interests embedded within them, architects cannot escape the problem of an existential impasse. They cannot but replicate the mechanisms of the higher power they serve under, and understand themselves as separate from communities which have been deliberately othered. Attempts to serve the disenfranchised still struggle with this separation by preserving the role of the architect as expert and by seeking to transform the "other" into a citizen.

The way out of architecture's existential impasse follows a similar path as this revised master-slave dialectic. It is the agency of the oppressed in actively laboring and changing the world that makes them aware of their own humanity,

15 I refer here to Peter Eisenman's insistence on the reading of architecture as an instrument of resistance to power, most recently in Peter Eisenman, Kurt W. Forster, Jacques Herzog, and Philip Ursprung, "The End of Theory? A Conversation," *e-flux architecture* (November 10, 2017): http://www.e-flux.com/architecture/history-theory/159231/the-end-of-theory-a-conversation/.

leading to a cognizant, higher form of liberation. Thus the agency of the oppressed holds the key for self-recognition, and it is only by joining these very populations and understanding their leadership can the discipline understand and supersede its impasse. In order to resist the exclusionary potential of the civitas, the architect must become part of the community they are designing for. This is not to argue that architects must necessarily belong to or come from to the communities they serve, although certainly every effort must be made to diversify the discipline. Rather, I argue for a conceptual remapping of the role of the architect as critical members of the communities that work as concerted collectives to change their environments. Here I follow the Indigenous Action Media group, which advocates for "accomplices not allies," that is, a rejection of the ally—as a separate, sympathetic, but ultimately condescending and advantage-seeking trope—in favor of an understanding of what it means to be in complicity with communities in struggle.[16] To clarify, standing in complicity with those under struggle is the complete opposite to the French notion of "collaboration"—the cooperation with the representatives of power.[17] As long as architects design for an "other," they remain enmeshed in a discourse of alterity that prevents them from participating as active members of the community. Furthermore, as poet and organizer Tawana "Honeycomb" Petty explains, by emphasizing difference and privilege, alliance contributes to a politics of dehumanization. Petty proposes we can supercede this impasse through a politics of co-liberation which challenges us

16 Indigenous Media Group, "Accomplices not Allies: Abolishing the Ally Industrial Complex," *Indigenous Action* (May 4, 2014): http://www.indigenousaction.org/accomplices-not-allies-abolishing-the-ally-industrial-complex/.

17 A notion that stems from collaboration with the Axis powers during World War II.

to understand that projects of exclusion affect us all, regardless of whether we are excluded or included by practices of systemic racism, gender discrimination, and predatory capital.[18] What might this project entail for architecture?

An architecture of co-liberation understands that exclusionary spaces also affect the populations they include, by suggesting those included have a different, additional set of rights. An architecture of co-liberation refuses to collaborate with projects that participate in spatial practices of aggressive exclusion, particularly in carceral spaces such as the prison industrial complex, housing projects conceived as exclusionary spaces of investment rather than dwelling, infrastructural projects mobilized to push the urban poor away in order to make space for redevelopment, and the privatization of public space at large. An architecture of co-liberation understands public space can only be designed by making space for the

We the People of Detroit Community Research Collective, *Mapping the Water Crisis: The Dismantling of African-American Neighborhoods in Detroit: Volume One*, front cover, http://wethepeopleofdetroit.com/communityresearch/water/, 2016.

18 Tawana "Honeycomb" Petty, "Shifting the Language: From Ally to Co-Liberator," *Eclectablog* (December 17, 2017): http://www.eclectablog.com/2017/12/shifting-the-language-from-ally-to-co-liberator.html.ter-issues-a-statement-on-trump-s-election.

leadership of those traditionally excluded because of gender, race, class, or origin. Projects such as *Mapping the Water Crisis*, the community research done by We The People of Detroit Research Collective, and the *Abolitionist Planning for Resistance* pamphlet, produced by the UCLA Abolitionist Planning Group, are instances of this ongoing task.[19] In the words of Black Lives Matter, "we center the most marginalized, and look to them for leadership. We fight for our collective liberation because we are clear that until black people are free, no one is free. We are committed to practicing empathy for one another in this struggle."[20] Let us construct and understand architecture as a practice of co-liberation.

[19] See Abolitionist Planning for Resistance, https://challengein-equality.luskin.ucla.edu/abolitionist-planning/; and We The People of Detroit Community Research Collective, http://wethepeo-pleofdetroit.com/communityresearch/.

[20] "Black Lives Matter issues a statement on Trump's election," *mic.com* (November 15, 2016): https://mic.com/articles/159496/exclusive-black-lives-matter-issues-a-statement-on-trump-s-election.

UCLA Abolitionist Planning Group, *Abolitionist Planning for Resistance*, front cover, https://challengeinequality.luskin.ucla.edu/abolitionist-planning/, Institute on Inequality and Democracy at UCLA Luskin, 2016.

"Right now, the earth is full of refugees, human and not, without refuge," writes Donna Haraway. No safe harbors remain. The scale of the region asks where any of us—all living things—can belong on a planet at risk of ecological collapse. Debates over what to call this new geologic era, and when it began, abound: Anthropocene, Capitolocene, Gynocene, Cthulucene. These names are a Rorschach test for the ways that we reckon with climate change, chemical toxicity, and depleted resources as the legacies of human histories of empire and extraction. These changes cannot be isolated to pure "science" or a mythological "nature": the changing environment is a crucible which has, and will continue to, shape human communities and conflicts.

Consider the United States' regional belts—Corn Belt, Rust Belt, Bible Belt, Sun Belt—which constitute rich parts of the American identity. Typically organized around an area's shared resources—oil, ore,

shale, or fertile soil—regions share unique cultural values, political movements, health crises, and economic challenges. On a global scale, even as divisions between nation-states marked in *plan* become more pronounced, the parallel vertical rise of the oceans in *elevation*, in feet above sea level, produces new hierarchies and constructs new affiliations among coastal regions facing shared risk.

SCAPE's work operates at the intersection of design, science, and community participation. This formulation of landscape architecture positions the responsibilities of citizenship and opportunities born of activism as new directions at our collective ecological crossroads. Against the backdrop of environmental change which can seem illegible or impenetrable because of its massive proportion, complexity, or rate of change, SCAPE's work both renders visible a space for action and provides tools to intervene in post-Holocene currents.

ECOLOGICAL CITIZENS

SCAPE

At the core of *Ecological Citizens* is the idea that
regions are not fixed political boundaries but rather
assemblages of ecosystems, interspecies entangle-
ments, infrastructural imperatives, and climatic
forces. The project does not assume that culture
and nature are separate domains, but are joined
as a shared space of imagination and action. If
past notions of "the region" based on power and
geography recede and are only fully understood
by systemic, ecological collapse and the unwinding
of social structures, new regions will emerge from
a cohesion of committed citizens, interspecies
alliances, mud, and sticks.

 Now more than ever concepts of landscape
are tied to practices of citizenship and engagement.
Regions are becoming unbound, and the coil of
interspecies interdependence is giving way to highly
managed and stratified landscapes. Nowhere is
this more apparent, and more critical, than at the
shifting gradient between land and water—the
intertidal zone—as sea levels rise rapidly and shore-
line habitats, wetlands, and salt marshes vanish
in front of our eyes. Broad-front systemic changes
to climate policy, water quality improvement, and
sediment management need to be matched by

Left: Mussel spat fuzzy rope being installed by SCAPE, Gowanus Bay, NY.
Right: View after installation with diverse biomass.

Left: Salt marsh planting unit, Venetian Lagoon, Italy.
Right: Marsh planting by ecological citizens.

immediate and direct action by local ecosystem
activists working to transform the physical land-
scape. Growing, planting, stacking, bundling,
cultivating, stabilizing, shoring up, monitoring—this
is the hard work of the ecological citizen. This is
the landscape aesthetic of survival and the ethic of
the future, a new cohesion of citizens and species.

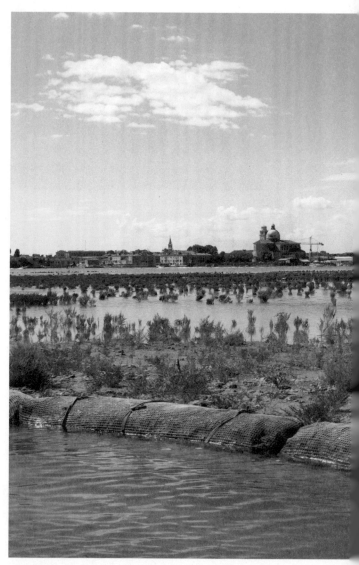

Erosion control and salt marsh restoration project in the Venetian Lagoon.

The Venice lagoon serves as a globally significant case study in the need for an expanded ecological citizenry. It is a proxy for ecological threats to intertidal landscapes across the planet. From Staten Island to the Gulf Coast to La Certosa Island in Venice, informed eco-citizenry—scientists, activists, designers—are participating in new management regimes amidst a backdrop of ecosystem and animal annihilation.

Over centuries, the morphology of the Venetian Lagoon has been heavily modified for shipping, trade, and other economic purposes. Today, it is being shaped by the unintended consequences of wave action and erosion from cruise ships and oil tankers, all set against the realities of rapid sea-level rise. Salt marsh loss in the lagoon has been estimated at almost seventy-five percent since 1900.

Ecological Citizens envisages the bio-physical reclamation of the disappearing salt marshes through an array of 1:1 materials of intertidal architecture. The exhibit foregrounds an operational landscape of sediment fences, fascines, biodegradable coir logs, and Econcrete® micro-tide pool units. These marsh rebuilding units are stored and displayed in the US Pavilion until the Biennale closes.

After the exhibition, the elements will be deployed on nearby La Certosa Island as part of a larger, ongoing salt marsh creation and public access project in collaboration with scientists from the Università di Bologna and the Italian Institute of Marine Sciences. The "ugly" ecosystem architecture contained in the US Pavilion will ultimately serve to help regenerate biodiverse marshlands and create a scaffolding for the shellfish and critters, endangered wading birds, muck and mud, to persist in the larger landscape outside the Pavilion's doors, hence defining a role for an activist regional eco-citizenry.

Vanishing intertidal landscape, Venetian Lagoon.

SCAPE Project Team
Kate Orff
Nans Voron
Gena Wirth
Nabi Agzamov
Tara Mohtadi

Key Advisory Team
Dr. Laura Airoldi,
Marine Science
Dr. Shimrit Perol-Finkel
and Dr. Ido Sella, Marine
Ecology and Structures
Dr. Andrea Barbanti,
CNR-ISMAR

Alberto Sonino,
La Certosa
Prof. Allan Holzman,
Video/Film
Alberto Barausse,
LASA Research Group,
University of Padova
Luca Palmeri, LASA
Research Group,
University of Padova

Sponsors And
Institutional Partners
Graduate School of
Architecture, Planning

and Preservation,
Columbia University
National Research
Council of Italy, CNR
Institute of Marine
Sciences, ISMAR
Vento di Venezia
ECOncrete®
Besser
Life VIMINE

ON THE POLITICS OF REGION

IMRE SZEMAN

Indifferent Systems

In November 2017, the Nebraska Public Service Commission voted 3-2 in favor of allowing the proposed Keystone XL pipeline to be built in the state. Actively opposed by groups such as 350.org and blocked during the presidency of Barack Obama, Keystone XL was revived by the new administration under Donald Trump as one of its very first acts of state. When finished, it will extend over 1,000 miles from Hardisty, Alberta, to Steele City, Nebraska, where it will join up with the existing Keystone network. The pipeline system will move Canadian oil from the Alberta tar sands and US oil from Montana and North Dakota to refineries on the Texas Gulf Coast and to tank farms in Cushing, Oklahoma and Patoka, Illinois. It will have a capacity of up to 1.1 million barrels per day. For a world still hungry for fossil fuels, this "export limited" (the "XL" in the name) pipeline is expected to generate profits for TransCanada Corporation—the owners of Keystone— as well as for the oil companies that use its massive infrastructure to move their products to market.

One of the surprises of the Nebraska decision was that the Commission shifted the pipeline's route through the state. Instead of sticking with Trans-Canada's preferred route, for which the company

has already secured easements from the majority of
impacted property owners, the Commission proposed
to follow an existing Keystone line through the area.
Environmentalists who object to the expansion of the
fossil fuel system and to the possible repercussions of oil
spills along pipeline routes—like the one TransCanada
was dealing with in South Dakota at the time of
the decision—drew attention to the fact that no envi-
ronmental studies had been done on this new route.
Impacted landowners objected for similar reasons, as
well as for the fact that no easements had been negoti-
ated. While TransCanada expressed unhappiness
with the extra cost implications of the new route, they
were also pleased that, at long last, a decision had been
made and the final stage of the full Keystone system
could be built.

Pipelines like the Keystone obliterate the spaces
and environments that exist between oil source
and its end users. They cut straight lines across land-
scapes, indifferent to the specifics of geography. For
city dwellers, these technologies of energy transport
generate indifference not only of a spatial kind, but
also of an ethical or political one: extraction zones
and networks of transport have little impact on the
majority of those who use fossil fuels, for whom the
stuff of energy appears, as if by magic, in their furnaces
or at gas stations. The protracted and public struggle
over Keystone XL shows that other lines on maps—the
borders of states or countries, the lines around prop-
erty—can inhibit or block the easy passage of pipelines
through space. Property owners can, at a minimum,
make financial claims against pipeline companies when
ribbons of steel make their way across their fields and
gardens. Everything else that shapes geography—
from distinctive geologies to watersheds and animal
habitats, and from indigenous communities to histories

of human habitation other than property and politics—gets ignored and left out of cost-benefit calculations.

From the perspective of the Nebraska Commission, which nudged the vector of the pipeline without considering what regions it traversed and brought into its danger zones, one route is as good as any other. Yet regions are where the consequences of technologies—whether physical technologies such as pipelines or the *technē* of governments that establish borders and property—are felt most determinately. The region in which the November Keystone spill of 5,000 barrels took place will take years to clean up (a 2016 spill of 400 barrels at another site in South Dakota took ten months to ameliorate).[1] Spills always take place in-between, in the space of the region, as far away from the abstract legislative space of a state

1 Mitch Smith and Julie Bosmannov, "Keystone Pipeline Leaks 210,000 Gallons of Oil in South Dakota," *New York Times*, November 16, 2017.

Warren Cariou, *Water Treatment Facility on Bank of the Athabasca River*, 2017.

or country as the cities to which the black pools of fuel were intended to move.

Region is a term and a concept that we rarely consider, even if much of the trauma and crisis of modernity is happening there. We need to understand the dynamics of region if we are going to challenge the indifferent systems of infrastructure and politics that carve up and control everything in their orbit. Region owes nothing to the forms of citizenship granted to subjects by states, or to the power that comes from indifference to the spaces traversed by the infrastructure of modernity. Might region allow us to understand anew the connections of space, belonging, and environment needed to take on the political challenges of our era?

Toward a Theory of Region

On a scale from the global to the local, the region hovers somewhere in between. *Where* in between is difficult to determine, in part because region lacks any precise definition. A region can be an expanded sense of the local—a city and its suburban and exurban pseudopods. It can be comprised of a series of nations, linked by trade, history, religion, or ethnicity. Region can point to zones within nations, demarcated by as little as the points on a compass (Northeast, West, Midwest, etc.). It can be understood in relation to religion (Bible Belt, Borscht Belt, Jell-O Belt), or be shaped around labor and industry (Wheat Belt, Rust Belt). Region can also be defined in relation to geology (the Rockies, the Mississippi Delta), a configuration that overlaps only inexactly with the spaces staked by existing political forms and laws that intend to make a claim on spaces and their inhabitants (e.g., the Rockies run through both Canada and the US).

Region is thus a messy term. But to develop a precise definition of region would be to miss the point

of the demand that the concept makes on us. It is in the
indistinct nature of region, in the broad and shifting
set of characteristics and qualities that extend from one
idea of region (the Middle East) to another (the Ogallala
Aquifer), that its power lies.

What is inherent in every idea of region is a
contiguity of geographic space. On a map, regions are
paramecium-like zones of connection that refuse to
obey the sharp lines of state borders or property. No
nation-state is a region (even if region is sometimes used
to designate groups of nations), and no region has laws,
police, and military—the apparatus of modern power
that has so deeply shaped ideas of community and sub-
jectivity. Regions rub raw the self-certainties of modern
state formations. A region is that spot on the Achilles
tendon (of capitalism, property, or liberal democratic
governance) where an ill-fitting shoe raises a bloody
patch and threatens to sever altogether both the tendon
and the power mythically contained within it.

In addition to contiguity of space, what is of
primary importance to a region is that there is a *there*.
Every region can be seen as a type of ecology—an envi-
ronment (a contiguous geographic zone), the subjects
that animate it (whether these are animals and plants,
specific religious groups, the resources that lie beneath
the ground, or the strata of the inanimate), and the
relation between these two. Just as important to note
is that there is never a single *there* there, but rather,
of necessity, a rich, heterogeneous set of overlapping
ecologies that speak to the multiple relations that exist
in any geographic zone.

Against the abstraction of the nation-state and
other political boundaries, regions demand that we
be alert to the innumerable ecologies that constitute
the lives of individuals and their communities. Their
multiplicity asks not that we try to name all of these

relations in order to codify them into some new logic of regionality. The necessary multiplicity of ecologies, each environment linked in an essential way to the organisms that dwell there (people, animals, plants, fuel, minerals, non-humans, forces, processes) asks that we undo the abstract mechanisms of power, which pay little attention to the planet's ecologies and operate instead via well-established modes of power linked to inclusion and exclusion. Nations and cities do not seem to pay attention to the demands that multiple ecologies make on them. Regions, on the other hand, are attuned to the realities of the shifting ideas and realities of being there—including the *there* of nations and cities—and spill over beyond established political borders.

Regions thus pose a challenge to accepted ideas of citizenship that lie at the heart (of the myth) of the modern democratic state. A citizen belongs to a nation-state. With this belonging come responsibilities (such as defending the nation, when necessary) as well as, at least potentially, rights and opportunities (security from internal and external threats, education and health, and the right to own property). One of the powers of the concept and practice of citizenship is that it insists that all citizens within the spaces it delineates are equal. A map of the globe shows every nation-state to be a single, flattened color. The jigsaw shapes of red, blue, green, and yellow differentiate the citizens of one country from another, and at the same time assert that inside these flattened color fields all citizens are the same. But in truth, citizenship is shaped around inclusions and exclusions, around violent delineations of belonging. The differential quality of citizenship extends not just to who one is, but what they do and where they live within a nation-state.

Even before the law there are enormous inequal-ities between citizens, which are recognized by the

disparate zones of policing, incarceration, and state violence against its citizens. There are zones of opportunity and hardship, wealth and poverty, black and white. Regions speak the lie of nations with respect to their claim on space by drawing attention to differential experiences of citizenship that exist within any nation at any point in its existence.

There are still other regions to which we need to be alert—regions of dispossession, of poverty and wealth—which emerge from the extension of the logics of capitalism to the whole of the planet. Free trade zones, spaces of cheap labor, abandoned spaces of productions—all emptied of the faintest traces of workers' rights—appear as spaces in which nations have forsaken the commitments that they might have once promised to their citizens in favor of the logics of globalization that would render the entire world (and not just the internal space of nations) into a single indifferent space.

The environmental consequences of global, neoliberal capitalism create further regions—of eco-destitution, monocultures, commodity frontiers, soils drained of life, polluted geographies. These toxic ecologies emerge out of the utter disinterest shown by capitalist states to the specificity and complexity of regions. These spaces might often be described in the language of region (as in "regions of pollution"), but they are regions in name only. These ecologies are the consequence of the abstract logic of power, control, property, and profit, the outcome of the instrumentality of statecraft as well as extrastatecraft.[2]

It is essential to grapple with the forces that generate these toxic ecologies, since they offer up a false idea of political change.

2 The term "extrastatecraft" was coined by Keller Easterling in *Extrastatecraft: The Power of Infrastructure* (New York: Verso, 2014) to describe protocols and standards connected to the design of structures and infrastructures, which generate outcomes that support and amplify neoliberalism.

One can understand why inhabitants of dispossessed and distressed regions might want to restore what was removed or taken away, such as the factories that once provided jobs. But it is a mistake to imagine this dispossession as a deficit of true citizenship, which now needs to somehow be restored or made full (the national restored from the global; regional differences inside the nation flattened out to restore the promised equality of citizenship). Neoliberal citizenship has ensured that *all* citizenship has been torn asunder; it no longer even hides behind the narrative that citizenship ensures equality, as it might have once done. If citizenship is based on inclusion and exclusion, then it is only natural that those once included in its fold should want the safety and privilege that had been (minimally) accorded them. Yet at a moment when we need to pay greater attention to the complex ecologies we inhabit, citizenship is a crude, abstract device of being and belonging

Warren Cariou, *Bitumen Strip Mine with Pipeline and Truck Turning Loop*, 2017.

that doesn't help make it possible to understand the
multiplicity and heterogeneity of regions or to address
the forces that generate the toxicity of all too many
regions on the planet.

 We have to be alert to the limits, too, of existing
practices and techniques of region, such as those that
exist in the practice of architecture. "Critical region-
alism" names structures that employ the codes and
character of modern architecture, while also paying
attention to a building's geographic context.[3] Even as
it challenges the flattening universality of dominant
forms of architecture (such as the International Style),
the way in which critical regionalism foregrounds
geography provides little more than shading to a style—
the modern—that exists before and beyond it. At best,
the region in critical regionalism appears as small
adjustments that different geographies might demand
of modern architecture. These modern buildings can
congratulate themselves for being attuned to differ-
ences of landscape, while still being modern and not
truly dealing with the challenge of region at all.

 Critical regionalism speaks only to a single ecol-
ogy—the environment of modern buildings, which exist
within the dictates and demands of capitalism. A true
critical practice of region would instead explore multi-
ple ecologies, attending to the full range of relationships
that exist in any geography. What defines the environ-
ment and organisms that make up a
region can and should vary widely.
How might architecture respond
to regions defined, for instance, by
different forms of energy? Or by
diverse modes of labor and income?
Or by immigration and political
counter-narratives? How might
an architectural practice react to

3 The idea of "critical
regionalism" is elaborated
in Kenneth Frampton,
"Towards a Critical
Regionalism: Six Points
for an Architecture of
Resistance," in *Anti-
Aesthetic: Essays on
Postmodern Culture*
(Seattle: Bay Press, 1983),
16–30.

and interact with multiple regions—with geographies of living and non-living bodies, or with geological and environmental zones that might assert that the construction of modern architecture is akin to the abstraction of the nation-state, whatever shading style one might apply?

To the Region!

The Keystone XL pipeline system operates both in and outside of the logic of region. It draws on discrete regions of resources (e.g., the Athabasca Tar Sands, the Bakken Oil Shale), artificially assembling them together in order to move resources elsewhere. Region matters to the XL, but only as sites of entry and exit. Everything in between is a hindrance, whether due to scale (the length of pipeline requires forty-one pump stations to keep the oil moving), the geology it has to navigate (e.g., the Ogallala aquifer, which stretches from South Dakota to Texas, the Missouri River, or the Sandhills of Nebraska), or its impact on communities that might challenge its logics and embedded presumptions. While the Keystone XL and pipelines like it depend on the existence of resource regions, the primary logic they follow is that of capitalist modernity and its under-standing of resource as a "standing reserve."[4]

The flattening of geography, geology, and com-munity (and every other region) along the path of a pipeline mirrors the operations of citizenship, a political infrastruc-ture that uses the cloak of equality (especially before the law) to deny or disavow all manner of inequali-ties and the disequilibria between its citizens. The logic of region laid out here is intended as a heuristic rather than something like a law of

4 Martin Heidegger writes that over the course of modernity, "Nature becomes a gigantic *gasoline* station, an energy source for modern technology and industry." Martin Heidegger, *Discourse on Thinking*, trans. J. M. Anderson and E. Hans Freund (New York: Harper, 1969), 50.

nature—rough around the edges, not always workable in each and every evocation of region. What attention to region offers is a rejoinder to protocols of dividing up space that do not attend to the rich and multiple ecologies that exist there. As the path of a pipeline shows us, the sovereign space of the state and private property, along with other practices of spatializing, have consequences for the ecologies of these regions. Yet what a pipeline can never name are the relations between people, place, environment, objects, animals, gases, and plants that inhabit and shape a region. If for no other reason than the environmental challenges we face, we need now to actively and attentively inhabit non-flattened, non-empty spaces.

Could region act as a possible site of citizenship—an alternative to the one to which we presently seem fated? We have examples of regions creating powerful new forms of belonging and community. The protests that took place near the Standing Rock

Warren Cariou, *Bitumen Mine Abstract with Pipeline*, 2017.

Indian Reservation against the Dakota Access Pipeline
in 2016 and 2017 brought together indigenous people
from across North America, as well other protestors.
Those assembled at Standing Rock wanted to draw
attention to the threat of the pipeline to sacred burial
grounds as well as to the quality of the communi-
ty's water. Attempts by members of the Standing
Rock Sioux Tribe to use the mechanisms of official
citizenship (e.g., appeals to the Advisory Council on
Historic Preservation, the Department of Interior, the
Environment Protection Against, and suits filed in
court) went nowhere. And so a new community—one
intimately alert to the reality of region and the multi-
plicity of ecologies in their lifeworlds—came into being
in the protest camps that blocked the abstract, indiffer-
ent logics of the pipeline.

 It seems difficult to adapt the old language of
citizenship to truly new modes of being and belonging
in space, like those enacted at Standing Rock. The
moment one declares citizenship in relation to a region,
it fixes a single ecology in place, creating something
akin to a micro-nation. Citizenship is a damaged
concept that insists on inclusions and exclusions, on
the establishment of borders and sovereignty. It might
be that region allows us rethink how to commit to one
another and to the ecologies we inhabit without the
necessity of sovereignty. Region constitutes a powerful
redefinition of the political on a planet where borders
have threatened the health of communities and ecolo-
gies far more than it has helped them.

NATION

What are the boundaries of a nation?
Architecture can account for certain edge
conditions that mediate citizenship:
the apparatus of customs, processing,
patriation, and detention. Beyond border
architectures, however, the limits of
nationhood are much blurrier, constructed
through immaterial realms of changing
legal language, policy, and shared cultural
narratives. The *national cage* is a term, first
used by political economist Ronen Palan,
to describe the combination of geographic,
constructed, and legal forms that define
the parameters of the nation-state, forming
a spatial cage, which has come to replace
the old defensive walls of the city-state.

 "Only complete world desovereigniza-
tion can permit the realization of an all
humanity high standard support," wrote
Buckminster Fuller in his 1968 manifesto-
like *Operating Manual for Spaceship Earth*,
arguing for an industrial and ecological
synergy for the planet. But the recent rise of

nationalist rhetoric and the construction of
eight wall prototypes along the US-Mexico
border reveal that despite economic and
environmental, social and technological
factors that favor otherwise, we are not yet
prepared for a post-wall nation-state.

Teddy Cruz and Fonna Forman's
research via their Cross-Border Initiative
at the University of California San Diego
directly investigates the spatial and political
implications of national boundaries. They
are interested in the way in which the com-
plex geological, surveillance, bureaucratic,
and physical armatures constitute, or recon-
stitute, the definition of a nation-state. The
fortified border is reimagined as a trans-
national commons that, through the logic
of natural and social systems—watersheds,
indigenous lands, ecological corridors, and
migratory patterns—critically envisions
a binational border region and suggests
opportunities for reimagining others across
the globe.

MEXUS

A GEOGRAPHY OF INTERDEPENDENCE

ESTUDIO TEDDY CRUZ + FONNA FORMAN

The Mexico-US border is often maligned as a site of violence and crime, division and fear. By contrast, *MEXUS* represents this national threshold as a site of urban and political experimentation, from which more inclusive public imaginaries can emerge based on interdependence and cooperation. It rethinks the concept of citizenship beyond the jurisdictional limits of the nation and the politics of territorial identity, and toward a more expansive idea grounded in shared assets and opportunities, which often remain hidden in border zones.

 MEXUS visualizes the many cross-border flows—the watersheds, indigenous and protected lands, and ecological and metropolitan zones— that transgress the line. The wall cannot contain many things. The border is not simply a place where things end. This reality presents a challenge: un-wall our political imagination and consider a more porous border region. *MEXUS* challenges the legitimacy of an undifferentiated line between nations imposed onto a territory, which truncates

the social and environmental systems that bridge divided nations. *MEXUS* presents a thicker set of ecologies framed by the existing structure of binational watersheds that sustain the entire region.

This swath of land is a region rather than a border. Un-walling reveals this thickened system of interdependencies. Even though the wall is regularly presented as an object of national security, it may prove to be a self-inflicted wound—the cause of great international environmental and economic insecurity in the years to come. The wall undermines vital regional ecosystems that are essential to the coexistence and survival of the communities on either side.

When environmental systems emerge as an organizing framework for a new transnational bio-region with corresponding cross-border opportunities and ethical imperatives, the primacy of the nation retreats. As development economist Amartya Sen argues, global ethics necessitates a "cross-border public framework" that includes not only voices within our own jurisdictional and territorial boundaries, but also the voices of those beyond our borders who we impact through our decisions and actions.

The challenges and opportunities that *MEXUS* opens are exemplified by zooming deeper into the region's westernmost watershed. The Tijuana River Watershed ends at the Pacific Ocean as it filters through the Tijuana River Estuary, in the southernmost tip of San Diego County. In recent years, the activities of the US Department of Homeland Security, the building of a militarized "third border wall," and the installation of more invasive infrastructures of surveillance and control, have impacted this sensitive environmental zone—the federal land flanking the border wall.

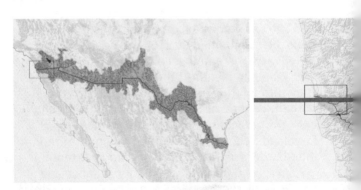

MEXUS is comprised of the eight watershed systems shared by Mexico and the United States, including the westernmost Tijuana River Watershed.

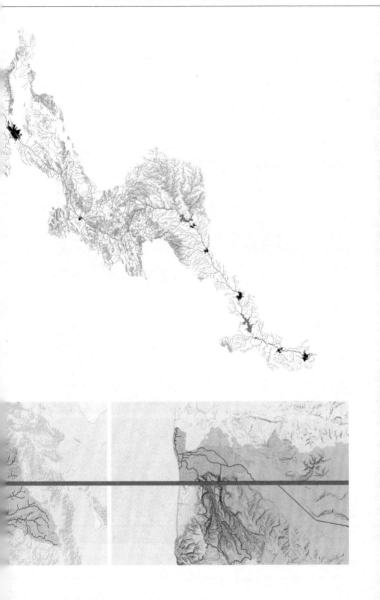

The Mexico-US continental boundary collides with cross-border environmental systems that force interruptions and gaps in the border wall. A new wall proposes to close these gaps, further impacting transnational ecologies and the shared destiny of border communities.

The US imposition of concrete dams and drains truncates the many canyons that travel north and south as part of the bi-national watershed between Tijuana and San Diego. The collision between natural and administrative systems, and between ecological and political priorities, is profound.

The informal Tijuana settlement of Los Laureles, home to 85,000 people, sits in one of these canyons, at an elevation higher than the estuary. The construction of a new border wall by American authorities serves to accelerate the north-bound flow of waste from the slum into the estuary, siphoning tons of trash and sediment with each rainy season, and contaminating one of the most important environmental zones, the "lungs" of the bio-region.

MEXUS anticipates the development of a land conservancy that identifies slivers of land in the slum, bundles them, and connects them with the American estuary, forming a new jurisdiction that is socially and ecologically continuous. Led by Estudio Teddy Cruz + Fonna Forman, this is an unprece-dented cross-border coalition of state and municipal government, communities, and universities. This specific juncture of *MEXUS* exposes the dramatic collision between informal urbanization, militariza-tion, and environmental zones, and articulates the need for strategies of coexistence between these two border communities.

Project Research
and Design
Teddy Cruz
Fonna Forman
Jonathan Maier
Marcello Maltagliati
Benjamin Notkin

Project Support
Emmanuel Fraga
Kyle Haines
Paulina Reyes

Institutional Partners
**The UCSD Center on
Global Justice**

**Tijuana River National
Estuarine Research
Reserve
Instituto Metropolitano
de Planeación de
Tijuana**

ALMA MATER

DAN HANDEL

> There was nothing but land: not a country at all,
> but the material out of which countries were made.
> —Willa Cather, *My Antonia* (1917)

In the United States, land precedes the nation. Of
course, historically speaking, all nations were defined
in relation to a given territory, but land in America
isn't simply a territory. Rather, it is a civilizing entity
through which citizenship is continuously negotiated.
For centuries, the formation of Americans was described
as the result of encounters with vast expanses of land,
rich deposits of natural resources within that land, or
the price per square mile it demanded. From carrying
the word back east on gold found in the Sacramento
River Basin to the portrayals of farming paradise in rail-
road brochures, the cons of speculators or the architect's
imagination of a uniquely American way of building,
the role of land's description was paramount.
 Land was thus transformed into a country
through words. Different genres of writing—surveyors'
logs, personal diaries, public speeches, modern lit-
erature experiments, and gonzo-style architectural
theory—have employed description in a variety of ways
to shape an understanding of and meaning of American
citizenship. While these modes first appeared in dis-
tinct historical periods, they are still present today, not
only in the public sphere and literary circles, but also
in architectural discourse. Throughout, land has been

assigned different cultural roles far beyond its everyday functions, yet three stand out for their lasting presence throughout centuries of American development: liberation, speculation, and history.

Liberation

One of the foundational myths of the United States is that the sheer quantity of land could spark a degree of freedom otherwise unheard of in the Old World. The association between the cultivation of land and the emergence of a new civilization became a prominent theme during the eighteenth century in the form of an agrarian myth. "He has become an American," writes J. Hector St. John de Crèvecœur in his popular *Letters from an American Farmer* of 1782, "by being received in the broad lap of our great *alma mater*." Elsewhere, he argues that the land shapes civic virtue: "the instant I enter on my own land, the bright idea of property, of exclusive right, of independence exalt my mind."[1] Thomas Jefferson famously shared this sentiment when he wrote that "cultivators of the earth are the most valuable citizens. They are the most vigorous, the most independent, the most virtuous, & they are tied to their country & wedded to it's liberty & interests by the most lasting bands."[2]

These descriptions implicitly link cultivation, culture, and civilization, echoing the three terms' shared origin in the Roman *cultus*, which was used in works such as Cicero's *De Republica* or Virgil's *Georgics* and which Jefferson likely knew well.[3] In each, interaction with the land liberates one from

1 J. Hector St. John de Crèvecœur, *Letters from an American farmer* (London: Thomas Davies and Lockyer Davis, 1782)

2 Thomas Jefferson, Letter to John Jay, August 23, 1785.

3 Virgil's ideal landscape and the pastoral ideal were of central importance to the American experience as it was outlined by both Europeans and Americans. See Leo Marx, *The Machine in the Garden: Technology and the Pastoral Ideal in America* (Oxford: Oxford University Press, 2000).

the oppression of class structure and allows a republic of free people to arise. Yet even in eighteenth-century America, Jefferson's agrarian wonderland was mostly an illusion, inaccessible to large parts of society, deadly to others, and soon to be taken over by realtors and speculators. As American democracy matured, it became clear that farmers would be joined by workers and industrialists to build the nation. While reconciling the tensions between republic and democracy was a process that slowly unfolded throughout most of the nineteenth century and well into the twentieth, land maintained its capacity to reject all forms of old world maladies. It was as if, as Alexis de Tocqueville observed, "the soil of America was entirely opposed to territorial aristocracy." The result of this inherent opposition was a democratic nation with "simply the class of the rich and that of the poor."[4] The liberating and democrati-cizing potential of the land became a popular myth of its own, reflected in both patriotic hymns, "swearing allegiance to the land that's free," and individualistic folk lyrics, maintaining that "this land was made for you and me."[5]

As working the land was no longer the essential task of all citizens, working with the land became synonymous with rein-forcing American democratic principles. When Frank Lloyd Wright, for instance, advocated that all buildings should be "of the land," manifest in "architec-tural features of true democratic ground-freedom [that] would rise naturally from topography," or when the LSD soaked founders of Drop City declared that the land

4 Alexis de Tocqueville, *Democracy in America* (New York: George Dearborn & Co., Adlard and Saunders, 1838).

5 Irving Berlin, "God Bless America" (1938) and Woody Guthrie, "This Land is Your Land" (1939). Guthrie wrote his lyrics in critical response to Berlin's song, emphasizing individual freedom:
Nobody living can ever
 stop me,
As I go walking that
 freedom highway;
Nobody living can ever
 make me turn back
This land was made for
 you and me.

will be "forever free and open to all people," they were reaffirming, each through his own set of values, the links between land and liberty, thus bringing its mythic narrative into the heart of postwar America.[6]

Curiously, even when land became an oppressor, land didn't stop omitting an aura of liberty and promise. "[My parents] erred," writes Ben Metcalf, "in their shared assumption, with so much of America, that ownership of the land was a natural right handed down from heaven, as opposed to a shameful ruse perpetuated by the banks ... we were led to believe we had acquired the land, when in fact the land had acquired us; and whereas the land was, in my estimation, perfectly happy with this arrangement, in a remarkably short time we were not."[7]

Speculation

While American leaders may have been musing on agriculture, it was always profit that led their way. The inherent gain to be found in vast expanses of land spawned a class of people whose task was to describe faraway places to potential buyers: speculators, boosters, and promoters whose words transformed the technical language of surveyors into frontier fantasy.

This practice was no stranger to the political elite. George Washington himself, a land surveyor by training, led the way. Having an eye for business, he became one of the most active land speculators in the country in the years before the American revolution. He was first involved with the Ohio Company which speculated on lands for the settlement of Virginians, and then partnered with neighbors to form their own Mississippi Company. In the 1760s,

6 Frank Lloyd Wright, *The Living City* (New York: Horizon Press, 1958); John Curl, a Drop City founder, recalling the 1966 declaration in Curl, *For All the People* (Oakland: PM Press, 2012).

7 Ben Metcalf, *Against the Country* (New York: Random House, 2015).

Washington developed his own schemes based on land granted to veterans, which he hoped to actively colonize while securing the best lands to himself. In 1770, he set on a "hunting trip" with the intention to describe lands around Fort Pitt, Pennsylvania, and others nearby on the Ohio River. His descriptions of these lands, being "contrary to the property of all other lands I ever saw," in which "the hills are the richest land; the soil of them being as black as coal and the growth walnut and cherry," led to successful patents.[8] In 1773, he advertised his 20,000 acres of acquired land to settlers, alluding that their value may increase dramatically if the plan to establish a new government on the Ohio "in the manner talked of" will materialize.

Boosterism, of course, was not always so elegant. As the westward race continued, it took an aggressive turn against the agrarian ideal. When describing the history of land in Southern California, Reyner Banham writes:

> The Yankees stormed in on the crest of a wave of technological self-confidence and entrepreneurial abandon that left simple ranching little hope of survival. Land was acquired from the grant holders by every means in the rule book and some outside it, was subdivided, watered, put down to intensive cropping, and ultimately offered as residential plots in a landscape that must have appeared to anyone from east of the Rockies like an earthly Paradise.[9]

Paradise was often promised, and an entire history of financial bubbles—from the Yazoo land fraud in Georgia and Jay Cooke's Banana

8 George Washington, *Journal of a tour to the Ohio River* (1770), in *The Writings of George Washington* (Boston: Ferdinand Andrews, 1840).

9 Reynar Banham, *Los Angeles: The Architecture of Four Ecologies* (Allen Lane, 1971).

Belt railroad lands to the countless boom cities in Kansas, Oklahoma, Nebraska, or California—followed. Throughout that history, richly illustrated promotional materials used architecture and urban design to color the often-exaggerated descriptions of instant cities in remote locations with a realistic tone.

Sarcastically referring to the hyper-optimism of such publications, one congressman from 1871 said:

> I see it represented on this map, that Duluth is situated exactly half-way between the latitudes of Paris and Venice, so the gentlemen who inhaled the exhilarating airs of one, or based in the golden sunlight of the other, may see at a glance the Duluth must be a place of untold delights, a terrestrial paradise, fanned by the balmy zephyrs of an eternal spring, clothed in the gorgeous sheen of ever-blooming flowers, and vocal with the silver melody of the choice songsters.[10]

Echoes of boosters' pompous statements of the past still resonate with contemporary real estate developers, marketers, and their architects, narrating tracts of land for sale as "the future of Florida," or marketing a bunker compound in South Dakota as the "largest survival shelter community on earth."[11] Long after the frontier closed and the entire country was colonized, land is still being described by speculators as enabling an American way of living, thus luring new immigrants, returning GIs, or retiring

10 Congressman J. Proctor Knott, a speech delivered in the US House of Representatives (1871), quoted from A. M. Sakolski, *The Great American Land Bubble* (New York and London: Harper & Brothers, 1932), 305–6.

11 Quote from Howard H. Leach of Foley Timber and Land Company, as the company offered a 560,000 acres of land, roughly the size of the state of Rhode Island, for sale. See David Gelles, "560,000-Acre Swath of Florida Land Going on the Market," *New York Times*, April 1, 2015. See also, Marketing materials for the Vivos xPoint project (2017).

baby boomers to join the ride. In the Levittowns and the planned communities of New Urbanism, backed by government loans and sub-prime debt, one is invited to reaffirm his belonging to an imaginary nation of like-minded individuals. In these fantasy enclaves, carefully set up against a hostile environment of immigration, economic crises, and disappearing jobs that proliferate in the media, one becomes an American by living up to the land's speculative promise. What lies outside these enclaves is mere fiction.

History

Beyond the reach of both agriculture and development there was always another category of land. The existence of immeasurable surfaces that were either out of reach or too difficult to cultivate, thus making them hard to be speculated upon has always been, and continues to be a defining element of American culture. "In the United States," wrote Gertrude Stein, "there is more space where nobody is than where anybody is. That is what makes America what it is."[12]

The emptiness where nobody (or at least nobody like *us*) is has been romanticized in countless accounts by scholars and popular media alike, from the lingering Jacksonian myth of the frontier as the condition in which the American character was defined, to Leonardo DiCaprio's portrayal of surviving fur-trader Hugh Glass in *The Revenant*. While it was removed from human habitation, it was still associated with the natural rights of every (white) American. As James Fenimore Cooper wrote: "The air, the water, and the ground are free gifts to man, and no one has the power to portion them out in parcels. Man must drink, breath, and walk—and therefore each has a right to his share of earth."[13] The emptiness formed such a powerful

[12] Gertrude Stein, *The Geographical History of America* (New York: Random House, 1936).

image of American culture that vast areas were allocated by states and the federal government for its preservation, and citizens flocked by the millions to experience it. Nevertheless, it remains difficult to express with words, overwhelming narrators with its complexity, strangeness, and sheer size. Landscape historian John Stilgoe writes that that "spatial immensity beggars designation," urging intellectuals and designers to find words to confront "the continent itself," and thus challenge their own disciplinary and social boundaries.[14]

One such provocation was put forth by Aldo Leopold, based on years of attentive observations and detailed descriptions collected in his *Sand County Almanac*. Leopold's concept of "land ethic" simply calls for enlarging "the boundaries of the community to include soils, waters, plants, and animals, or collectively: the land."[15] Once the land is understood as part of a community of interdependent parts in which individuals compete or cooperate, the implications to notions of citizenship and natural rights become radical. For Leopold, the land ethic can become a lens through which the entirety of human history can be reconsidered: "Many historical events, hitherto explained solely in terms of human enterprise, were actually biotic interactions between people and land ... The characteristics of the land determined the facts quite as potently as the characteristics of the men who lived on it."[16] In other words, the description of what was considered too difficult to describe—the complex systems that comprise the land and determine its interactions with humans—is a first

13 James Fenimore Cooper, *The Prairie: A Tale* (Paris: Hector Bossange, 1827).

14 John Stilgoe, "Wuthering Immensity," *Manifest – Journal of American Architecture and Urbanism* 1 (2014): 12–19.

15 Aldo Leopold, *A Sand County Almanac* (New York and Oxford: Oxford University Press, 1949).

16 Ibid., 216.

step towards a more a new definition of an American way of life.

Future

In 2017, President Trump decided to roll back the decisions of his predecessors and cut down the size of two national monuments in Utah—Bears Ears National Monument and Grand Staircase-Escalante—by roughly two million acres. This decision was regarded by the liberal media as a dangerous precedent in which public lands could be made available to oil drilling and other extractive operations, thus betraying an American tradition of conservation. Yet Trump reasoned his decision by addressing the freedom of each citizen to take care of the land based on intimate firsthand acquaintance, rather than delegate it to professional bureaucratic sagacity: "Your timeless bond with the outdoors should not be replaced with the whims of regulators thousands and thousands of miles away. They don't know your land, and truly, they don't care for your land like you do." In his view, a more direct democracy can emerge once the land will belong to the citizens who live on it. "I've come to Utah ... to reverse federal overreach

Jay Mark Johnson, *Carbon Dating #1, Hazard, Kentucky 2008*, 2008.

and restore the rights of this land to your citizens."[17] This perspective blends the understanding of land as liberation, speculation, and history almost seamlessly, moving backward and forward in time to an imagined America. In this speech, as in other instances outlined above, description becomes more than a literary device, not only reflecting upon given realities of citizenship, as it is reflected in land allocation and manipulation, but actively pursuing the preservation or changing of such realities. In an era when words speak louder than actions, how we choose to describe our environment and ourselves becomes even more crucial to the definition of a national identity, whatever the term may mean today. Then again, perhaps this was always the case in the United States.

17 Donald Trump, Remarks on the Antiquities Act at the Utah Capitol, December 4, 2017.

It could be argued that the spatial history
of citizenship at the scale of the globe is one
of visualizing data: trade routes, migratory
shifts, and the flow of capital, goods, and
people. The systems of global exchange offer
up new spaces to enact statehood through
logistics, tourism, investment. From the
origin myth of the arrival of the Mayflower,
the tragedies of the slave trade from Africa,
to contemporary ethnic diasporas that
construct new familial and cultural net-
works across the earth, global routes have
played a central role in structuring the
demographics of American citizenship.
Today, the global scale takes on new reso-
nance as transnational corporations operate
across and through sovereign boundaries,
capitalizing on their numbers through free-
trade zones and offshore markets.

　　And yet we have a problem with scale
and scalability, as Anna Lowenhaupt Tsing
informs us through her survey of the marks
of capitalism on the planetary landscape.

Not every condition neatly expands outward. Architectural assets, which also dovetail with spaces of belonging, such as home, housing, and urbanization, are unequally distributed—either atomized or densified—at the global scale. "In an era of neoliberal restructuring, scalability is increasingly reduced to a technical problem rather than a popular mobilization in which citizens, governments, and corporations work together," Tsing writes in *The Mushroom at the End of the World*.

The collaboration between Diller Scofidio + Renfro, Laura Kurgan, and Robert Gerard Pietrusko is indebted to open source datasets and the abstract aesthetics that follow such materials. Yet their work homes in on something much more subjective: the implication of the viewer, who, caught between two screens, must bear witness to the unevenness of globalization and the impossibility of seamless scalability.

IN PLAIN SIGHT

DILLER SCOFIDIO + RENFRO
LAURA KURGAN
ROBERT GERARD PIETRUSKO

WITH COLUMBIA CENTER FOR SPATIAL RESEARCH

Hannah Arendt once said, that "only with a completely organized humanity could the loss of home and political status become identical with being expelled from humanity altogether."[1] Today, using the best technologies available for data collection, we are able to see settlements and count their populations. Registering the sites of exclusion and expulsion—the places of refuge and resistance—presents a powerful challenge, however. In a world of would-be global citizens, do we truly know where our fellow citizens live? And if we don't, how can we make them count?

This is a question of representation. Twice a day, twelve hours apart, a new image of Earth is scanned and saved by the Soumi National Polar Partnership satellite and its sensors. The 1:30 p.m. daytime image, assembled from data gathered over a number of days, shows a cloudless Blue Marble. The 1:30 a.m. nighttime image, similarly composited, forms a Black Marble, a cloudless view of lights across the

1 Hannah Arendt, *The Origins of Totalitarianism* (San Diego: Harcourt Brace & Co, 1973 [1951]), 297.

planet. The sensors can observe light in extraordinary detail, all the way to the level of a traffic lamp or a fishing boat. According to NASA, "the sum of these measurements gives us a global view of the human footprint on the Earth."

In 1972, the Blue Marble photo of Earth from Apollo 17 marked a paradigm shift: the image of a solitary sphere floating in space became the icon of a unified, borderless, and vulnerable planet, and catalyzed an appeal to a global "humanity" around something natural that we all share and that binds us together. Without frontiers, it demands of us another kind of stewardship or citizenship, beyond the law and the state, a status that has no legal standing but an often powerfully affective one.

Forty years later, the Black Marble became the new portrait of our planet. While more binary and less textured in form, it provided us with evidence of the extent of the human footprint on the planet. According to NASA, it "shows [us] where the major population centers are and where they are not."

For Marshall McLuhan, the great technological and mediatic revolution came in the form of electric light. The Black Marble puts this in simple on-off terms: Either there is light, or there is not. Where McLuhan saw "electrical contraction" and the emergence of a global village, NASA sensors show us the gaps in the network, the individual lights and the zones where lights are missing. And the image doesn't simply represent this world—it actively constructs it. As evidence, the Black Marble imagery is put to work by a range of political and economic actors to craft policies and interventions organized around a set of parallel binary oppositions: urban-rural, developed-undeveloped, and rich-poor.

Blue Marble, 2002; Black Marble, 2016.

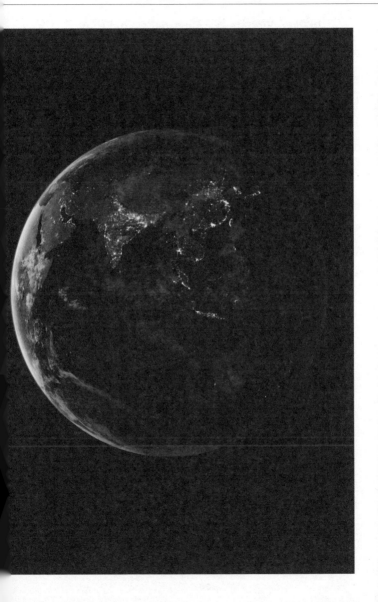

In Plain Sight reveals anomalies and the consequent perils at the core of this binary world view. Two opposing rear-projection screens display two versions of the same place—a daytime and a nighttime view of the planet. Visitors are caught between these layers and between the discrepancies of the data. The sweeping motion of a scanner beam refreshes both screens in unison, changing scenes, zooming in close, and introducing new layers of information. Visitors are shown places in the world with many people and no lights, and those with bright lights and no people, and are suspended between day and night and light and darkness— exposed to the political and social realities of being invisible in plain sight.

Project Research and Design team
Elizabeth Diller, Diller Scofidio + Renfro
Laura Kurgan, Columbia Center for Spatial Research
Robert Gerard Pietrusko, Warning Office
Grga Basic, Columbia Center for Spatial Research
Dare Brawley, Columbia Center for Spatial Research
Will Geary, Columbia Center for Spatial Research
James McNally, Diller Scofidio + Renfro
Scott March Smith, Warning Office

We wish to acknowledge the critical contributions of Ricardo Scofidio, Kumar Atre, and Matthew Johnson in the development of the project.

Nighttime lights, Canada and Northern United States. 1: 6,000,000.

Nighttime lights, Athabasca oil sands, Alberta Canada. 1:11,000.

Nighttime lights, Eastern United States. 1:200,000.

SMELTING POT
JENNIFER SCAPPETTONE

Consider two terminals of American architecture, one positive, one negative, in an epicenter of global capital flows: a colossus and a void. The colossus rises from the harbor at the metropolis' Southern pole; the void is cloaked as a helical shell at the edge of a park to the North. Both operate as conductors, waystations in an immense circuit of goods and services. The statue attracts the laborers and potential citizens from across the globe who will fuel the circuitry; the museum channels illustrious artifacts of that economy's glut in privileged zones of operation. One of these monuments is a public figure financed by collective fundraising efforts in two countries, the other an amphitheater for the edifying fruits of private enterprise rendered accessible to the citizenry out of generosity, with the mission of enlightening the public. Icons of American politics and cultural affairs—the promise of US citizenship taking the form of liberty and a strike-it-rich fantasy—these New York landmarks were nevertheless forged by global flows: by exploitation of the elsewhere. Both were built by copper. Liberty's legendary skin is constituted by 62,000 pounds of it, the amount in thirty million copper pennies, or 1,771,429 iPhone 5s; the Guggenheim testifies to a family's countless millions derived through copper's extraction and capitalization from afar.

The Statue was the brainchild of Édouard de Laboulaye, poet, jurist, president of the French

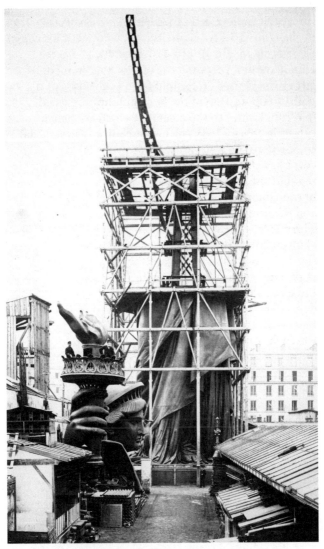

Albert Fernique, *Assemblage of the Statue of Liberty in Paris, Showing the Bottom Half of the Statue Erect under Scaffolding, the Head and Torch at Its Feet*, 1883.

Anti-Slavery Society, and professor of comparative law at the Collège de France with a novel specialization in the United States Constitution, who spent his career advocating for the return of democracy to France.[1] Laboulaye first proposed the idea of a monumental gift to the United States in 1865—in the midst of the political oppression of the Second Empire, extending from France to the colonies (which doubled in extent in this period); the monument was strategized to celebrate the centennial success of the US as constitutional republic, honoring the victory of the Union in the Civil War and the attendant passage of the Thirteenth Amendment, which abolished slavery. By 1871, when the Third Republic was established upon Napoléon III's defeat by Prussia, Laboulaye had teamed up definitively with Frédéric-Auguste Bartholdi, an ambitious sculptor who had traveled to Egypt and unsuccessfully campaigned to produce a Rhodes-like colossus at the Suez Canal under the title "Egypt (or Progress) Brings Light to Asia," thereby glorifying a private French enterprise built by thousands of Egyptian forced laborers.[2] A reincarnation of the Roman Libertas, their sculpture would concretize an ideal bond between two effectively tenuous and imperfect republics—a bond that, conjured on such a colossal scale, might even have brought constitutional

1 My thanks to Sean Gohman and William Rose of Michigan Tech and Tom Wright of the Quincy Mine and Hoist Association for their generosity in abetting my fieldwork in the Keweenaw Peninsula; to Marina Resende Santos for research assistance; and to Joshua G. Stein for his readings of this essay in draft form.

According to Walter Dennis Gray, Laboulaye was in fact the first French academic to teach American history: Walter Dennis Gray, *Interpreting American Democracy in France: The Career of Édouard Laboulaye, 1811-1883* (Newark, DE: University of Delaware Press, 1994), 55-72.

2 See Stephen W. Sawyer, "Édouard Laboulaye and the Statue of Liberty: Forging the Democratic Experience," *The Letter of the Collège de France* 4 (2008/2009): 55-56. For more on Laboulaye, see Gray, *Interpreting American Democracy in France*.

democracy to post-revolutionary France.[3] Laboulaye and Bartholdi's project held out the promise not merely of an alliance between two would-be democratic nations, but of worldwide enlightenment: "on the threshold of the continent so full of a new life—where vessels from all parts of the world are constantly passing," the sculptor intoned, "it will rise from the bosom of the wave and represent 'Liberty Enlightening the World.'"[4]

The frontispiece to a pamphlet describing the statue written by Bartholdi and generated to raise funds contains an 1885 autograph contributed to the text by the dying Victor Hugo: "*La forme au statuaire est tout, et ce n'est rien; Ce n'est sans l'esprit, c'est tout avec l'idée*" ("Form to the sculptor is all and yet nothing. It is nothing without the spirit; with the idea it is everything.")[5] How does the monument's significance change if we read against the grain of this pronouncement by France's illustrious Romantic, whose ideological inconsistencies led him to oppose the death penalty, for example, but not slavery, or France's colonial atrocities in Algeria? What if we instead consider the material of composition as it precedes ideological projections, and that material's shaping, as determinant—as "everything"—and the spirit or idea that which roves capriciously according to whims of governance and the shifting perspectives of the citizenry? What is revealed if we dig up the fundament of form in the material sense, excavating its underpinnings in earth and labor,

3 These developments are carefully laid out in Chapter 8 of Yasmin Sabina Khan, *Enlightening the World: The Creation of the Statue of Liberty* (Ithaca, NY: Cornell University Press, 2010), 117–32.

4 Quoted in Frédéric Auguste Bartholdi, *The Statue of Liberty Enlightening the World, Described by the Sculptor* (New York: North American Review, 1885), 53: http://archive.org/details/statuelibertyenoobart-goog; and in YA Pamphlet Collection (Library of Congress) DLC, *An Appeal to the People of the United States, in Behalf of the Great Statue, Liberty Enlightening the World* (New York: s.n., 1884), 2: http://archive.org/details/appealtopeopleofooyapa.

5 Frontispiece to Frédéric Auguste Bartholdi, *The Statue of Liberty Enlightening the World*.

and take as literal the quest to enlighten the world that characterized the last century of US enterprise, paving the way for its ascendancy?

The copper of Liberty's facture, like the technological miracle of its structural engineering, testifies to worldly circuits of crucial importance to the development of the long twentieth and twenty-first centuries. In 1904, Sandford Fleming would articulate the importance of the projected system of Pan-Brittanic cables and telegraphs stringing subject nations "like jewels on an epoch-making electric girdle." "All British subjects throughout the world will be kinsmen in the truest sense; trade and commerce will be aided; the Empire will be strengthened in all its parts and made mutually helpful; ... and this world-wide union of commonwealths will become more and more a civilizing agency making always for the peace of the world and the welfare of mankind."[6] Though articulated through the imperial design of the US' former sovereign, this statement anticipates a panorama applying in equal measure to the globally dispersed territories to be bound through resource extraction by American barons of the Gilded Age, who would swiftly come to dominate the copper industry that laid the foundations for this worldwide telecommunicative union. Fleming's baldly imperialist "girdle" also brings out the way that contemporary networks, as extensions of historical copper cabling infrastructure, manifest what Tung Hui-Hu identifies as "a *reemergence* of sovereign power within the realm of data," despite their decentralized and apparently ethereal and democratic nature.[7] Overtly advertising the constitutional value of US citizenship, the allegory of

6 Sir Sandford Fleming, "Our Empire of Cables," in *Empire Club Speeches; Being Addresses Delivered before the Empire Club of Canada during Its Session of 1903–04*, ed. William Clark (Toronto: William Briggs, 1904), 94.

7 Tung-Hui Hu, *A Prehistory of the Cloud* (Cambridge, MA: MIT Press, 2015), xiii.

Liberty Enlightening the World that rose in New York Harbor simultaneously vaunts as matter, as weathered verdigris skin, the eclipsed substructure of the global village. By tracking the origins and ramifications of this substructure we can decrypt the expression of a way-side, leaching citizenship of extraterritorial reach—and drastically uneven beneficence.

The sculpting of *Liberty Enlightening the World* was envisioned as a gift of the French people (not the French government), and US citizens were asked in turn to fund its pedestal. The fabricators took advantage of the optimism of two World's Fairs, each following a national trauma (the Civil and Franco-Prussian wars), to generate interest and further the cause: Liberty's torch-wielding hand was displayed at Philadelphia's 1876 Centennial Exhibition, while her head and shoulders were featured at the Universal Exposition of 1878, in Paris, an event the brothers Goncourt described dryly as a "Babel of industry ... inundated with people collected to celebrate the fraternizing of the Universe."[8] Beginning in 1875, Laboulaye raised funds for the statue through elaborate banquets aimed at politicians, journalists, artists, and descendants of French heroes of the American revolution, a popular lottery authorized by the French government, and the sale of models and promotional photographs, eventually drawing more than one hundred thousand subscribers.[9] Despite campaigns ranging from collection of school-children's pennies to a promotional auction, success to the pedestal

8 Edmond de Goncourt and Jules de Goncourt, May 27, 1867, *The Goncourt Journals, 1851–1870*, trans. Lewis Galantière (Garden City, NY: Doubleday, Doran, 1937).

9 For the role of photography in creation of the statue see Luce Lebart and Sam Stourdze, *Lady Liberty* (Paris: Le Seuil, 2016), and a review of the accompanying show, Sarah Moroz, "How Photography Helped Build the Statue of Liberty," *New York Times: Lens Blog*, https://lens.blogs.nytimes.com/2016/07/07/how-photography-helped-build-the-statue-of-liberty/.

fundraising efforts in the US was harder to muster; it came only after a latebreaking harangue by Joseph Pulitzer in his newspaper the *New York World*, which raised over $100,000 in an act now recognized as one of the first examples of crowdfunding in this country: "The $250,000 that the making of the Statue cost was paid in by the masses of the French people," Pulitzer petitioned; "It is not a gift from the millionaires of France to the millionaires of America, but a gift of the whole people of France to the whole people of America." Eighty percent of the resultant contributions amounted to less than one dollar each.[10] Despite the extensive popular funding on both continents, the most crucial donation to *Liberty Enlightening the World* hailed from one of the world's leading industrialists: Pierre-Eugène Secrétan, who owned a major mill in Sérifontaine, France, and donated all the copper for a sculpture that represented the single most massive deployment of the metal at that time.[11]

In seeking a medium and an engineering solution through which to build his colossus, Bartholdi approached the well-known decorative metal specialists Gaget, Gauthier & Co., who had constructed the dome for Paris' new opera house and statues for the spires of Notre Dame and Sainte-Chapelle; they were experienced in the use of copper, a malleable and lightweight material capable of being sculpted in France and transported across the Atlantic for reassembly. The foundry was particularly skilled in *repoussé*, a laborious millennia-old technique

10 "*Let us respond in like manner. Let us not wait for the millionaires to give us this money.*" Joseph Pulitzer, "The Unfinished Pedestal: What Shall Be Done with the Great Bartholdi Statue?" *New York World*, March 16, 1885.

11 See Jean-Marie Welter, "Understanding the Copper of the Statue of Liberty," *JOM* 58, no. 5 (May 2006): 30–33. As will be reinforced later, the amount of confusion surrounding the copper used in the statue is substantial. Khan's account, by far one of the most thorough, names as the benefactor Japy Fréres, a French metal manufacturer that owned a mine at Vigsnes, in Norway.

requiring the hammering of copper sheeting into molds. For structural engineering Bartholdi consulted Eugène Viollet-le-Duc, who advised that copper sheets be hammered into a wooden framework and joined through armature bars.[12] Upon Viollet-le-Duc's unexpected death in 1879, Gustave Eiffel took over. Eiffel retained the plan for the sculpting and connection of the skin, but modernized the internal trusswork by deploying a central iron pylon—foreshadowing that of his 1887–89 Tower—and a secondary armature to bridge skin and frame. The skin would be beaten by hand into sections of a wooden skeleton to a final thickness measuring less than that of two pennies. It would then be secured with copper saddles to the puddled iron armature using 300,000 copper rivets, forming an early example of curtain-wall construction. A double helix of stairs rose at the monument's core. The 300-odd pieces were assembled in the 17th Arrondissement of Paris in 1884 before disassembly and shipment to Bedloe's Island in New York Harbor.

At his inaugural fundraising banquet for the Franco-American Union, Laboulaye made a fascinating claim about the material that was to constitute the 151-foot statue: this Liberty would not resemble *"ces colosses de bronze si vantés, et dont on raconte toujours avec orgueil qu'ils ont été coulés avec des canons pris sur l'ennemi"* ("those bronze colossi ever boasted to have been cast from cannons taken from the enemy")—"sad" monuments recalling *"le sang verse, les larmes des meres, les maledictions des orphelins"* ("spilled blood, mothers' tears, the curses of orphans"). Instead, it would be wrought of *"cuivre vierge, fruit du travail et de la paix"* ("virgin copper, the fruit of labor and of peace").[13]

12 See Eugène-Emmanuel Viollet-le-Duc, *Entretiens sur l'architecture* (Paris: A. Morel & Cie Éditeurs, 1863), http://archive.org/details/entretienssurla00goog.

13 From his speech to the Franco-American Union at the Hôtel du Louvre of November 6, 1875: Édouard Laboulaye, *Derniers discours populaires de Édouard Laboulaye* (Paris: G. Charpentier et cie., 1886), 226.

This was a beautiful idea that drew upon the contrast between copper and bronze, its alloy normally used for both monuments and field artillery. Laboulaye's boast is based on the fact that copper is one of the few metallic elements to appear in nature in "native," or pure, form—though it glosses over the fact that copper more typically occurs in oxidized states, mixed with other elements, and thereby requiring chemical purification. That the material used for Laboulaye's allegory of Liberty would be untampered with on a chemical level, the result of honest skilled manual labor in a time of peace, bespoke a selective and ultimately impossible ideal of purity in origins, sincerity in construction, and pacificity in deployment. At the time, "virgin" copper was still available for mining in a few areas of the globe through shafts sunk to follow native copper lodes. In the twenty-first century it is all but depleted, like the immaculate form of citizenship this metal was supposed to constitute. It is now far more economical to mine lower-grade copper minerals by blasting large quantities of rock and purifying them by chemical means to forge the metal that has only sunk itself more profoundly into contemporary technologized foundations of labor and social relations. Yet even the processing of native copper requires milling and smelting, or the extraction of minerals from the ore: operations that yield not only copper, but mountains of poor (waste) rock, stamp sands (crushed waste rock), slag (molten waste rock), and particulates from furnace smokestacks containing potentially hazardous levels of trace metals such as lead and arsenic that, while wholly detached from any salutary allegory of citizenship, are released into the refinement-hosting environment, often irremediably.[14]

Laboulaye's bold claim for the laboring of a virgin material begs the question of where the copper in *Liberty Enlightening the World* actually came from,

and what sort of "native" it is. Yet the statue's mineral genealogy is shrouded in myth to an even greater extent than its ideological underpinnings. Documentation of the exact source of the donated copper was lost in a fire, giving way to numerous global claims on its origins. Norwegians have held as tradition that the copper came from Vigsnes Mining Field, on the island of Karmøy, given that at the time it was owned by a French company that shipped the ore to Belgium. Meanwhile, Nizhny Tagil, a remote monocity in the Urals developed for mining and metallurgy, still reels from a reality of smokestacks, smog, and pervasive illness to the idea that their region provided the ore, technology, and labor power for the statue.[15] Secrétan's commercial and industrial relations suggest otherwise. By the late 1870s, the benefactor owned native copper mines in Michigan's Upper Peninsula and in Corocoro, Bolivia, and purchased most of his copper in London, maintaining a close relationship with the British Rio Tinto company, which was named after its founding mine in southwestern Spain and operated in the Chilean Andes.[16] Analyses of impurities in the statue's skin via two samples suggest that the copper used in the upper portion of the statue, rich in arsenic, could have come from Spain

14 Useful and highly accessible sources for understanding the byproducts of smelting appear in Bill Carter, *Boom, Bust, Boom: A Story about Copper, the Metal That Runs the World* (Tucson: Schaffner Press, 2014); Timothy J. LeCain, *Mass Destruction: The Men and Giant Mines That Wired America and Scarred the Planet* (New Brunswick, NJ: Rutgers University Press, 2009); and (specifically on ASARCO) Lin Nelson and Anne Fischel, "Public Health and Environment," *Their Mines, Our Stories*, http://www.theirminesour-stories.org/?cat=44.

15 The story goes so far as to suggest that the lack of evidence for Nizhny Tagil's role points to Masonic involvement in the statue's facture (as secret societies were prohibited in Russia at the time). See Olga Zaikina, "Mining Lady Liberty's Russian Lineage," *Hyperallergic* (March 6, 2015): https://hyperallergic.com/188640/mining-lady-libertys-russian-lineage/. This article covers an exhibition called *Skin of Liberty: Fractured and re-Structured*, which brings artists from Brooklyn and Russia's Ural region together to reflect on myths surrounding industrialization in the two cities.

or the Lake Superior mining district, and that that of the lower portion, containing selenium and tellurium, could have its source in the Andes or the Rocky Mountains of Montana. It also suggests that these minerals were subject to different types of processing, meaning that the byproducts of milling and purification for the statue are lingering in more than one industrial waystation on earth.[17] The transnational network of copper production, with its labyrinthine chains of responsibility and irresponsibility, produces and invites this ambiguity of origins as it buries genealogies of extraction in favor of seamless corporate branding at home. Along the way, copper "exploitation," as it is conventionally called, confuses notions of *jus soli* (right of soil) and *jus sanguinis* (right of blood) that form the bases of citizenship law. The circuitry, or short-circuitry, of extraction economies defies the most apparently inalienable ties of birthright to land: when the extraterritorial interests of capital begin to lay claim to zones of copper bonanzas at home and abroad, the "natives" of a place are often divested of the rights to the soil beneath their feet. That soil is then churned beyond recognition, and the so-called overburden (material deemed uncapitalizable) is unleashed into the air and water table that enters the local bloodstream. As articulated by Municipal Judge Neil V. Reynolds, a fifth-generation resident of Leadville, Colorado, the town where Marshall Field, Charles H. Dow, and the Guggenheims made their millions, "Mining is a community of occupation, not a community of place."[18]

16 Secrétan eventually owned a copper syndicate whose members included the powerful companies Rio Tinto, Anaconda, and Calumet & Hecla, all of whom became notorious for their harsh treatment of a sporadically restless and activist labor force.

17 Welter, "Understanding the Copper of the Statue of Liberty."

18 James Brooke, "Wealth of Mine Barons Turns to Dust at Source," *New York Times*, November 4, 1997, https://www.nytimes.com/1997/11/04/us/wealth-of-mine-barons-turns-to-dust-at-source.html.

Few would have witnessed first hand the tactical
fabrication of the American ideal that was unfolding
in Bartholdi's atelier, the foundry, Secrétan's mill, or
the mines, but citizens of both Paris and New York who
watched the allegory riveted together in bright copper
pieces would have been aware of the lofty and even
imperious undertaking it represented. Liberty's chunks
were not to be seen again in their original copper cast
and portable, fragmentary form until a century later,
when Vietnamese-Danish artist Danh Vō outsourced
the statue's full-scale replication in some 250 pieces
to artisans at a foundry near Shanghai, and installed
them under the name *We the People (detail)* in museums
and public spaces around the world, from Bangkok
to Barcelona, Beijing, Chicago, Ghent, Kassel, New
York, and Paris. As to the title, Vō's fractured allegory
of liberty breaks off the first three words of the pre-
amble to the US Constitution: "We the People of the
United States, in Order to form a more perfect Union,
establish Justice, insure domestic Tranquility, provide
for the common defence, promote the general Welfare,
and secure the Blessings of Liberty to ourselves and
our Posterity." Detaching "We the People" from
"the United States" and redistributing pieces of the
statue seems to re-channel the "Blessings of Liberty"
toward the people of the entire world. Yet Vō's
unwieldy wreckage-like hunks also conjure Liberty's
occupation of spaces beyond the margins of this
national constitution, concretizing the uneven and
potentially violent global distribution of US national
interests under contemporary political economies of
trade and war. Liberty's is an occupation requiring nat-
ural resources offshore, in which, as Eduardo Galeano
puts it in *Open Veins of Latin America*, "As lungs need
air, so the US economy needs Latin American miner-
als ... Bullets are needed to kill Vietnamese, and bullets

need copper."[19] While it summons these assumptions
of contemporary political economy, Vo's installation
simultaneously brings out the splintered and dispropor-
tionately acknowledged status of "the people" and its
rights at the time of the monument's conception. The
statue, after all, celebrates the centenary of the United
States' independence from Britain while looking away
from the imperialist posture that fostered the colonial
constitution of French Indochina in 1887. Moreover,
France's ideal alliance with American freedom had to
gloss over the selective denial of citizenship and perpet-
uation of enslavement by other means within the US
and its own otherwise colonized zones.

Not all would-be citizens at home were ready
to celebrate the allegory of Liberty's achievement
or potential once the statue reached American soil.
Suffragettes aboard a boat in the harbor on the day of
the 1886 inauguration protested against the hypocrisy
of erecting a female allegory for liberty, when women
were excluded from core inalienable rights promised
by the Declaration of Independence, whose adoption
date is inscribed in the tablet cradled in her arm. A
July 1885 editorial of the African American weekly *The
Cleveland Gazette* had called for the torch to remain
unlit until freedom should become a reality within the
country: "This government is a howling farce. It can
not or rather *does not* protect the rights of the citizens
within its *own* borders ... The idea of the 'liberty' of this
country, 'enlightening the world,' or even Patagonia, is
ridiculous in the extreme."[20] The editors' reference to
newly conquered indigenous South
American lands might have been
meant as offhand irony, but in literal
terms, it was less ridiculous than
intended for the statue to signify
the enlightenment of undeveloped

19 Eduardo Galeano,
*Open Veins of Latin America:
Five Centuries of the Pillage
of a Continent*, trans.
Cedric Belfrage (New
York: Monthly Review
Press, 1997), 134.

South America—a region of the globe rich in mineral ore essential to electrification, and increasingly in demand.

An inverse irony accompanied the eclipsing of the statue's allegorical intention by its technical features: due to the late arrival of Bartholdi's torch at the Philadelphia Centennial, it was not included in the fair guide, and its intended symbolism was lost, with some programs mistakenly identifying it as "Bartholdi's Electric Light" rather than a means of figurative enlightenment.[21] This putative error, too, expressed an emphatic material actuality, exposing the relation between the statue's composition and copper's place in the booms, busts, and attendant promises and ravages of transnational modernity. The monument did comprise a novel electrical system: floodlights were installed inside the torch and an innovative illumination system made provisions for Liberty's floodlighting from below, with the American Electric Manufacturing Company donating a dynamo and other lighting equipment as a patriotic gesture. The statue's torch, rising 305 feet above sea level, contained nine electric arc lamps that were entrusted to aid navigation, though in practice, they were barely visible from across the harbor. Nevertheless, the statue was instated as an active lighthouse until 1902.

A 1950s advertisement featuring an artist's rendering of the

20 Quoted in Alan M. Kraut, "Lady in the Harbor: The Statue of Liberty as American Icon," in *Many Voices, One Nation: Material Culture Reflections on Race and Migration in the United States*, eds. Margaret Salazar-Porzio, Joan Troyano, and Lauren Safranek (Washington, DC: Smithsonian Institution Scholarly Press, 2017), 127. Kraut also cites African American periodicals such as the *Chicago Defender* who continued to point out the statue's use in the service of "'Liberty, Protection, Opportunity, Happiness, for All White Men' and 'Humiliation, Segregation, Lynching, for All Black Men.'"

21 See for instance *United States Centennial Commission, International Exhibition, 1876, Official Catalogue. Part III: Machinery Hall, Annexes, and Special Buildings. Department V. Machinery*, 2nd ed. (Philadelphia: Centennial catalogue Company/John R. Nagle & Company, 1876), 6.

Statue of Liberty for the Anaconda Copper Mining
Company—one of the largest trusts of the early twen-
tieth century and then-owner of the largest mine
in the world at Chuquicamata, near the foothills of
the Chilean Andes, which was acquired from the
Guggenheims in 1923—impeccably articulates the
bond between copper, technology, and a prototypically
American concept of liberty as it reads:

> COPPER ...
> Friend of freedom
> It is symbolically proper and fitting that the Statue
> of Liberty should be completely clad in copper.
> For copper is, like Liberty herself, a proud symbol of
> our free and better way of life.
> Copper brings us the electricity that frees us from
> the toil and drudgery of farm and factory—from
> darkness in the night. It pipes warmth and water
> through millions of our homes—helps to join our
> far-flung nation through magic networks of com-
> munication and transportation.
> And the versatility of copper and its alloys, brass
> and bronze, has helped strengthen our economic
> freedom, too. For these shining metals have
> enabled industry to manufacture so abundantly
> that the luxuries of life yesterday are considered
> necessities today.
> Anaconda, with the leading name in copper, brass
> and bronze, works unceasingly at developing new
> sources. For tomorrow's better way of life—tomor-
> row's freedom, too—may well depend on copper.

The advertisement's unspecified yet unmistakably
American first person plural boasts that Anaconda is a
leading force in forging the unity, necessities, leisure,
and even the freedom that characterize the US way of

life—its enlightenment—while the text upholds assorted ambiguities. "Our far-flung nation" can be read as a nation either distributed over a vast terrain or geographically remote, "joined" by copper to other parts of itself or to others through "magic" networks of transit and exchange. Previously untapped ores are to be prospected, not invented, but the phrase "developing new sources" suggests that they can be created, homespun. The principal elision in this passage, however, is the swapping of political freedom for freedom from labor in "farm and factory," leading the reader to realize that "we" are not part of the class or race that mines, processes, or mills the copper here or abroad, nor of the group that toils to manufacture, install, or service pipes, cables, wires, switches, cathodes, motors, motherboards, and dozens of other applications of this modern conductor.

"Tomorrow's freedom," interjected vaguely into a sentence about lifestyle, may well depend on copper due to the red metal's strategic and military value as well. This value would have been more palpable in the preceding decades of world conflict, as the names of publications like *Copper Commando* (the official newspaper of the Victory Labor-Management Committees of Anaconda and its union representatives) suggest. As we pore through the archive, we find the military value that was anathema to Laboulaye's colossal vision yoked to the copper industry by the fate of poet, labor leader, and anti-war International Workers of the World activist Frank Little, lynched outside of Butte, Montana, while organizing a strike against Anaconda at the dawn of World War I. We confront it again in an alarmingly xenophobic 1942 billboard installed at Anaconda's Butte operations tallying the number of employees absent from war production, picturing racist caricatures of Axis nationals outside the walls of the complex.

While a US-bred Liberty's enlightenment of the
world is easily discernible on a purely technical level, it
remains unclear from the Anaconda advertisement who
exactly will be the beneficiaries of "tomorrow's better
way of life." For copper miners themselves, electricity
meant better ventilation and lighting underground,
but also carried the risk of electrocution. It meant less
manual effort in excavation, but more hazards resulting
from the use of mechanical drills, including tunnel
collapse and silicosis (the disease behind the tools' nick-
name, "The Widowmaker"). And in the long run,
it meant a diminished workforce as shovels took the
place of men. For eventually the higher-grade ore in
the tunnels they blasted would be depleted, the costs
of shaft mining would increase, and soon enough
copper prices would fall with demand as well as spike.
Anaconda, owned by the French and British Rothschilds
and the Rockefellers, managed to safeguard profits in
the first half of the century by union-quashing and
controlling its unprotected immigrant workforce with
an iron fist. In the postwar years demand for copper
dropped, and to reduce costs and cut losses, the com-
pany started mining at Butte Hill in 1955 through an
open pit. The resultant Berkeley Pit, a defunct mine
which plunges to a depth of 1,780 feet while filling
gradually with acidic water—the result of displacing one
billion tons of rock, roughly a third of which was ore—
has lain fallow since 1982 but for the two dollar viewing
fee paid by each morbidly curious tourist. The Anaconda
Copper Mining Company now exists only as an immense
environmental liability for the Andeavor Corporation
in the form of the nation's largest Superfund site.
Or not, given an announcement by the Trump admin-
istration of December 1, 2017 that it will not require
hard-rock mining companies to prove they have
the financial resources to clean up their pollution.[22]

The benefits of Liberty continue to trickle down and outward through sulfuric acid and copper, cadmium, zinc, lead, and arsenic released by the decomposing ore and nearby smelter waste into the air and Clark Fork River Basin. Meanwhile, beyond home, Anaconda's all-important Chilean holdings would be seized when the democratically elected Socialist Salvador Allende nationalized Chilean mines in 1971, only to be compensated for once the US-backed Pinochet dictatorship ended civilian rule soon thereafter, and the "Chicago Boys" of Latin America instated policies of deregulation, privatization, and overall economic liberalization.[23] Citizenship continues its leaching—beyond Liberty's borders.

Downward Babel

There are various ways of understanding the helical shell of the Solomon R. Guggenheim Museum at the other end of New York City, the product of sixteen years of design on the part of Frank Lloyd Wright and his collaborators. Hilla Rebay, the visionary curator and consultant who proposed the commission to Wright in 1943, called for a "Temple of Peace" to house Solomon Guggenheim's founding collection of non-objective painting,

22 The financial responsibility proposal issued by the administration of President Barack Obama would have required companies mining metals such as gold, silver, copper, and lead to show they had the financial means to clean up their sites once they finish mining by issuing bonds or buying insurance. It was aimed at taking the burden off of taxpayers to assume the cost of cleanup for sites when mines declare bankruptcy. See "EPA Passes on Rule Covering U.S. Hardrock Miners' Cleanup Costs," *Reuters*, December 2, 2017, https://www.reuters.com/article/us-usa-mining-epa/epa-passes-on-rule-covering-u-s-hardrock-miners-cleanup-costs-idUSKB-N1DW00J. See also Susan Dunlap, "Butte, Anaconda Bracing for Stripped-down EPA, Superfund," *Montana Standard*, June 25, 2017, http://mtstandard.com/news/local/butte-anaconda-bracing-for-stripped-down-epa-superfund/article_a9c5c200-51e3-5027-8774-860aab910dcd.html.

23 The "Chicago Boys" were Latin American economists who held positions of power during the military dictatorship of Pinochet, named as such because they were either trained or influenced by University of Chicago theorists and proponents of free-market capitalism Milton Friedman and Arnold Harberger.

which she regarded as the expression of a universal language with the promise of uniting nations.[24] Wright himself described the building as an "optimistic ziggurat," overturning the pyramid. Tracking Wright's gradual development of spiral forms based on the idea of a "fabulous Tower of Babylon" as pictured by early modern artists such as Pieter Brueghel the Elder, Neil Levine develops a reading of the museum as an inverted, hollowed out Tower of Babel.[25] The myth of Babel invokes both the striving to unite humankind and that aspiration's punishment by dispersion; Nico Israel's study of spirals reads this geometrical form by extension as the sign of "a nascent world picture."[26] The spiral form gave

[24] Quoted in Neil Levine, *The Architecture of Frank Lloyd Wright* (Princeton: Princeton University Press, 1996), 318.

[25] Text of a 1925 letter from Wright to client Gordon Strong, quoted in Levine, 302; see also 351–55.

[26] See Nico Israel, *Spirals: The Whirled Image in Twentieth-Century Literature and Art* (New York: Columbia University Press, 2015), 28–31. See also Peter Sloterdijk, *Globes: Spheres, Volume 2: Macrospherology* (Cambridge, MA: Semiotext(e)/MIT Press, 2014).

Michael Waters, interior view of Solomon R. Guggenheim Museum.

rise to renowned self-consciously international designs
at the dawn of modernity that would attempt to reverse
the cultural scattering and linguistic confoundment
recounted by Genesis, composing instead a force field of
communal striving and progress: Vladimir Tatlin's revo-
lutionary 1919–20 *Monument for the Third International*,
and Le Corbusier's 1928–29 Musée Mondial, part of
a utopian Mondaneum to be built in conjunction
with the League of Nations. In the years leading up to
the Great War, Daniel Guggenheim, chairman and
president of American Smelting and Refining and chief
operating partner of Guggenheim Brothers, understood
how important his family's control of copper would
be to global conflict; he strategically joined the hawkish
National Security League, an association in favor of
military preparedness founded in 1914, which served as
the chief motor for the entry of a then-neutral US into
World War I. Yet Wright's museum project would ger-
minate in the postwar moment when the Guggenheims,
who emerged from World War I with a net worth in the
neighborhood of 250–300 million dollars, could retire
from the front lines of the war business—when the
United Nations headquarters was being constructed,
as the dawning notion of world governance called for
a visionary new architecture.

The material source of the wealth that erected
this memorial museum to Solomon Guggenheim bears
a startlingly precise resemblance to its apotheosis as an
integrative temple to the arts. The extraordinary riches
of Meyer Guggenheim and sons hailed in substantial
part from Daniel Guggenheim's turn-of-the-century
decision to invest in new technologies surrounding
open-pit mines: those terraced spiral craters pointing
in Dantesque fashion toward *"lo mezzo / al quale ogne
gravezza si rauna"* ("the center toward which each grave-
ness is drawn").[27] From 1891 to 1901, the Guggenheims

engaged in a struggle with the Rockefellers over the American Smelting and Mining Company (ASARCO), eventually winning control of one of the first transnational corporations for two critical decades of copper production, while expanding ever outward through the family's distinct and lavishly financed assayings in additional undeveloped territories at the edges of the continent and abroad.[28] The spread of open-pit copper mining depended on the development of gigantic mechanical shovels running on tracks along the corkscrew "benches" of the trenches and on new refinement techniques, making it possible to excavate and purify immense quantities of ore at a low cost—but only after colossal initial investments in infrastructure. These investments, possible only for the super-rich, included the construction and coal fueling of mills and smelters in strategic territories like the US-Mexico border at El Paso, and of railways, ports, steamship lines, aqueducts, electrical power plants, and company towns from which to excavate in the remoteness of Alaska's Kennicott Glacier or Chile's Northern Atacama Desert. Open-pit mining was a key spur in the Guggenheims' definitive evolution from traders of

27 Dante Alighieri, *Inferno* 32.73–74, my translation. Los Angeles-based Chilean artist Ignacio Perez Meruane expresses the same intuition in *Circuitos*, a project entailing a spiral shelving system at the Galeria Tajamar in Santiago juxtaposing postcard views of the Guggenheim and Chuquicamata Mine, as well as copper bowls and verdigris-pigmented spiral paintings "to evoke copper's extraction from the earth and subsequent movement as a material export, and the way in which the industrial use of the copper for the movement and transference of electricity, gas, liquids, and information, echoes the materials['] own movement across the globe." See the press release at Ignacio Perez Meruane, "Circuitos," Ignacio Perez Meruane, May 29, 2015, http://www.ignacioperezmeruane.com/Circuitos. Ignacio Acosta also suggests a link, albeit in passing, describing the museum and the corporate town of Chuquicamata as "post-industrial archaeologies that resist forgiving their history of exploitation." See Ignacio Acosta, "Urban Gating in Chile: Chuquicamata—a Corporate Mining Town: 'Bounded Territory within a Territory,'" in *Beyond Gated Communities*, eds. Samer Bagaeen and Ola Uduku (New York: Routledge, 2015), 234.

pastoral European commodities to the leading finance capitalists in the world's metal market, controlling over two-thirds of the world's copper, silver, and lead by the beginning of the Great War. Open-pit operations cemented the Guggenheims' position as patriarchs of the copper industry in the critical decades of electrification at the turn of the twentieth century, which not only bolstered US war efforts in the form of cables and arms, but paved the way for the systems of mass illumination, the automotive and aerospace industries, and the radio, telephony, and eventual wireless networks at the core of virtually every modern industry.

28 An exhaustive account of the Guggenheim empire and its branches would be impossible to include here. For a useful chart of the genealogy of their mining and smelting interests in 1910, see John H. Davis, *The Guggenheims: An American Epic*, 1st ed. (New York: Morrow, 1978), 94; and the following chapter, "Lords of the Earth (1905–1923): Building the Guggenheim Empire," 95–134. Another accessible history appears in Debi Unger and Irwin Unger, *The Guggenheims: A Family History* (New York: Harper Collins, 2009); see especially pp. 69–99.

Sandro Botticelli, *Map of Hell*. Pen and brush on vellum (32 × 47 cm), c. 1485. Courtesy Vatican Library, Rome.

The Guggenheims initially built their transnational empire through smelting—and specifically by processing cheap, low-grade materials en masse, rather than through the ownership and management of mines (a far riskier business). As Isaac Marcosson details in his boosterish history of ASARCO, *Metal Magic*, Daniel Guggenheim teamed up with metallurgist Daniel Jackling, who pioneered the exploitation of porphyry ores containing as little as two percent copper content at the Bingham Canyon Mine in Utah. Jackling introduced a process called "concentrating," in which crushed ore is floated on water and sulfuric acid to separate copper minerals from material regarded as waste. Smelting then extracts copper from these minerals, and refining purifies the metal. ASARCO accordingly built what would become the largest smelter in the world at Garfield, Utah, on the banks of the Great Salt Lake. Such technical advancements turned Bingham into the first open-pit and largest copper operation in the world, especially when combined with an exploited workforce of immigrants representing twenty-four national groups. These groups included unskilled and un-unionized, yet militantly organized Japanese, Italian, and Greek "muckers" who were needed to lay rail tracks for shovels in the pit and unload ore at the smelter, who finally revolted over deplorable conditions via strike and guerrilla warfare against the Utah Copper Company and the Utah state militia in 1912.[29] The open-pit

29 See Isaac Frederick Marcosson, *Metal Magic: The Story of the American Smelting & Refining Company* (New York: Farrar, Straus, Giroux, 1949), 86–91. See also Leonard J. Arrington and Gary B. Hansen, *The Richest Hole on Earth: A History of the Bingham Copper Mine* (Logan, UT: Utah State University Press, 1963). On the 1912 Bingham strike, which featured an unusual prominence of rank and file immigrant workers protesting both against immigrant elites or "padrones" and would-be union leaders of the Western Federation of Miners, see Gunther Peck, "Padrones and Protest: 'Old' Radicals and 'New' Immigrants in Bingham, Utah, 1905–1912," *The Western Historical Quarterly* 24, no. 2 (1993): 157–78.

technique spread from Bingham to Kennecott in the
newly purchased Alaskan territory that Guggenheims
colonized with J. P. Morgan, and to the Chilean Desert
at Chuquicamata, an immensely rich terrain once
mined by the Incas, which the Guggenheims were
able to acquire via the Bingham bonanza in 1913. The
lasting importance of Chuquicamata's purchase and
sale is visible within the offices of the Guggenheims'
most recent venture, Guggenheim Partners, a financial
services firm founded by Solomon's great-grandson Peter
Lawson-Johnston II in 1999. There, a bar of copper from
Chuquicamata commemorating the opening of oper-
ations in 1915 and a 1923 check for $70 million for the
sale of two million shares of the Chile Copper Company
to the Anaconda Copper Mining Company, the largest
check in history at the time, exhibited as trophies.[30]
The hole in the ground at Chuqui, as it is called locally,
is presently deeper than the tallest building on earth,

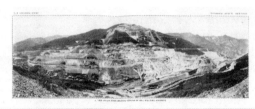

Utah Copper Company's porphyry ore deposits in Bingham Canyon. Top: view
in 1908, when original outline of hill was still apparent, and (below) in 1915,
after stripping was nearly complete. Plate XXXVI from Department of the Interior/
US Geological Survey report "The Ore Deposits of Utah," 1920.

the Burj Khalifa in Dubai, is high. Surface or open-pit mining has since eclipsed the traditional shaft and tunnel mining that would have yielded the copper for *Liberty Enlightening the World*, a somewhat less deleterious, covert endeavor based on the risky prospect of excavating along what scarce rich mineral deposits remain unexploited underground. Jackling and the Guggenheims emerge as legendary pioneers, even revolutionaries, in the transformation of mining into a calamitously destructive (yet paradoxically stable) long-term business with far-reaching consequences for modern industrial society. Under this regime, "Mines are more often made than discovered," as Jackling averred.[31] They no longer need to be contained by the limits established by veins of ore.

Wright's museum thus memorializes not only Solomon R. Guggenheim, but the model of resource extraction on a novel border-blasting scale that built his family fortune. It concretizes the material unconscious of this illustrious bequest, and forces us to contend with the social implications of its revolutionary form. In a 1912 essay, Wright described the circle as a representation of infinity, and the spiral in terms of its Romantic conception, as "organic progress."[32] For Hilla Rebay, Guggenheim's purchased non-objective paintings were "sensitive (and corrective even) to space," representing the promise of transcendence from the materialistic to the spiritual: "We are merely tunnels through which the spiritual

30 Graham Bowley, "The Guggenheim Connection," *New York Times*, September 17, 2011, http://www.nytimes.com/2011/09/18/business/the-guggenheim-connection-fame-riches-and-a-masquerade.html?_r=1&hpw.

31 For a reading of open-pit mining as a symbol of the ultimate pretension of technology's ability to overcome all natural limits see Timothy J. LeCain, *Mass Destruction: The Men and Giant Mines That Wired America and Scarred the Planet* (New Brunswick, NJ: Rutgers University Press, 2009). The quote is in LeCain, 119.

32 Frank Lloyd Wright, *The Japanese Print: An Interpretation* (New York: Horizon Press, 1967), 16.

must pass," she wrote in the first collection catalogue of 1936.[33] The white cast of the Solomon R. Guggenheim Museum suggests spiritual transcendence of this order, but this was not part of Wright's design; the architect vigorously resisted the solution to "whitewash" the museum that was imposed on him by James Johnson Sweeney late in the process, having projected a marble aggregate in rose with white veins, and at other points a marble alternating with verdigris copper—lamenting that white paint would make the building resemble "the toilets of the Racquet Club."[34] One can imagine the original pigmentation, in conjunction with the red marble slabs Wright imagined for the ground floor, recalling the monumental copper mines Wright would have known from the Arizona of his Taliesin West. This substantially complicates the interpretation of the building as a means of aesthetically induced spiritual transcendence. Against this backdrop, the building so easily read in terms of abstract geometry emerges instead as the Anthropocene corollary to Fallingwater: a disclosure of its sources in geology. As Immanuel Kant said of Plato's *Republic* and metaphysical philosophy's towering palaces of edification, "under this ground there are all sorts of *Maulwurfsgänge* ("mole-paths"), all sorts of passageways, such as moles might have dug, left over from reason's vain but confident treasure hunting, that make every building insecure."[35] Wright's exemplary cosmic sublimity was predicated

33 See Hilla Rebay, *Solomon R. Guggenheim Collection of Non-Objective Paintings* (Charleston, SC: Carolina Art Association, 1936), 12.

34 Quoted in Levine, 346. Rebay thought red too "materialistic," as Levine points out on 328.

35 Immanuel Kant, *Critique of Pure Reason*, trans. Paul Guyer and Allen Wood (Cambridge, UK: Cambridge University Press, 1998), 398. I am citing a translation modified by John Hamilton in an unpublished conference paper for which I was a respondent: John Hamilton, "Burrowers, Builders, and the Principle of Insufficient Reason," Habitation: Literature and Architecture, University of Chicago, 2016.

on, and should invoke, a destabilizing burrowing into the earth that was strategically blind to its collateral consequences.

Extending the logic of Levine's inverted Tower of Babel to the history we have thus far traversed, we should regard the eternal progress of Wright's utopian construction as an eternal spiraling downward rather than heavenward: a tunneling by coils into the earth—or to be more specific, into the porphyry copper deposits formed from hydrothermal fluids in scattered zones of the globe that gave rise to this memorial edifice. Given that the striving to build and unionize by diverse peoples of the world responsible for mining the bedrock of such fortune was repeatedly to be smitten down, scattering them as individual subjects in atomized struggles for life, liberty, and the pursuit of happiness (or, depending upon the founding document one consults, property), the only direction in which these builders were or could have been consummately united was earthward. This vision and the underground history that accompanies it recasts while literalizing Saskia Sassen's hopeful projection that under globalization, "insofar as the national as container of social process and power is cracked, it opens up possibilities for a geography of politics that links sub-national spaces across borders."[36] The whitewashing of Wright's realized building and of the Guggenheim heritage whose sources were drawn from the earth's bowels emerges as a perfect corollary to the purified chronicle of these benefactors and copper kings.

The relationship between Wright's inverted tower of Babel and the open-pit copper mine as an icon of transnational bonding through resource exploitation and its financing leads to deductions surrounding the reach of citizenship even more elusive and confounding than those

36　Saskia Sassen, "The Global City: Introducing a Concept," *Brown Journal of World Affairs* 11, no. 2 (Winter/Spring 2005): 39.

implied by the facture of *Liberty Enlightening the World*. Multinational corporations establish their own colonies and legal regimes that run parallel to state sovereignty, and even dip below it—literally undermining the rights of citizens abroad to the land under their feet. This land is then restored to them in the form of tailings—the result of extracting the valuable from the uneconomic fraction of ore, also known as dumps, slimes, leach residue, slickens, or terra-cone. The Guggenheim sons' transborder empire expanded from Colorado into Mexico, for instance, under the regime of Porfirio Díaz, who granted them extensive privileges and subsoil rights to the extent that ASARCO eventually became the largest privately owned business in the country and led to virtual and untaxed "Guggenheim States" in Northern Mexico.[37] It's for this reason that some historians have cast Guggenheim business practices as the incitement for the Mexican Revolution, though ironically, ASARCO ultimately maintained a relationship of reciprocal favors with Pancho Villa and his men.[38] The resolution of Babel via the irrepressible ascendancy of the US language of enterprise was impeccably expressed in Villa's response when asked whether he knew any English: "'American Smelting' y 'son of bitch.'"

A common defense of multinational investments overseas argues that foreign capital modernizes and thereby improves life for workers abroad. In a 1920 essay on building mining towns

[37] This situation was rectified with the nationalization of subsoil rights in 1917. See Monica Perales, *Smeltertown: Making and Remembering a Southwest Border Community* (Chapel Hill: University of North Carolina Press, 2010), 35.

[38] Villa worked at ASARCO's Smeltertown plant. In January 1916, sixteen ASARCO employees were killed brutally by Villa's men near the town of Santa Isabel, an incident that sparked the U.S. Army's attempt to capture Villa. On Villa's paradoxical collaboration with ASARCO, see William K. Meyers, "Pancho Villa and the Multinationals: United States Mining Interests in Villista Mexico, 1913-1915," *Journal of Latin American Studies* 23, no. 2 (May 1991): 346.

in South America, Daniel Guggenheim's son Harry F. Guggenheim describes achievements of the family business' "Industrial Democracy" in the upgrading of nineteenth-century-style mining camps at Braden and Chuquicamata, Chile to modern company towns planned by more than thirty hired architects in 1912, and furnished with housing, stores, schools, entertainment spaces, and eventually hospitals and sanitation services—efforts much praised by colleagues in the field who said that these home-making efforts in a desolate part of the country had helped Chileans "in every way to become good citizens."[39] Guggenheim justifies paternalistic strategies of occupation and accompanying "welfare work" through repetition of "the old saw, 'What is everybody's business is nobody's business.'"[40] In the Guggenheims' business, or the branch of it called Chile Copper Co., provisions for

39 A. W. Allen, "The Chuquicamata Enterprise—III," Mining and Scientific Press 123 (July 23, 1921): 121. See, for contrast, Alejo Gutiérrez-Viñuales, "Chuquicamata: Patrimonio Industrial de La Minería Del Cobre En Chile," Apuntes: Revista de Estudios Sobre Patrimonio Cultural—Journal of Cultural Heritage Studies 21, no. 1 (2008): 74–91.

ADOBE HOUSES AT THE NEW CAMP

Adobe houses at Chuquicamata, constructed of bricks made with mine tailings, pampa dust, and concrete in proportions of 13:4:1.

the housing and schooling of "natives" must have as foundation "the firm conviction that humanity progresses, that human progress means efficiency, and ... that commerce is a means and not the end, that there is only one end—humanity." And if patriarchs lose sight of these conceptions, "then the welfare movement may become a whirlpool of anarchy ... carrying everything with it to destruction."[41] "Natives" responded to these magnanimous claims through reports of conditions on the ground: "Housing is crowded, unsafe, unhealthy, and inadequate ... The comfort, decency, and hygiene of the American Camp has not been furnished for the 'blakman,' because the Yankee democracy that lynches the Negro son of the Union on their soil has established in Chuqui the division of classes and races ... Chuquicamata at present is the cemetery of the race!"[42]

Among the progressive yet efficient provisions for humanity of which Guggenheim was most proud was the innovation of manufacturing housing for "natives" at Chuquicamata with adobe bricks manufactured from sifted mining tailings the workers themselves had unearthed—the inevitably toxic residue of blasted waste ore, mixed with small amounts of pampa dust and cement.[43] This architectural legacy, enduring for local citizens well beyond the moment of the seventy million dollar check from Anaconda, yet free of consequences for the patriarchs, ought to be considered astride the discussion of architectural masterpieces like the Guggenheim New York.[44]

40 Harry F. Guggenheim, "Building Mining Cities in South America: A Detailed Account of the Social and Industrial Benefits Flowing From the Human Engineering Work of the Chile Exploration Co. and the Braden Copper Co.," *Engineering and Mining Journal* 110 (December 1920): 210.

41 Ibid.

42 Eulogio Gutiérrez and Marcial Figueroa, *Chuquicamata, Su Grandeza y Sus Dolores* (Santiago: Imprenta Cervantes, 1920), 10–11.

43 Ibid., 206.

The modest adobe tailings home is copper's spectral monument, made of all that was left out of Wright's upended tower: a third edifice for our consideration no longer made of copper, but by copper—from the detritus of the purification process. The Chuquicamata settlement, once home to 30,000 workers, exists now only as a ghost town beside the pit that artist Daniela Rivera refers to as "*The Andes Inverted.*"[45] Because saturation of the water, air, and consumed food by arsenic and sulfur dioxide was too severe for human habitation and meeting stepped-up environmental standards would have made the mine economically unviable, the Corporación Nacional del Cobre de Chile resettled its labor force to the nearest oasis town in 2008.[46] As poet Juan de Dios Reyes Franzani observed,

> El verde de las olas tomó el mar
> del vaporoso óxido de cobre.
> Con sus sulfuros vistió la
> camanchaca
> la mortaja de sus sábanas de
> azogue.

> The green of the waves drank
> the sea
> of vaporous copper oxide.
> It adorned the cloudbank with
> its sulfides,
> the shroud of its quicksilver
> sheets.[47]

44 It must be noted that a commission of government officials was sent to Chuquicamata and commented upon the deplorable and unhygienic qualities of the encampments, including the New Camp, which they judged to be "el más antihigiénico, insalubre e inadecuado de ver," lacking water, electricity, and sewage, since the bathrooms were distant from the homes. See Eulogio Gutiérrez and Marcial Figueroa, *Chuquicamata, Su Grandeza y Sus Dolores.* An analogy would be Fordlândia, Henry Ford's would-be civilizing mission and rubber plantation in the Amazon jungle, recently engaged by Brazilian artist Clarissa Tossin in *Fordlândia Fieldwork* (double-sided inkjet prints on paper, 2012).

45 Rivera's immersive installation based on Chuquicamata's disruptive impacts, *The Andes Inverted* was on display at the Museum of Fine Arts Boston from March 2017 through February 2018. See documentation at Rivera, "The Andes Inverted," DANIELA RIVERA, accessed January 1, 2018, http://www.danielarivera.com/the-andes-inverted/.

The ghosting of these landscapes that are destined to be exhausted by the unbounded demands of development calls not merely for memorials, but for reparations, and at the very least for reclamation, such as the kind Robert Smithson imagined in his *Bingham Copper Mining Pit—Utah / Reclamation Project*: this late project would have constructed a massive revolving platform for the Bingham pit's base from which to survey the gradual overtaking of industry's devastating vortex by planted vegetation.

"After three thousand years of explosion, by means of fragmentary and mechanical technologies, the Western world is imploding," wrote Marshall McLuhan in 1964, during the period in which he coined the term "global village." "Today, after more than a century of electric technology, we have extended our central nervous system itself in a global embrace, abolishing both space and time as far as our planet is concerned."[48] Tracking the mineral sourcing of this embrace, which manifests palpably in the wires that lace and extend outward from our own homes, should help us extend and complicate McLuhan's observation, now half a century old. It should refract the way we talk about global citizenship, pressing us to ask what constitutes such citizenship, spiritually and materially. It should incite us to articulate the political paradoxes that present themselves when *jus soli* and *jus sanguinis* are fused in the bodies of those manning the extraction and smelting of "our

46 For more on the hard-won environmental policy change in Chile, and the gains for regulation of Chuquicamata, see José Carlos Orihuela, "The Environmental Rules of Economic Development: Governing Air Pollution from Smelters in Chuquicamata and La Oroya," *Journal of Latin American Studies* 46, no. 1 (2014): 151–83.

47 "Cobre Rojo," in Juan de Dios Reyes Franzani, *Salitre: Poesía Joven del Norte* (Antofagasta, Chile: Universidad del Norte, 1973), 6.

48 Marshall McLuhan, *Understanding Media: The Extensions of Man* (New York: Gingko Press, 2013). *eBook Academic Collection (EBSCOhost)*, EBSCO*host* (accessed December 23, 2017).

free and better way of life," or when both are trumped by the rights of corporate persons. We have become accustomed to witnessing the privileges of citizenship granted to corporations operating transnationally as a

Robert Smithson, *Bingham Copper Mining Pit – Utah Reclamation Project*, 1973. Photostat, plastic overlay, grease pencils, 18½" × 13½", The Metropolitan Museum of Art, New York, Art © Holt-Smithson Foundation/ Licensed by VAGA, New York, NY.

default, yet denied to those whose labor nourishes and shelters those same corporations.[49]

Strangely enough, the Statue of Liberty, in spite of the relatively progressive values it represented in its time, anticipates some of the unfortunate miscarriages of citizenship that we have traced. We can track these through the statue's commemoration of the Thirteenth Amendment abolishing slavery, and the amendment that followed that extended rights to the formerly enslaved. Though the term "citizen" appears in the Constitution, it was not defined until the 1868 addition of the Fourteenth Amendment, which described it as pertaining to "All persons born or naturalized in the United States" not possessing foreign allegiance. Formerly enslaved people were not guaranteed full citizenship until this Amendment provided that "No State shall ... deprive any person of life, liberty, or property without due process of law; nor deny to any person ... the equal protection of the laws." The fiction of corporate personhood that enables modern and contemporary corporations to behave as though they possessed the rights to life, liberty, and property, and to undermine those of mere natural persons in the process, dates to the year of the statue's unveiling: an 1886 suit before the Supreme Court which due to either offhand commentary, clerical mistranscription, or outright forgery expanded the application of the Amendment to commercial or private groups of people acting collectively.[50] The

49 For a reading of Chuquicamata as an example of urban gating under transnational capital, see Ignacio Acosta, "Urban Gating in Chile: Chuquicamata—a Corporate Mining Town: 'Bounded Territory within a Territory,'" 227–39.

50 For background, see Howard Jay Graham, *Everyman's Constitution: Historical Essays on the Fourteenth Amendment, the "Conspiracy Theory," and American Constitutionalism* (Madison: State Historical Society of Wisconsin, 1968). I have written more extensively about this issue in Jennifer Scappettone, "I owe v. I/O: Poetics of Veil-Piercing on a Corporate Planet," *Jacket2*, December 14, 2016, https://jacket2.org/article/i-owe-v-io.

case was made by a Gilded Age senator who argued that the Congressional Committee that drafted the amendment vacillated between using the term "citizen" and "person," and ultimately chose "person" specifically to extend rights to corporations. Despite the nation's enduring qualms in safeguarding constitutional rights for all citizens, corporations have been granted the theoretical rights of natural persons ever since, being cordoned off from their successors as they cash in or pass away to evade responsibility for generations of civil wrongs there would be little trouble of ascribing otherwise. It is as though the corporation as person were protected from all eventualities beyond its fictional skin. McLuhan offered a corrective to this broken chain of accountability in observing that "In the electric age, when our central nervous system is technologically extended to the whole of mankind and to incorporate the whole of mankind in us, we necessarily participate, in depth, in the consequences of our every action."[51]

Though the status of the Statue of Liberty as a signifier of slavery's abolition has been contested since the statue's conceptual birth, Bartholdi insisted on retaining a broken shackle and chains at the allegory's feet, and recent official accounts have begun to present this fact as part of the monument's narration.[52] Danh Vō's reproduction of the statue's copper links renders this charged feature of Bartholdi's work visible from ground level for the first time, forging a new allegory of Freedom's orphaned privileges—and

[51] McLuhan went on to say, "It is no longer possible to adopt the aloof and dissociated role of the literate Westerner." *Understanding Media.*

[52] See the National Park Service's account of the statue's links to abolition at National Park Service/ U.S. Department of the Interior, "Abolition - Statue Of Liberty National Monument," US National Park Service, February 26, 2015, https://www.nps.gov/ stli/learn/historyculture/ abolition.htm.

[53] Links in the chain were stolen from Vō's installation of *We the People (detail)* between New York's City Hall and Brooklyn Bridge Park in 2014, furthering the dispersion.

concretizing the broken chain of responsibility in the leaching citizenship of copper production.[53]

Liberty's Tailings

This survey of the meanings of the Statue of Liberty has willfully withheld the monument's most potent significance worldwide: its status as a symbol of the migration of people from many nations into the United States in search of work and a new homeland. Between 1882 and 1924, Ellis Island processed some twelve million immigrants traveling to the United States in third-class carriage, denying entry to approximately two percent of the arrivals. A political cartoon titled "The Proposed Emigrant Dumping Site" served as the cover of *The Judge* on March 22, 1890, and revealed white nativist discomfort with the juxtaposition of conditions at Bedloe's and Ellis Islands. Picturing the sculpture recoiling from the dumping of human "refuse" by two vessels labeled "EUROPEAN GARBAGE SHIP," the caption reads,

Danh Võ, *We The People (detail)*, 2011–16, exhibition view at Fridericianum, Kassel (2011).

"STATUE OF LIBERTY: 'Mr. Wisdom, if you are going to make this island a garbage heap, I am going back to France.'"

In 1883, Emma Lazarus, a young leftist Sephardic intellectual and Zionist of Portuguese descent, who assisted refugees and advocated for greater acceptance of Russian Jews fleeing pogroms into the US,[54] composed

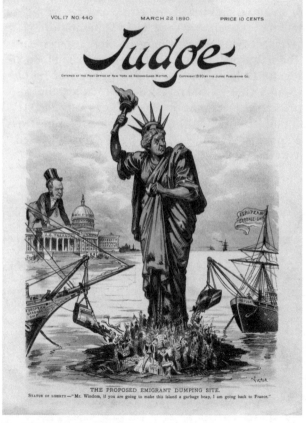

Cover of *The Judge*, March 22, 1890.

her Petrarchan sonnet "The New Colossus" to help with the flagging fundraising efforts for the statue's pedestal, describing the allegory to come as:

> A mighty woman with a torch, whose flame
> Is the imprisoned lightning, and her name
> Mother of Exiles. From her beacon-hand
> Glows world-wide welcome; her mild eyes command
> The air-bridged harbor that twin cities frame.[55]

In *Send These to Me: Immigrants in Urban America*, historian John Higham demonstrates that Lazarus' was a marginal view, entirely absent from the statue's inaugural rhetoric, which instead focused on the beneficent effect of American ideals on the rest of the globe, and the desirability of international friendship in a moment of swelling anti-immigrant sentiment. A bronze plaque containing the text of Lazarus' sonnet was placed without ceremony on the statue's interior wall in 1903 due to the singular efforts of Georgina Schuyler, whom Higham describes affectionately as "another shy, poetry-loving spinster who belonged to the old New York aristocracy."[56] The poem's interpretation of the statue as a welcome to foreigners was not to be yoked to the monument in official discourse until the immigrants who arrived before the restrictive covenants of 1924 began to be Americanized through textbook interpretations of the sculpture aimed at the groups' assimilation. With the Immigration Act of 1924, an outgrowth of the 1907 Dillingham Commission which is now receiving a revival in the aims of the Trump administration's

54 See Esther H. Schor, *Emma Lazarus* (New York: Knopf, 2017).

55 Heinrich Edward Jacobs, *The World of Emma Lazarus* (New York: Schocken Books, 1949), 178.

56 John Higham, *Send These to Me: Immigrants in Urban America* (Baltimore: Johns Hopkins University Press, 1984), 80. Higham provides details surrounding the rhetoric of the statue's unveiling on page 81.

RAISE Act, quotas were imposed on immigrants according to their national origins, excluding Asians altogether and limiting visas for others to two percent of the total number of people of each nationality in the United States as of the 1890 national census.[57] This policy increased the percentage of visas available to individuals from the British Isles and Western Europe, but severely limited immigration from "undesirable" areas like Southern and Eastern Europe. Since borders were being clamped down, the role of Ellis Island shifted sharply, and it was transformed from a processing facility (a task now to be accomplished by consulates) to a detention and deportation facility. Ironically (or aptly), this was the year that the Statue of Liberty was declared a national monument. A boost to Lazarus' sentiments came when anti-racism (and in particular the resistance to anti-Semitism) became part of the US nationalist mobilization against Nazi Germany in the late 1930s: Schuyler's plaque of "The New Colossus" was finally moved to the statue's entrance in 1945.

Questioning of the poem's relevance to the statue has been spreading in the discourse of twenty-first-century white supremacists, continuing the tradition of interpretation that reverses the role of Liberty's torch—reading the colossus as a beacon to other nations and an admonition of American ideological supremacy. "The claim that America was to welcome 'the wretched refuse of your teeming shore' is a Jewish demand upon America, and not the original intention of the Statue of Liberty," wrote Klan icon David Duke in 2012,[58] while on January 28, 2017, white nationalist Richard Spencer tweeted, "It's offensive that

[57] See United States Department of State, "Milestones: 1921–1936: The Immigration Act of 1924 (The Johnson-Reed Act)," Office of the Historian, accessed December 3, 2017, https://history.state.gov/milestones/1921-1936/immigration-act. Note that this website, "Milestones in the History of U.S. Foreign Relations," has been retired under the Trump administration.

such a beautiful, inspiring statue was ever associated with ugliness, weakness, and deformity." At a briefing regarding the RAISE Act, which intends to severely limit immigration to the United States by privileging those with English proficiency and other advanced skills, White House Senior Policy Advisor Stephen Miller rebuked the invocation of the statue as Mother of Exiles by CNN reporter Jim Acosta, who cited Lazarus when stating that the policy proposal countered a US tradition of welcoming the tired, poor "huddled masses yearning to breathe free." "The Statue of Liberty is a symbol of American liberty lighting the world," Miller replied; "The poem that you're referring to was added later [and] is not actually part of the original Statue of Liberty."[59] The eclipsed history in these pages brings out the unfortunate truth in this statement, which nevertheless disavows altogether the transnational and immigrant-driven sourcing of the Liberty in question. The contemporary fiction of the United States as melting pot concocts a figure of Liberty that is contained by the ideal sculpture's copper skin, imagining Liberty's forge as operative only upon its own sanctioned citizens. We now have to ask: where did the tailings of this Liberty end up? Clark, Michigan? Corocoro, Bolivia? Nizhny Tagil, Russia? This unanswerable query obliges us to confront a spectral and abject form of smelted citizenship, leaching and offgassing into territories beyond Liberty's mild gaze, on the move, and without a trace.

58 See Hillel Italie, "Miller Comments on Lazarus Poem Echo Far-Right Opinions," *Associated Press News*, August 3, 2017, https://www.apnews.com/b815605ef54d-448790d3728a8badab7e.

59 *Acosta's Full Exchange with Stephen Miller - CNN Video*, 2017, http://www.cnn.com/videos/politics/ 2017/08/02/white-house-briefing-immigration-plan-acosta-april-ryan-miller-full.cnn.

NETWORK

We are more than a decade beyond the mainstreaming of the open commons promised by Web 2.0. Early internet ideals delivered a shrinking of the globe, bound by instantaneous communication between far flung populaces. In recent years, our sense of belonging and the scale of our communities have been transformed profoundly by these communication technologies. Yet the same "disruptions" of old structures that initially led to the network publics and digital democracy witnessed in the innovative use of Twitter and citizen journalism during the Arab Spring, or in the boom of the "sharing economy," are also the cause of online echo chambers, the spread of nationalist memes, and racial exclusion. Life online reproduces and reinforces cognitive boundaries between people that have real life impact.

Given the contradictions of the network as a scale for identity and inclusion, we must ask what is citizenship when borders are as slippery as IP addresses and digital personae

are subject to AI algorithms? Contemporary
online platforms and algorithmic tools
can be thought of as spaces of citizenship,
reflecting terrestrial conflicts via alternative
tools: bots, cryptocurrencies, illegal surveil-
lance, and fake news.

Keller Easterling's writings and
projects routinely demonstrate the way
digital networks and global capital touch
the ground via spatial products, economic
zones, and organizational space—the
touchpoints where the network meets
statehood. With the collaborative platform
MANY, Easterling and team return to and
repurpose the early internet optimism of
many-to-many digital interfaces. While
they employ crowdsourced content from
distributed publics, they do so with little
techno-futurist naiveté. The approach is
clear-eyed, considering the seriousness of
what's at stake: the exchange of needs in
global networks.

MANY

KELLER EASTERLING

WITH MANY

MANY is an online platform designed to facilitate migration through exchanges of needs.

Global infrastructure space has perfectly streamlined the movements of billions of products and tens of millions of tourists and cheap laborers, but at a time when over 65 million people in the world are displaced, there are few robust ways to facilitate the migrations of people in response to political, economic, or environmental crises. The nation-state has a dumb on-off button to grant or deny citizenship/asylum. And the NGOcracy offers as its best idea storage in a refugee camp—a form of detention that lasts, on average, seventeen years.

Can the legal and logistical ingenuity that lubricates trade or links millions of strangers in the sharing economy be applied to a global form of matchmaking between the sidelined talents of migrating populations and a multitude of endeavors and opportunities around the world?

While existing help and exchange networks for asylum seekers face intense opposition from nativist right-wing groups, MANY proposes to diffuse or outwit this opposition by more robustly networking short term visas and exchanges that may not involve travel. Deliberately positioned at a distance from the sharp end of migration emergencies, the

Groups on either side of the MANY exchange form a no-tech block chain to increase security and community.

Addressing migrations related to both climate and labor, existing global agricultural and educational networks generate short-term training and research internships that might be aggregated and accredited.

Exchange networks that may not involve travel develop cooperative structures to facilitate migration in times of political, economic, or environmental crisis.

platform serves those who want to resettle as well as those who want to keep traveling—those who never wanted the citizenship or asylum that the nation withholds or reluctantly bestows. Irrespective of national identity, one-to-one relationships share a visual language of exchange where there are no have or have-nots. Instead, needs and problems are assets to be linked in non-market exchanges. MANY aggregates an abundance of existing networks and reinforces them with underexploited potentials embedded in urban space. As it develops over multiple iterations, the site hopes to alter habits and reduce the violence surrounding migration. Rejecting the characterization of migration as crisis, MANY asserts the reality of migration as constant.

Might another kind of cosmopolitan mobility organize around intervals of time or seasons of a life to form a branching set of options that is both more practical and politically agile? Can the platform guard against the dangers that it critiques and avoid association with the sunny, one-world vision of the sharing economy? And might this exchange be anticipated, celebrated, and accredited as the means to global leadership credentials?

MANY
Kate Altman
Nilas Andersen
Michelle Badr
Jacob Bendicksen
Santiago Del Hierro
Neil Donnelly
Adam Feldman
Nicholas Herrera
Paul J. Lorenz
Mariana Riobom
Radhika Singh
Dina Taha
Maggie Tsang

Julie Turgeon
Shuyi Yin

Advisors
Heather Bizon
Brian Cash
Ayham Ghraowi
Bernd Kasparek
David Kim
Ahmet Ogut
Kim Rygiel
Pelin Tan
Matthew Ward

Institutional Support
Yale School of
Architecture, Dean
Deborah Berke
Tsai Center for
Innovation at Yale
Yale Center for
Engineering, Innovation
and Design

Cities can bargain with their underexploited spaces to attract a changing influx of talent and resources—matching their needs with the needs of mobile people to generate mutual benefits.

EFFORTLESS SLIPPAGE

CARTOGRAPHIES OF THE NETWORKED WORLD

INGRID BURRINGTON

For about as long as there has been a networked world there have been people adorning it with the accessories and ephemera of the nation-state. Some of these gestures were more of a literal attempt to translate the borders of the world onto the net, such as ARPANet legend Jon Postel's decision to assign two-character ISO country codes to every nation as top-level domains. Postel assumed a future of domain names functioning more like folder directories or physical mailing addresses—the website of IBM offices in Armonk, New York, might live at "IBM.Armonk.NY.US"—rather than the linguistic hacks and poetics they're used for now.[1]

But perhaps the more familiar nation-state accouterment applied to the internet is the rebellious manifesto. The most literal and famous of these is J. P. Barlow's 1996 "Declaration of the Independence of Cyberspace," which borrowed the rhetoric of Jeffersonian outrage to situate the net as beyond the purview of

1 John Postel, "Request for Comments 1591: Domain Name System Structure and Delegation," March 1994, https://www. ietf.org/rfc/rfc1591.txt.

governments.[2] If the network-as-nation had a fundamental character in the early days of the internet, it was an outlaw one—where Barlow and the cowboys of cyberspace could declare independence from the dunces of Davos, a Wild West conveniently lacking in genocidal baggage from the last time Americans attempted to manifest their destiny (though still infused with Orientalist aesthetics in cyberpunk culture). This Wild West was only stealing control away from fuddy-duddy benevolent technocrats like Postel and the ARPAnauts, the federally funded squares who laid the foundation but lacked the cowboy's imagination.

Regardless of whether the network was viewed as a tidy technocrat state or an unruly terrain of rebels, both versions needed their own *mappa mundi*. This is perhaps the most obviously necessary artifact of a would-be sovereign—stamps or seals (in tech, manifest in the litany of company and conference logo stickers festooning hacker laptops) and declarations of independence can instill pride or cultivate a sense of identity, but citizens of a collective imaginary need a *place* to imagine. Additionally, sovereigns like being able to visualize their terrain and, by extension, the scope of their power. The historical maps made of the internet—and, later, the maps of the world made *by* the internet—are both reflection and instrument of the ideologies and entanglements of the networked world. They are one way we might navigate the premise of the networked citizen and her obligations to her fellow travelers in the networked landscape.

The early ARPANet maps aimed for at least some geographic accuracy when there weren't too many nodes—SRI, UCSB, UCLA, and Utah are more or less in the correct locations against a void USA in 1969 maps. But as new nodes

2 John Perry Barlow, "Declaration of the Independence of Cyberspace," 1996, https://www.eff.org/cyberspace-independence.

accumulated (mostly along the coasts), our network
cartographers switched to a logical map that eschewed
gestures at geography and had more resemblance to a
circuit diagram.

This form would be echoed by maps like the
"Internet Road Map" included as a supplement to
MacUser magazine around the same time that Barlow
issued his secessionist jeremiad. The map divided up

ARPANet map, 1969.

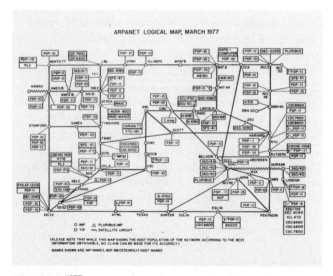

ARPANet map, 1977.

the 1996 internet into "zones" depending on inter-
ests—there are zones of "government information,"
"education and reference," "internet reference,"
"business and commerce," "Macintosh resources,"
and "arts and humanities." From the center point of
the "MacUser Web," readers could chart a path to
one of the five US states with a website (at that time,
California, Washington, Minnesota, Oregon, and Texas)
or some of its quainter entries such as a "graphics-
intensive, thorough frog dissection tutorial with lots
of images and movies." Its listings also invoke spatial
metaphors, such as "The Internet Mall" and "The
Electronic Newsstand." Skeuomorphism of this kind
is hardly a novelty in the realm of personal computing.
It's a deliberate, and arguably necessary, strategy for
beckoning new settlers. As infrastructure began to tame
the so-called wild frontier of the web, novice home-
steaders arrived to an increasingly settled terrain full of
fun, convenient, prefab architecture. All they had to
do was select which fanciful neighborhood of GeoCities

MacUser Internet Road Map, 1996.

(which literally referred to their users as "homestead-ers") spoke to their desires.[3] Not everyone wants to be an outlaw; some people just want to settle down in EnchantedForest with their gifs and blink tags.

The *MacUser* zones suggest a better metaphor for the internet as sovereign body—not as nation-state or wild frontier but more like a constellation of special economic zones. The internet is full of sites of exception carved out by nation-states, ostensibly in the service of innovation and commerce, but in practice an easy recipe for labor exploitation and corruption. But the early web of *MacUser* zones felt more like makeshift railroad company towns waiting to see if the water would run out than the monoliths of Shenzen or Dubai.

One can, of course, find hints of the future networked regime to come in the archaeology of the old web. In 2013, a *Hacker News* poster discovered what appeared to be Mark Zuckerberg's first personal website (hosted, somewhat surprisingly, on Angelfire).[4] The site has since been purged, but lives on in screenshots and on the Internet Archive.[5] While the clumsy jokes and coding experiments of an awkward fifteen-year-old boy might only be revelatory in that they suggest that Zuckerberg is, in fact, human, one page stands out. Young Zuckerberg made a Java applet for his site called "The Web," which appeared to be a network diagram mapping Zuckerberg's personal connections and his friend's extended connections—in short, a social graph. Fifteen-year-old Zuckerberg described it thusly:

3 Richard Vilgen, "Deleted City," 2017, http://deletedcity.net/.

4 *Hacker News*. "Mark Zuckerberg's first website is still on Angelfire," April 3, 2013, https://news.ycombinator.com/item?id=5486014.

5 Casey Chan, "Holy Crap, Is This Mark Zuckerberg's Embarassing Childhood Angelfire Website?" *Gizmodo*, April 3, 2013, https://gizmodo.com/5993535/holy-crap-is-this-mark-zuckerbergs-childhood-angelfire-website; "Mark's Homepage." Archived April 4, 2013. https://web.archive.org/web/20130404151448/http://www.angelfire.com/ny/mez51/.

As of now, the web is pretty small. Hopefully, it
will grow into a larger web. This is one of the few
applets that require your participation to work
well. If your name is already on The Web because
someone else has chosen to be linked to you, then
you may choose two additional people to be linked
with. Otherwise, if you see someone who you know
and would like to be linked with but your name is
not already on The Web, then you can contact me
and I will link that person to you and put you on
The Web. If you do not know anyone on The Web,
contact me anyway and I will put you on it.

While it's unlikely that his Angelfire website was
at the forefront of Zuckerberg's mind when creating
Facebook years later, it's sort of reassuring to know that
the impulse to index, map, and sort human beings like
nodes in the ARPANet goes further back than the hokey
mythos of the jilted freshman or the flash of genius
ascribed by cinema and hagiography.

Facebook is the company that seems most easy for
people to see like a state; since Rebecca MacKinnon's

Screenshot of "The Web" on Mark Zuckerberg's first website, 1999.

first coining of "Facebookistan" in *Consent of the Networked*, the nickname has been used by dozens of journalists and at least one made-for-television Danish documentary.[6] It's catchier than MacKinnon's other sovereign example "Googledom" (which sounds kind of like a painfully banal kink), and Facebook leans into the nation-state comparison more explicitly in its constant invocation of "community" and appropriation of democratic movements to serve its IPO. But in trying to pinpoint the moment when the collapse of boundaries between networked zones and nation-states occur, we need to return to cartography (and we will, via cartography, return to that fish in a barrel Zuckerberg). Although social media undoubtedly facilitated a sea change in public understanding of the false dichotomies of online and IRL, a more literal transformation emerged with the launch of Google Maps. In this moment, the network became the vantage point for mapping the world. In so doing, it became a means through which the network could perpetually mediate the world while the network itself became harder and harder to map and comprehend.

Of course, there were prior mapping services online, but Google Maps introduced two crucial technical innovations that would transform both the way that internet users saw the world and, eventually, how they moved through it. The first technical shift popularized by Google Maps was the map tile. Earlier web mapping services were a bit more like desktop GIS software: zooming in or panning across the map reloaded the entire webpage with a new image. The tiled web map is a collection of thousands of 256 × 256-pixel-sized images of the world at different zoom levels. As a user zooms or pans across a tiled map application, the page sends

6 Rebecca MacKinnon, *Consent of the Networked: The Worldwide Struggle for Internet Freedom.* (New York: Basic Books, 2012).

a request to a server for new tiles, refreshing on the fly with lots of tiny images instead of waiting for one enormous image to load. Making these server requests required the use of AJAX (Asynchronous Javascript and XML) requests in the background, which was at the time a new and experimental technical framework for running code, but would soon become the backbone of the increasingly real-time web. Google Maps didn't invent AJAX so much as find a clever use for it and contributed to its popularization across the web. It's AJAX that made that rapid reload of your News Feed possible, that renders news sites into something like abandoned Josef Albers compositions of various rectangular color fields while a server fetches article text, that makes it trivially easy for tracking software to capture your every move and click on a website in real-time and pass it along to advertisers. It also means that Google can rapidly send information like your location back to a server and, based on that information, choose which version of the world to show you. Depending on where you're viewing the map, the Crimean Peninsula may or may not be a secessionist region.

That ease of use on the web eventually transferred to mobile, and Google Maps proved to be the crucial

Crimea, as displayed on Google Maps in Russia, 2017.

Crimea, as displayed on Google Maps in Ukraine, 2017.

killer app of the iPhone. While it's perhaps unreasonable to say that Google Maps and smartphones led to an entire generation never really developing a sense of direction, relying instead on the tiny blue dot hovering on their screens, maps did transform public movement. They also had an influence on commerce—why chance it with one of a handful of coffee shops in a neighborhood when you can go to the first one that Google Maps recommends? At some point, it became more important for companies to proactively make themselves legible to Google than for Google to seek them out.

The other technical shift of Google Maps might be misunderstood more as an aesthetic one. Around the same time that the company was assembling its maps team, it bought Keyhole—a CIA-funded mapping company that made software for viewing satellite imagery. According to a *Recode* article on the tenth anniversary of Google Maps' launch, the decision to acquire Keyhole came when Sergey Brin interrupted another acquisition meeting to show off the software, declaring "this thing's cool and we should buy it."[7] Executives were instantly thrilled by the software, and began yelling out their addresses so that they could see their homes from space. "If our mission is to make all the world's information useful and accessible," VP of engineering Wayne Rosing is reported to have said during the meeting, "then this is the real world."

Prior to what would become Google Earth, civilian access to high-resolution satellite imagery was extremely limited by both monetary cost and technical expertise. Through Keyhole, Google literally created a new way for most people to see the world—and while it's been normalized enough to be readily taken for granted, what a bizarre,

7 Liz Gannes, "Ten Years of Google Maps, from Slashdot to Ground Truth," *Recode*, February 8, 2015, http://recode. net/2015/2/8/11558788/ ten-years-of-google-maps-from-slashdot-to-ground-truth.

beautiful way to see it. Brin was right: this thing *is* cool.
I've personally lost countless hours to panning and
zooming through the perpetual cloudless afternoons
of the Google satellite basemap—jewel-like lithium
fields, enormous satellite dishes like tiny moons in New
Mexico, the dazzling order of container ports. But there
remain blank or at least fuzzy spots on the map, usually
due to negotiations with nation-states: high-resolution
imagery of Palestine, for instance, is never available and
probably never will be.

Another name often used by developers for tile
maps is, quite satisfyingly, the "slippy" map. While
the term references the map's seamless pan and zoom
effects, it also resonates with the political slippages
between web and world that the maps, and the tech-
nology underlying them, enable. Cries of "Google Maps
censorship" at territories erased or character encodings
mangled assume that Google has some responsibility
to truth or a public record, rather than to shareholders.
Furthermore, it assumes that being legible in Google's
landscape is not only somehow a right, but a desirable
outcome. But being a fixed point in the slippy map
doesn't afford individuals greater freedom of movement
or any kind of diplomatic recognition. It merely distills
people, places, and things into another piece of the
world's information made, or to borrow from Google's
mission, useful and accessible (to Google).

While platforms and smartphones were mapping
the world in precise detail, transforming it if not in its
own image then maybe in its aesthetics, maps of the
internet—and particularly the internet as manifested
in the world—were only becoming more illegible. Gone
were the days of logical nodes and an internet so small
that it could fit on a printed "road map." All that can
be learned from visualizations like the now-ubiquitous
2005 map of network connections by Matt Britt is that

the internet is an unfathomably complex place, an infinite maze. The only way to navigate that dense complexity was via the platforms, which ranked, indexed, streamlined, and mapped the internet into pristine dashboards, news feeds, and eerily accurate product recommendations. Much as Google Maps and smartphones atrophied innate senses of direction, platforms atrophy the capacity for wandering through the web in search of questions and connections rather than instantaneous answers or desultory dopamine hits from the "like" button.

The tendency of users to remain in filter bubbles and propagation of myopic communities via platforms and recommendation engines has been well-documented, as has the tendency of these narrow environments to enable mass harassment, misinformation, and propaganda campaigns. In response, companies offer resources on media literacy and piecemeal hiring of content moderators or fact-checkers. But placing the onus on individuals to season their news feeds with opposing viewpoints (rather than, say, designing a platform optimized for bringing multiple viewpoints to users) or assuming the issue is the ability to critically discern sources (rather than recognizing that many users are entirely media-literate but happen to hold racist or fascist beliefs) suggests platforms consider power something that the invisible hand of the market has clumsily pushed them into against their will, and not something abused in the absence of a meaningful praxis. Furthermore, it assumes that greater legibility of a user and their nuanced perspectives is a desirable outcome. Users have the agency to reshape the territory of their digital bubble, but they remain mapped subjects.

There is some irony to the mapping impulse of platform companies, insofar as they largely emerge from

landscapes historically willfully in denial of their own spatial confines. As a place in public imagination, Silicon Valley is more often defined by its companies than its geography. This, in part, might be ascribed to the particular way most tech companies inhabit these suburban cities on the San Francisco Bay Peninsula: on campuses, enclaves set apart from the day-to-day of the cities they inhabit. To claim that Facebook has "offices" in Menlo Park doesn't really do justice to the experience of driving along its particular expanse of the Bayfront Expressway where its (former Sun Microsystems) compound and its Frank Gehry–designed expansion loom in the distance. Today's platforms inherit a landscape architecture and urban planning approach pioneered in the 1950s and 1960s. The corporate campus and suburban sprawl is not an invention of Facebook or Apple so much as the natural habitat from which their particular worldview might emerge. No landscape could inspire the dream of the autonomous vehicle more than traffic on the southbound 101 trying to make the Moffett Field exit.

What has changed since the dawn of the corporate campus is the movement of companies to make their campuses more like towns, and more active participats in the construction *of* the urban environment. Google has been in a years-long negotiation with the city of Mountain View to help develop nearly 10,000 new homes (in exchange for yet more office space). Facebook had contributed $600,000 to Menlo Park to construct a top-of-the-line new police substation down the street from the company's offices in 2014—a development that the city's police chief Robert Jonsen described as "setting the standard of public-private partnerships."[8] In July 2017, the company announced plans

8 Cyrus Farviar, "Facebook-funded Silicon Valley police station, with free wi-fi, opens," *Ars Technica*, April 26, 2014, https://arstechnica.com/tech-policy/2014/04/facebook-funded-silicon-valley-police-station-with-free-wi-fi-opens/.

to build out 1,500 residences and a retail district for the "Willow Campus" adjacent to their current compounds in Menlo Park.[9] Reports describe these efforts as Facebook trying to be a "good corporate citizen," showing more responsibility to that "community" that Zuckerberg is so fond of speaking about.[10] Never mind the fact that meanwhile, Zuckerberg's philanthropic arm, the Chan-Zuckerberg Initiative, has been displacing trailer-inhabiting residents of East Palo Alto, the town right on the border of the Facebook campus, in order to construct a charter school.[11]

 As platforms grew, so did their needs for computing power, energy, water, and their real estate footprint. This, too, was obscured in maps. For years, I heard rumors that Google actively removed their data centers from Google Earth. I only ever saw two screenshots that suggested that possibility might be true, so I remain skeptical, but as fable it fits well.[12] One of the most ingenious details of Google Earth was its compositing of historical satellite imagery to create a picture of the world from space with zero clouds. Of course the company would want to also scrub out their own cloud computing. The world in Google Maps is a world of effortless slippage, and to see the weight

9 George Avalos, "Facebook campus expansion includes offices, retail, grocery store, housing," *Mercury News*, July 7, 2017. http://www.mercurynews.com/2017/07/07/facebook-campus-expansion-includes-offices-retail-grocery-store-housing/.

10 Jessica Floum, Facebook proposes campus expansion, pledges millions to Menlo Park," *SFGate*, July 15, 2017, http://www.sfgate.com/business/article/Facebook-proposes-campus-expansion-pledges-8381447.php.

11 Nellie Bowles, "Facebook Founder's Favor Comes With Complications," *New York Times*, November 23, 2017, https://www.nytimes.com/2017/11/23/technology/mark-zuckerberg-housing.html.

12 One incident documented by the author in 2015, the other by Andrew Blum in 2012: "Google's famed mission statement is 'to organize the world's information and make it accessible and useful.' Yet at The Dalles, they'd gone so far as to scrub the satellite image of the data center on Google Maps– the picture wasn't merely outdated, but actively obscured." Andrew Blum, *Tubes: A Journey to the Center of the Internet* (New York: Ecco, 2012).

of material infrastructure that makes that slippage possible would destroy its magic.

But if this fable was ever true, it likely isn't now: today, searching for Google data centers on Google Earth is as easy as searching for your own house. Google and Facebook both publish glamour shots of their data centers, shifting them from trade secrets to PR props on which charming murals can be painted and carbon offsets can be applied. While this outward-facing shift may be in part due to the realization that hiding giant buildings mostly located in the middle of nowhere is slightly pointless, it also reflects an understanding of the role of platforms as increasingly foundational communications and information infrastructure. Showing off their actual infrastructure might inspire confidence, or awe, or fear, or all of the above. Google and Facebook of course aren't alone in this—recall Jeff Bezos standing atop a wind turbine to celebrate Amazon's efforts to cut down its carbon footprint—but they are perhaps the most prominent figures.[13]

13 Jeff Bezos, "Fun day christening Amazon's latest wind farm. #RenewableEnergy," Twitter, October 19, 2017, https://twitter.com/jeffbezos/status/920999-561564274688.

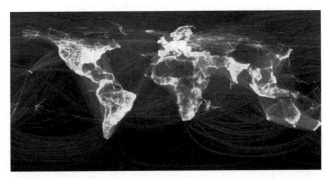

Visualization of ten million relationship connections among Facebook users, 2017.

Eleven years after teenage Mark Zuckerberg built out a web of his peers in a Java applet, an engineering intern at Facebook produced a visualization of ten million relationship connections among its users, geographically plotted and connected with arcs. The resulting image provided a startlingly close outline of a world map. An updated version of the visualization in 2017 showed an even more detailed map, with east Africa and South America filling in quite nicely.

Fifteen-year-old Mark's web shows no sign of diminishing. Facebook's visualization of global connections is a pure *mappa mundi*: it's useless for wayfinding and not even particularly illustrative of how relationships across the network actually work. When isolated from the image of the whole, the mapped relationships reflect dense pockets of pre-existing ties and diaspora connections, rather than the composite image's gossamer strands connecting strangers and making neighbors of nations. But as propaganda serving a vision of Facebookistan as a united global community, it's perfect. A world without Facebook would be a world of total darkness; a disconnected web and a collapsed society (or maybe just a world that's a little more like the obviously absent China).

This is, perhaps, where the SEZ comparison starts to become more obvious and pernicious: not only are Google and Facebook too big to conceal their infrastructure, they're also too big to fail. No matter how many moral or potentially illegal transgressions platforms enact, their quarterly earnings statements dazzle. No matter how much users complain about how much they actively dislike the platforms, no matter how cognizant they are of the manipulations to the timeline or the map (either algorithmically or geopolitically), they remain users. No matter how egregious the harms, governments will at best fine these multi-billion

dollar platforms somewhere in the tens of millions and generally treat regulation more as a question of "which superpower should moderate public speech" instead of "is this business model fundamentally toxic for public speech." At some point, it became easier to imagine the end of capitalism than the end of the network.

The compacts between platforms and users afford the latter little political power or agency in these increasingly overlapping zones. Maybe we're more like embittered indentured employees or squatters on the fringes of an SEZ. The maps made by platforms— of themselves or of the world which they increasingly reshape in their own image—will never offer their users convenient escape routes.

That being said, transgression, rebellion, and personal expression can and does still take place within and around the margins of the platforms. A sovereign is only ever as stable as its underworld, and it's worth asking whether recent manipulation of platforms to propagate misinformation and hate speech is an example of transgressive use, or the platform working exactly as it was intended. Like most spaces of transgressive exception, some blank spots on the map exist in part due to the benevolence and discretion of other powerful actors (lest we forget that the Tor Browser wouldn't exist without the Naval Research Lab and the State Department). But remaining on the imagined fringes of the network might only afford us the kind of freedom Barlow opined for in 1996: the convenient imaginary of outlaw cyberspace, the wild frontier in which white men can always mean well while moving fast and breaking things, or where the privileged prepper can build her own infrastructural enclave apart from the platforms, but remain no less complicit in isolationism.

In an interview on the occasion of the twentieth anniversary of his declaration, Barlow lamented to

The Economist that "Over the decades, it has been continuously fashionable to make a straw man of my declaration, to hoist it up as the sort of woolly-headed hippie nonsense you'd expect from techno-utopians like me."[14] Perhaps then it is more constructive to expand upon what even Barlow admits was a glaring absence in his declaration: in that same interview, he noted that had he a chance to revise the document, "I would make it more obviously clear that I knew that cyberspace was not sublimely removed from the physical world," and therefore, to some extent, beholden to the laws of governments that maintained its infrastructure.

Indeed, the so-called immateriality of the internet—a vision popularized in its maps and the gaps on it—is perhaps the greatest source of plausible deniability for earnest CEOs invoking community and empowerment while enacting complicity and arbitrage. The forums and platforms on which we shop, share, and protest, and the nation-states within which we pay taxes, vote, and protest, have always been in a state of misunderstood entanglement: never really separated by false dichotomies of IRL and online, always inserting spooky actions across the distance of fiber-optic cable and wireless transmissions. As effortless slippage becomes context collapse, as revolutions give way to propaganda campaigns give way to ethnic cleansing, it becomes harder and harder to escape the feeling of slippage as freefall.

The geographies and architectures that networked platforms actually inhabit—their corporate campuses, data centers, water lines, power grids, submarine cables, and company towns—are distillations of those entanglements, the most heavy-handed options for material

14 "How John Perry Barlow views his internet manifesto on its 20th anniversary." *The Economist*, February 8, 2016, https://www.economist.com/news/international/21690200-internet-idealism-versus-worlds-realism-how-john-perry-barlow-views-his-manifesto.

manifestations of Facebook or Google's so-called borderless empires. Rather than merely finding pockets of freedom in the networked SEZ archipelago, it is high time to go on the offensive—not only constructing alternative infrastructure, but mapping, sabotaging, and expropriating theirs.

"We are all astronauts," wrote Buckminster Fuller. In his 1968 book, *Operating Manual for Spaceship Earth,* Fuller compared our planet to a vessel hurtling through space, with limited provisions and humanity as its crew. Originally delivered as a lecture to the American Planners Association, Fuller's Spaceship Earth both challenged designers and policy-makers to tackle global impending crises and contextualized our planet in a larger universe.

Space, as a site of potential belonging, has become a territory that both captures the imagination and serves as a theater for existing conflicts or conditions on earth. From the military industrial underpinnings of the Cold War space race to today's privatization of space exploration, from the armatures of communications and surveillance in orbit around the planet to the science fiction imaginary, outer space indexes both the hopes and fears for life on earth. How might architecture respond to

the off-planet extension of international issues and the creative imaginings of building new habitable worlds?

Design Earth's speculative visual narratives suggest possible cosmic architectural responses. The practice's work explores the possibilities of "geostories": mixtures of fiction and fact that combine technical and geopolitical histories, mythologies, and imminent technologies, with reflections on and projections beyond our contemporary condition. In situating citizenship in the cosmos, Design Earth illustrates both the expansion of human empire into unexplored territory and the ways these speculative efforts impact life on Spaceship Earth today.

COSMORAMA

MINING THE SKY, PLANETARY ARK, AND PACIFIC CEMETERY

DESIGN EARTH

Cosmorama responds to current issues that shape humanity's relationship to the cosmos in three geostories: "Mining the Sky," "Planetary Ark," and "Pacific Cemetery." These geographic fictions render visible important matters unaccounted for in the technological triumphalism and frontier narratives of the Space Age. They project some of humanity's present environmental and political hopes and fears, and bring forth these same systems and their attributes as generators of a renewed planetary imagination.

 "Mining the Sky" speculates on the landscapes of the 2015 SPACE Act (Spurring Private Aerospace Competitiveness and Entrepreneurship Act) that recognized the right of US citizens to engage in the exploitation of extraplanetary resources, argu-ably in violation of the 1967 Outer Space Treaty that prevents any state from exercising "national appropriation by claim of sovereignty, by means of use or occupation, or by any other means." This new franchising of outer space is expected to accelerate the nascent NewSpace entrepre-neurial movement as companies such as Planetary

Mining the Sky [1/3] Cosmic Rushmore.

Resources plan to extract billions of dollars worth of ore from near-Earth asteroids. The captured asteroids will be de-spun and towed to a mining depot at the Earth-Moon L1 Lagrange, a position where the combined gravitational pulls from the two celestial objects constitute a stable equilibrium point. Robotic arms process the asteroid. They either hollow out the asteroid collecting the trail of debris in the fabricated cave or mine the surface to carve out the face of the gods of the new space age. The mining station serves human settlements through the Interplanetary Transport Network, requiring minimal energy for an object to travel through such gravitationally determined highways through the solar system. The extraction stations constitute the first artificial constellation visible to human eye from Earth.

"Planetary Ark" is a collection of living animals that were launched into space on scientific missions to test the survivability of spaceflight for the human body, as well as other species currently threatened by the sixth mass extinction in Earth's history. Now that climate change and uncertain futures define a new normal on Earth, animal species at (or past) the brink of extinction are sent out, each in its cubicle, on an ark to the International Space Station. Once funding for the most expensive structure ever built is discontinued in 2024, the International Space Station is repurposed into a microcosm of scientific experiments on forms of life, what it means to be human, and the making of worlds. It is also a place of last refuge, where some scientists can tend to creatures with remarkable care, in spite of their imminent disappearance. A few thousand years later, the offspring of these "fellow travelers" embark on a journey to resettle the Earth.

Planetary Ark [1/3] (All Aboard) the Architekton.

"Pacific Cemetery" is a vortex spiral island where decommissioned satellites and other space debris are brought back from orbit and recycled at Point Nemo in the Pacific Ocean. Over the next decades, thousands of satellites will be launched into space and eventually decommissioned after fifteen years of operation. Building on the precedent of the Pacific Proving Grounds, in which the United States secured an agreement with the United Nations to conduct nuclear testing at sites in the Pacific Ocean between 1946 and 1962, the US designates Point Nemo as the Strategic Trust Territory of the Space Age. At more than 1,400 nautical miles from the nearest land, Point Nemo is already the cemetery of de-orbited spacecraft, such as the Soviet-era MIR space station, the Jules Verne ATV and other European Space Agency cargo ships, and a SpaceX rocket. Also dubbed the Oceanic Point of Inaccessibility, Point Nemo is the landfill of the Space Age. It is a planetary terraforming project, in which the vestiges of space objects are recycled into bits of sovereignty to house climate refugees from Pacific Islands. The strategic area directive also proclaims that the United States would promote the economic advancement, self-sufficiency, and right to self-determination of such planetary refugees against the disappearance of their lands.

Design Earth Team
Rania Ghosn
El Hadi Jazairy
Reid Fellenbaum
Jia Jane Weng
Kelly Koh
Shuya Xu
Monica Hutton
Rawan Al-Saffar

Lex Agnew
Garine Boghossian
Ranu Singh
Tianwei Yen
Sihao Xiong

Advisor
Benjamin Weiss, MIT
EAPS

Sponsors
MIT School of
Architecture + Planning
MIT Department of
Architecture
MIT Center for Art,
Science & Technology

Pacific Cemetery [1/3] Space Junk Island.

KOSMOS

NICHOLAS DE MONCHAUX

Prelude: Pine Gap

Joint Defence Facility Pine Gap, code named RAINFALL, sits outside of Alice Springs, in Australia's unincorporated Northern Territory. There are no pines there, and, practically speaking, no rain either. Instead, sprinkled on the red desert lies an irregular assembly of white geodesic domes and low buildings. The result almost precisely resembles contemporary renderings of settlements on Mars.[1] Planned from 1966 and operational from 1970, the facility was referred to in public until 1988 as a station for "Space Research." It is not.

Staffed by employees of the NSA, CIA, and National Reconnaissance Office, as well as the US Army, Navy, and Air Force, the station is one of several hubs of the United States' program of global electronic surveillance. It services a constellation of geosynchronous spy satellites that monitor wireless communications across Asia and the Pacific; these include military transmissions, microwave-radio signals, and many millions of consumer cell phones, whose world-wide, warrant-less surveillance was highlighted by the documents revealed by the former US Intelligence operative Edward Snowden. Since the 1970s, the station has also—despite its

1 See in particular the resemblance to the Elon Musk renderings shown here: Tariq Maliq, "Elon Musk Teases Images of SpaceX 'Moon Base Alpha' and 'Mars City,'" Space.com, September 28, 2017, https://www.space.com/38310-elon-musk-moon-base-mars-city-images.html, accessed Dec 10, 2017. permalink https://web.archive.org/web/20171218050907/https://www.space.com/38310-elon-musk-moon-base-mars-city-images.html.

deliberate isolation—been home to repeated non-violent protests against US military activities, and not least the perceived violation of Australian sovereignty.[2]

1. Cosmos

In April of 1959, responding to the announcement of the seven astronauts of NASA's Mercury space program, as well as to a decree issued from the Politburo four months earlier calling for "manned spaceflight," the Soviet Air Force issued the "Directive of the General Staff of the [Air Force] for the Selection of Cosmonauts."[3]

It was the first official use of a new word for Soviet spacemen. This was not for lack of language: the word "astronaut" already existed in Russian (астронавт), and was in global currency from the 1920s. The shift was more essential; The suffix "naut," in Russian and English both, originates literally with the ancient Greek ναύτης, or sailor. The "astronaut," sailor of stars, entered

2 Ryan Gallagher, "The U.S. Spy Hub in the Heart of Australia," *The Intercept*, August 19, 2017, https://theinter-cept.com/2017/08/19/nsa-spy-hub-cia-pine-gap-australia/, permalink https://web.archive.org/web/20171218034459/https://theintercept.com/2017/08/19/nsa-spy-hub-cia-pine-gap-australia/.

3 Asif A. Siddiqi, *Challenge to Apollo: The Soviet Union and the Space Race, 1945–1974.* (Washington, DC: National Aeronautics and Space Administration, NASA History Div., Office of Policy and Plans, 2000), 243.

Joint Defence Facility Pine Gap, as shown on Bing Maps, 2017.

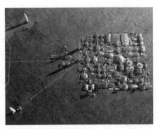

SpaceX rendering of Mars Settlement, 2017.

English language in the early twentieth century from "aeronaut," an eighteenth-century neologism coined for balloonists. The precise division between air and space would await a myriad of modern scientific definitions. But the two ideas remain joined by their nature as realms apart. "Good bye to you—people of Earth," exclaimed Charles Ferson Durant in his *First American Aeronaut's Address* of 1830, distributed in fluttering handfuls from a balloon above Manhattan. "I am soaring to regions above you."[4]

The word "cosmos," however, carries a different payload. From the Greek κόσμος, or "order," it was used by Pythagoras and his followers to define the world, planets, and stars as a whole, in their "perfect order and arrangement."[5] The word languished in disuse, however, until revived by Alexander Von Humboldt in 1845 for what would become his five-volume treatise, *Kosmos*; an attempt to describe the physical nature of space and earth together. And it was in this sense that Soviet nomenclature cast the cosmonauts' mission not as a journey beyond the earth, but as an extension, and expansion, from it. "New Soviet People," announced Nikita Kruschev himself in 1960, "will conquer cosmic space."[6]

2. Space

Kosmos was a literary phenomenon in its day, selling hundreds of thousands of copies, and on the way transforming the western understanding of nature. It was also controversial for the fact that it did not contain any mention of God. The first volume, published

4 Charles Ferson Durant Scrapbook, box 233, AIAA History Collection, Manuscript Division, Library of Congress.

5 See for example the entry for "Cosmos" in ed. Charles P. Krauth, *A Vocabulary of the Philosophical Sciences* (New York: Sheldon & Company, 1881), 621.

6 Deane Simpson, "The Vostok Cosmonauts: Training the New Soviet Person," in *2001: Building for Space Travel*, ed. John Zukowsky (New York: Abrams, 2001), 108.

in 1845, was divided not between heaven and earth, but between what Humboldt termed the "Terrestrial portion of the Cosmos" and the "Celestial portion of the Cosmos." Humboldt's more specific outline of his subject—"a physical description of the universe, embracing all created things in the regions of Space and in the Earth"—does, however, contain a seed of the

Plate 12 of Gustave Doré's 1866 engravings for Milton's *Paradise Lost* showing the angel Lucifer being cast down from heaven.

divine.[7] It was John Milton, in 1667's *Paradise Lost*, who in Satan's voice, first used this sense of the word "space":

"Space may produce new Worlds; whereof so rife / There went a fame in Heav'n."[8]

The word "space" therefore, describes its own opposite: the realm of man on the one hand, and that apart from man on the other (even Humboldt termed its denizens "heavenly bodies"). Beginning in the first balloon flights of the eighteenth century, and increasingly with the dawn of the twentieth, mankind encountered the boundary between the two as a physical reality. Jacques Alexandre César Charles ascending to 10,000 feet only a few weeks after the first Montgolfier ascent of 1784, encountered the hostility of altitude to human bodies for the first time, complaining of "intense fright and unease, cold, and earaches."[9] Despite a long and distinguished scientific career, Charles did not fly again.

From the nineteenth to the twentieth century, the boundary of space gained a common scientific definition that followed from Charles' experience of the hostility of altitude. For a whole variety of disciplines, "space" is that distance from the earth that we need technology to access; for a doctor, pressurized oxygen; for an engineer, a wingless rocket. And while the relevant altitude varies widely by discipline, the more profound implication remains consistent: space is, very precisely, that great portion of the cosmos where our technology positions us apart from man, as gods. And therefore, while almost completely empty of normal matter, it is densely saturated with imagined possibilities and utopian dreams.

7 Alexander von Humboldt, *Kosmos: A General Survey of Physical Phenomena of the Universe* (London: H. Baillière, 1845), 22.

8 John Milton, *Paradise Lost*, Book I, line 650. Cited by the *Oxford English Dictionary* as the modern "Space." Also Book II, lines 1052 and 1045.

9 Melvin B. Zifsein, *Flight: A Panorama of Aviation* (New York: Pantheon Books, 1981), 9.

In real terms, however, it remains an almost entirely uninhabited, inhospitable vacuum.[10]

3. Desert

There is a related realm on earth: the desert—a landscape named for our absence from it. Describing the resulting interdependence of arid environments and architectural imagination, Reyner Banham reflected that "In a landscape where nothing officially exists (otherwise it would not be 'desert'), absolutely anything becomes thinkable, and may consequently happen."[11] Where there is nothing—or rather, where we imagine there is nothing—everything appears possible.

4. Vacuum

The legal version of this idea, *terra nullius*, is derived from the Roman legal concept of *res nullius*, or, literally, "thing of nothing." Historically, this precept allowed men, animals, and objects seen to be without an owner—abandoned slaves, buildings, and livestock— to be claimed by discovery and use. *Terra nullius* was a concept developed by direct analogy and applied to the occupation of territory. In English law, the idea has its origins as well in what was termed *vacuum domicilium*: literally, a "vacuum home." By the end of the nineteenth century, the term was in common use as a shorthand for the legal principles underlying European occupation of colonial land.[12]

This legal rationale for colonization and occupation of the New World was initially not deemed necessary. The preface to Richard

10 For a larger exposition of this universal definition of "space," see Nicholas de Monchaux, *Spacesuit: Fashioning Apollo* (Cambridge, MA: MIT Press, 2011), 12–26.

11 P. Reyner Banham, *Scenes in America Deserta* (Salt Lake City: Gibbs M. Smith, 1982), 44.

12 Lauren Benton and Benjamin Straumann, "Acquiring Empire by Law: From Roman Doctrine to Early Modern European Practice," *Law and History Review* 28, no. 1 (February 2010): 1–38.

Hakluyt's 1582 *Divers voyages touching the discovery of America and the islands adjacent*, addressed to Henry VIII, speaks of "Godley rationale for riches and taking lands and things."[13] "The ends of this voyage are these," Hakluyt concluded, "1. To Plant Christian religion. 2. To trafficke. 3. To conquer. Or to doe all three."[14]

By 1630, however, John Winthrop, Founder of the Massachusetts Bay Colony, would invoke not just power as a rationale for colonial settlement, but also principle. "Being thus taken and possessed as *vacuum domicilium*," he would proclaim of the territories outside his original royal grant, "gives us a sufficient title against all men."[15] For Winthrop, as in part for John Locke writing at the end of the same century, territorial rights, and so citizenship, were grounded not in simple occupation or use of the land, but in the "improvement" of it by permanent (European) structures.[16] "We claimed Winicowett as within our patent or as *vacuum domicilium*," Winthrop writes in March 1639 (of what is now Hampton, Massachusetts), "and had taken possession thereof by building an house there above two years since"[17] To this end, early maps of the colony took care to depict the

13 Hakluyt Society, *Original Writings and Correspondence of the Two Richard Hakluyts*, 2 vols., second series, 76–77, ed. E.G.R. Taylor (London: The Hakluyt Society, 1935), I, 178.

14 Ibid., 331.

15 John Winthrop, quoted by David Grayson Allen, "*Vacuum Domicilium*: The Social and Cultural Landscape of Seventeenth-Century New England," in *New England Begins: The Seventeenth Century*, Vol 1, eds. Jonathan L. Fairbanks and Robert F. Trent (Boston: Museum of Fine Arts, 1982).

16 Ironically, while Locke recounts the principle of ownership through improvement in his *Second Treatise on Government* of 1790, his intent was as much to emphasize the sovereign right of English citizens over lands under their improvement as it was to provide any rationale for colonial expropriation. See Paul Corcoran, "John Locke on the Possession of Land: Native Title vs. the 'Principle of Vacuum Domicilium,'" *Proceedings*, Australasian Political Studies Association Annual Conference, (Melbourne: Monash University, September 2007).

17 Richard S. Dunn and Laetitia Yeandle, eds., *The Journal of John Winthrop, 1630–1649* (Cambridge, MA: Harvard University Press, 1996) 283.

structures of colonial settlements, while omitting the dwellings of native peoples in their separate villages in favor of only trees.[18] Yet in the legal and administrative records of the American colonies, there was recognition of native sovereignty as well. The Governor of New Haven, Connecticut, for example, wrote in 1647 to the Dutch administrator of New Amsterdam, rejecting his claim to Connecticut lands: "we first came into these partes, & vppon due purchase from the Indians, who were the true proprietours of the land (for we fownd it not a vacuum)."[19]

5. Incognita

When Captain James Cook set out from England in 1768, it was with the charter to seek out the postulated *Terra Australis Incognita* or "unknown southern land." On becoming the first European to land on the east coast of Australia (named Botany Bay for the diversity of its alien-seeming plants), he termed the vast continent *Terra Australis*.[20] Unlike the experience of the United States, Australia was a landscape where throughout the nineteenth and most of the twentieth century, no native sovereignty was recognized.

On his second voyage of 1772–75, Captain Cook would resume his search for a second uncharted southern continent, still imagined to exist alongside the first. On this journey, he made the first recorded crossing of the Antarctic circle in 1773, and sailed the following southern summer to the edge of its

18 Lawrence J. Vale, *From the Puritans to the Projects: Public Housing and Public Neighbors* (Cambridge, MA: Harvard University Press, 2009), 23.

19 James Warren Springer, "American Indians and the Law of Real Property in Colonial New England," *The American Journal of Legal History* 30, no. 1 (January 1986): 56.

20 The Dutch had landed on the north coast of what they called New Holland as early as 1606. It was officially named "Australia" by its British occupiers in 1830, a half-century after the establishment of the first penal colony at Sydney in 1783.

ice-shelf. Reaching 71°10' south on January 30, 1774, and facing a solid cliff of ice while surrounded by dangerous floes, Cook recorded in his journal, "I who had ambition not only to go farther than anyone had been before, but as far as it was possible for man to go, was not sorry in meeting with this interruption."[21]

6. Terra Nova

The physical exploration of Antarctica would await the late nineteenth and early twentieth centuries. It would culminate with the 1911 race to the pole between Roald Amundsen's Norwegians and the ill-fated party of Robert Scott, whose expedition was named for its supply ship, the *Terra Nova*. In his harsh recounting of their polar odyssey, *The Worst Journey in the World*, Scott's most junior surviving lieutenant, Aspley Cherry-Garrard, concluded, "Even now the Antarctic is to the rest of the earth as the Abode of the Gods was to the ancient Chaldees."[22]

Both despite and because of the new expeditions onto its vast surface, the legal and territorial status of Antarctica was uncertain. Overlapping claims were made on almost all of her territory by Argentina, Chile, Great Britain, New Zealand and Australia, France, and Norway. The US, while not making a territorial claim, reserved its right to do so by establishing multiple bases on the Antarctic coastline. In 1956, a party led by US Navy Rear Admiral George J. Dufek was the first to stand on the geographic south pole since Amundsen and Scott in 1911, having arrived by air in a modified Douglas Aircraft DC-3 named *Que Sera, Sera*.

In that same decade, conflicting national claims on Antarctica

21 Logbook of Lieut. James Cook (1770), The British Library, Add Ms 27885, f. 55.

22 Apsley Cherry-Garrard, *The Worst Journey in The World: Antarctica, 1910-1913* (Toronto: Penguin Classics, 2006), 49.

moved towards open conflict.[23]
The legal resolution of national
claims on the continent, and
its enduring designation as *terra
nullius*—free of sovereignty
and citizenship—would emerge,
not incidentally, alongside a
similar legal order for the entire
non-terrestrial (i.e. "celestial")
cosmos.[24] This grand new legal
order was the result of an informal
dinner party held in a compact
suburban home at 1105 Meurilee
Lane, Silver Spring, Maryland, on
the evening of Wednesday, April 5,
1950.[25] The result would also
make much of our modern world,
not least the contemporary surveil-
lance of Pine Gap, possible (and
perhaps, inevitable).

23 Klaus Dodds, Alan
D. Hemmings, and Peder
Roberts. *Handbook on
the Politics of Antarctica*
(London: Edward Elgar,
2017).

24 Roger Launius,
"Establishing Open Rights
in the Antarctic and
Outer Space: Cold War
Rivalries and Geopolitics
in the 1950s and 1960s," in
Dodds et al., 217–231. I am
grateful to Dr. Launius,
as ever, for drawing my
attention to this text and
these larger connections.

25 R. Bulkeley, "Origins
of the International
Geophysical Year," in S.
Barr and C. Luedecke,
eds., *The History of the
International Polar Years
(IPYs): From Pole to Pole*
(Berlin/Heidelberg:
Springer, 2010), 235–38.

Commander William "Trigger" Hawkes interviews Admiral George Dufek at the
South Pole.

7. IGY

The dinner was an impromptu celebration at the home of physicist James Van Allen and his wife, mathematician Abigail Halsey Van Allen. The occasion was a visit from Britain by Sydney Chapman. Merle Tuve, Lloyd Berkner, Harry Vestine, Wallace Joyce, and Fred Singer joined the party.[26] Save Tuve, Vestine, and Abigail Van Allen, all the guests were in the direct or indirect employ of the US government, and almost all were experts in high-altitude physics. The cause for celebration was the first measurements taken of the earth's magnetic field at altitudes of 100 kilometers by Aerobee sounding rockets off the coast of Peru. To the scientists' delight, the launch showed credible evidence of what had been a previously theorized jet of charged particles racing into the Earth's upper atmosphere from the magnetic equator.[27]

It is illustrative of both the intimate scale of the postwar scientific community and the influence it had forged for itself in the fires of wartime science that an idea hatched by the group on the tails of this discovery and end of the dinner party, ("while sipping brandy,") would quickly become global scientific and diplomatic policy.[28] Credited to Berkner, with contributions from Abigail Van Allen and Chapman, the idea was for a third, coordinated year of polar scientific research to follow that which was undertaken in the Arctic in 1882–83, and in the Antarctic in 1932–33. Before the "year" took place (actually timed from July 1957 to December 1958, to coordinate with the cycle of highest sunspot activity) it was expanded in both name and ambition. The INTERNATIONAL GEOPHYSICAL YEAR would combine coordinated measurements of geophysical

26 Ibid.

27 James A. Van Allen (1983), "Genesis of the International Geophysical Year," EOS 64(50): 977–977, doi:10.1029/EO064i050p00977-01

28 Ibid.

phenomena at the poles and along four lines of longitude with measurements in the upper atmosphere—and ultimately beyond.[29] Not only would the measurements involve ballistic "sounding" rockets such as the Aerobee, but they were planned from the outset to involve rockets launched so far and fast that their payloads would keep, continually, falling around the earth, and constantly examining it from above. These were to be the first manmade satellites.

8. Infinite Sovereignty

The Aerobee rockets were conceived of as an inexpensive substitute for captured Nazi V-2 rockets, which James Van Allen had started launching for scientific measurement above the deserts landscape of White Sands on April 16, 1945.[30] By 1955, both the Soviet Union and the United States were racing to expand the range and power of such missiles to allow nuclear weapons to be genocidally hurled across the globe. With their massive engines, such "intercontinental" missiles, their makers understood, would also allow the launch of large, photographic surveillance satellites, by which means the US could freely photograph the vast, otherwise inaccessible landscape of the Soviet Union's interior.[31]

This second objective provoked a legal and strategic debate within the Eisenhower administration, around the unsettled question of sovereignty as it extended beyond the earth. Long tradition allowed a nation to fire upon and capture a foreign vessel in its adjacent waters.

29 Barr and Luedecke, *History of the International Polar Years.*

30 Walter Sullivan, "James A. Van Allen, Discoverer of Earth-Circling Radiation Belts, Is Dead at 91," *New York Times,* Aug 10, 2006, C14.

31 Until the 1980s, satellite surveillance photography still used physical film, which necessitated complex airborne rescue missions of the returning celluloid in protective capsules. See Pat Norris, *Spies in the Sky. Surveillance Satellites in War and Peace* (Berlin: Springer Praxis Books, 2008).

This legal notion had been more recently extended
to the near-boundless air above (and would support,
for example, the assault on Francis Gary Powers'
U-2 spyplane in 1960). But how high did, or should,
sovereignty extend? The debate raged. Many advocated
the notion of "free flight," allowing satellites in space
to legally transgress national boundaries on the globe
below. But there was also official support for the
opposite position—the infinite extension of sovereign
space, expanding in crenellated cones of citizenship,
across the universe.[32]

At an influential summit in Geneva in 1955,
Nikita Khrushchev expressed preference for the latter
position when pressed by Eisenhower into consider-
ing the former.[33] But the Soviet Union's subsequent
actions would settle the question otherwise. As had
been long-planned part of International Geophysical
Year activities (including detailed
discussions at scientific conferences
leading up to the IGY), the Soviet
Union launched the first earth-or-
biting satellite on October 4, 1957.
The effect on the global imagination
was unprecedented, and unex-
pected. (The first publication of the
feat in *Pravda* placed the successful
launch below the front page's fold;
only subsequent international
attention brought a banner headline
on October 9.[34]) Marking the pis-
tol-start of the space race, Sputnik
also effectively established the prin-
ciple of free flight for all subsequent
satellites—leading some to even
(incorrectly) surmise that the US
had allowed itself to be beaten.

32 See Launius,
ibid; also *The Report
to the President by the
Technological Capabilities
Panel of the Science Advisory
Committee, Vol. II, Meeting
the Threat of Surprise
Attack* (Washington,
DC, February 14, 1955),
151. Office of the Special
Assistant for National
Security Affairs, NSC
Policy Papers, Box
16, Folder NSC 5522,
Technological Capabilities
Panel, Eisenhower
Presidential Library.

33 Howard Jones,
*Crucible of Power: A
History of American
Foreign Relations from
1945* (Lanham: Rowman
& Littlefield Publishers,
2009), 80.

34 Siddiqui, 168.

While the Soviet Union had organized its entire rocket program as a centralized military enterprise with one, robust rocket design developed from captured Nazi hardware by "chief designer" Sergei Korolev, the United States was home to multiple, competing rocket programs. The Eisenhower administration had deliberately chosen the least developed of these rocket systems—a largely civilian effort named Vanguard—to launch the United States' own satellite planned for the IGY, Explorer 1. For Eisenhower and his staff, the decision to use the civilian Vanguard rocket over multiple military alternatives was an important statement of principle in light of the IGY's public and scientific nature. But the decision to join the Soviets in planning a satellite launch for the IGY was also made for military and strategic reasons—the idea being that a self-evidently civilian US satellite could best establish the principle of free flight on which later surveillance efforts would depend. After the unexpected propaganda victory of Sputnik, the US raced to get its own (now clearly competing) satellite in orbit as fast as possible. After a series of failed launch attempts, the administration would sideline

William Pickering, James Van Allen, and Wernher von Braun holding a replica of the Explorer 1 Satellite after its successful launch.

the Vanguard rocket in favor of Juno—the latest variant of the Nazi V-2 rocket that was being developed at the time by rehabilitated Nazi Von Braun for the US Army.[35] Unlike Sputnik, however (which only contained instruments to record temperature and pressure in its own interior), the Explorer satellites, would contain scientific experiments to observe space directly for the first time, built under the direction of James Van Allen.[36]

The establishment of non-terrestrial space as an extra-terrestrial *terra nullius*—where sovereignty is confined to vessels, and where any may pass freely—was established *de facto* by the activities of the International Geophysical Year, and *de jure* by one of the last, indirect results of its administration: the "Treaty on the Principles Governing the Activities of States in the Exploration and Use of Outer Space, including the Moon and other Celestial Bodies," signed in 1967.

9. Mabo

The reality of postwar, post-colonial cold-war politics is inextricable from the "space race" that followed the IGY.[37] The public-relations realities of cold-war politics were also the precipitating reason for the gradual recognition of Aboriginal rights in Australia. The most globally recognizable of countless sacred landscapes for Australia's native people being Uluru, a massive

[35] Walter A. McDougall, *The Heavens and the Earth: A Political History of the Space Age* (Baltimore, MD: Johns Hopkins University Press, 1997) 112–32.

[36] Unlike Explorer and subsequent US satellites, which used transistor electronics, Sputnik had a pressurized atmosphere, the main purpose of which was to prevent damage to the vacuum tubes that constituted its electronic equipment. As the vacuum of space was inevitably more empty than the vacuum achieved by Russian tube-making machinery, the Soviet "vacuum" tubes would otherwise have exploded. See M. K. Tikhonravov, "The Creation of the First Artificial Earth Satellite: Some Historical Details," first presented in Russian at the 24th International Astronautical Congress at Baku, Azerbaijan (then part of the Soviet Union); translated in 1994 by Peter A. Ryan and published in the *Journal of the British Interplanetary Society* 47 (1994): 191–94.

[37] McDougall, 56

sandstone formation lying just a few hundred kilometers from Pine Gap in the same sparsely-settled corner of Australia's vast Northern Territory. In slow stages from 1948 to 1967, citizenship rights for indigenous Australians were extended, culminating in a nationwide referendum in 1967 that extended Aboriginal rights to that of full citizenship, including access to state pensions and inclusion in the national census.[38] It had only been in 1962 and 1965 that Aboriginal people had gained the right to vote in state elections in Queensland and Western Australia respectively,

Eddie Mabo.

38 On May 27, 1967, 90 percent of Australians approved a referendum on the question "Do you approve the proposed law for the alteration of the Constitution entitled—'An Act to alter the Constitution so as to omit certain words relating to the People of the Aboriginal Race in any State and so that Aboriginals are to be counted in reckoning the Population'?" Since Australia was administered as six separate colonies until Federation under the Australian Constitution in 1901, a variety of regimes had governed Aboriginal citizenship until that time in the separate states, most restrictively in Queensland and Western Australia, which had the largest number of Aboriginal residents—the section of the constitution in question was designed so that these numbers did not inflate their parliamentary representation—and in the Northern Territories, which remained under federal control. Aboriginal Australians had, technically, the right to vote in all federal elections from 1948; however this was optional and only became mandatory, as for all other Australians, in 1983. It is a popular misconception that the 1967 referendum established the Aboriginal right to vote; however it was undeniably an instrumental and essential step toward full citizenship rights.

and as late as 1957, all indigenous Australians in the Northern Territory had been declared "wards of the state" and denied the vote.[39]

A fuller verdict would await the 1992 landmark Australian High Court ruling *Mabo v. Queensland (No 2)*, commonly known as Mabo.[40] Ruling in favor of a group of indigenous Torres Strait Islanders led by Eddie Mabo, and against the government of Queensland, the decision established native sovereignty in Australia for the first time. The text of the ruling dwells extensively on the notion of *terra nullius* as it was developed for colonial purposes in the nineteenth century, and its use as justification first for the partition of Africa, and also across a range of cases against native land claims in Australia. The decision takes particular pains to point out that, in Africa as in Australia, the existence of ecological deserts cannot be used to justify the imagining of legal, political, and social deserts overlaying them. The conflation of ecological "desert" and legal *terra nullius* is addressed directly: "Even the proposition that land which is not in regular occupation may be *terra nullius*," the judgment finds, "is one that demands scrutiny; there may be good reason why occupation is irregular."

"The fiction by which the rights and interests of indigenous inhabitants in land were treated as non-existent," the ruling concludes, "was justified by a policy which has no place in the contemporary law of this country ... The lands of this continent were not *terra nullius*."[41]

10. *Ions*

Today, expeditions to the Moon and Mars are presented anew to the

39 See Australian Electoral Commission "Electoral Milestones for Indigenous Australians," http://www.aec.gov.au/ indigenous/milestones. htm, permalink: https:// web.archive.org/ web/20171218050038/ http://www.aec.gov.au/ indigenous/milestones. htm.

40 High Court of Australia, Mabo v. Queensland (No 2) [1992] HCA 23; (1992) 175 CLR 1 (June 3, 1992).

41 Ibid., sections 48 and 56.

public imagination. Instead of the struggle of the cold war, however, the *raisons d'etre* are the transnational ambitions of today's technological superpowers. But for Amazon's Jeff Bezos (Blue Horizon) or PayPal and Tesla's Elon Musk (SpaceX), the Moon and Mars offer a surface identical to that appropriated by the twentieth-century's more traditional empires; a canvas on which to project the promise and power of their own earthly mastery. "You want to wake up in the morning," Musk announces on the opening page of SpaceX's Mars website, "and think the future is going to be great."[42]

The interplanetary space these plans consider is currently devoid of long-term human occupation, but not empty. One profound and particular problem that would plague any human outpost relates to outer space's hostile ecology of electromagnetism. More specifically, it highlights the remarkable, invisible envelopes to the earth discovered by James Van Allen using measurements from Explorer 1 and its follow-on Explorer 3 and subsequently named in his honor.[43]

The Van Allen belts extend from 500 to 58,000 kilometers above the earth's surface. They consist of charged particles of solar wind trapped by the earth's magnetic field. While hazardous to geostationary satellites (which orbit at nearly 36,000 kilometers), the belt's charged particles deflect interplanetary radiation and the that from the sun, and prevent both from reaching—and effecting—the earth and its inhabitants. Without Van Allen belts, the atmosphere we breathe would have long since been stripped away from the planet.[44] And it is only thanks to them that all humans, including long-term

42 http://www.spacex.com/mars, accessed December 10, 2017, perma-link: https://web.archive.org/web/20171218065212/http://www.spacex.com/mars.

43 Explorer 2 did not successfully launch due to the failure of its Jupiter rocket.

44 James A. Van Allen, *Origins of Magnetospheric Physics* (Iowa City: University of Iowa Press, 2004).

residents of the International Space Station (orbiting at an average altitude of 253 miles above Earth), are protected from a constant barrage of potentially lethal radiation.[45] We are fortunate, too, that the earth's magnetic field generally aligns with our planet's axis, meaning that these magnetic fields are thinnest in our relatively desolate polar regions. *Aurora Borealis* and *Australis* are the result: an endless cascade of cosmic contamination.

ii. *Fooled*

A 2016 medical paper outlined the effect of this ocean of invisible radiation on its only human sailors—the astronauts of Apollo's missions 10 through 17, each of which spent between six and twelve days beyond the Van Allen belts.[46] The study examined a single indicator of health—mortality due to cardiovascular disease—and found that Apollo's extra-planetary astronauts were more than four times as likely to die of cardiovascular disease than their equally fit low-orbit compatriots, and more than twice as likely to die of cardiovascular disease than the American population at large.[47] A manned journey to Mars would involve many times more exposure to cosmic radiation and solar wind, and each doubling of spacecraft shielding—a prohibitive exercise itself given the physics of

[45] Even then, space station astronauts are instructed to shelter in the thickest portions of the station during active periods of solar storms. See Nola Taylor Redd, "Radiation Remains a Problem for Any Mission to Mars" *Smithsonian. com*, May 17, 2016, https:// www.smithsonianmag. com/science-nature/ radiation-remains-problem-any-mission-mars-180959092/, accessed Dec 10, 2017; and Tony C. Slaba, Christopher J. Mertens, and Steve R. Blattnig, *Radiation Shielding Optimization on Mars*, 2013, <http://purl.fdlp.gov/ GPO/gp045816>.

[46] M. D. Delp et al., "Apollo Lunar Astronauts Show Higher Cardiovascular Disease Mortality: Possible Deep Space Radiation Effects on the Vascular Endothelium." *Sci. Rep.* 6 (2016) doi: 10.1038/ srep29901.

[47] Ibid. It is theorized that the solar wind, interacting with the lightweight aluminum, of which spacecraft substantially consist, produced charged particles particularly destructive to DNA and cellular reproduction of fragile cardiovascular membranes.

spaceflight—would reduce this risk by only 10 percent.[48]
A 2016 *Smithsonian* article dryly concluded, "Engineers have yet to find ways to protect astronauts from cosmic rays and solar radiation."[49]

Outer space indelibly remains the surface on which we shadow our aspirations and ambitions for our technological future. Yet it is also our technology's most unforgiving gauntlet. As Richard Feynmann concluded his personal Appendix to the official report on the 1986 destruction of the spacecraft *Challenger*; "For a successful technology, reality must take precedence over public relations, for nature cannot be fooled."[50]

12. Ashes

Thanks to the legal framework of 1967's Outer Space Treaty, when Apollo 11 landed on the lunar surface and its astronauts erected the American flag, they did so not as an expression of permanent sovereignty, but as a deliberately staged performance of the origin of their own, momentary occupation. It remains the case that the entire, multi-billion-dollar exploit of Apollo can best be understood as a vast machine for the creation of a single image; that of an American, and American flag, on the surface of the moon.[51]

The three-by-five-foot nylon flag so highlighted was obtained from a government supply catalog

48 Slaba, ibid.

49 Redd, ibid.

50 Richard F. Feynmann, "Personal Observations on the Reliability of the Shuttle," *Report of the Presidential Commission on the Space Shuttle Challenger Accident*, Volume 2, Appendix F (Washington, DC: US Government Printing Office, 1986): https://science.ksc.nasa.gov/shuttle/missions/51-l/docs/rogers-commission/Appendix-F.txt.

51 The NASA-convened Committee on Symbolic Activities for the First Lunar Landing, gathered in February of 1969 and briefly considered the use of a United Nations Flag, but its own mission statement charged it with envisioning activities to "signalize the first lunar landing as an historic forward step of all mankind that has been accomplished by the United States." Anne M. Platoff, "Where No Flag Has Gone Before: Political and Technical Aspects of Placing a Flag on the Moon," *NASA Contractor Report 188251*, August 1993.

and altered only by the addition of a hem across the top,
to hold the crossbar allowing the flag to unfurl in the
absence of all but the cosmic wind.[52] Yet in describing
the final flight of the Lunar Module's iconic, angular
ascent stage, pilot Edwin E. "Buzz" Aldrin remembered:
"There was no time to sight-see. I was concentrating
intently on the computers, and Neil was studying the
attitude indicator, but I looked up long enough to see
the flag fall over."[53] And even if it was still standing,
subjected to decades of unfiltered radiation and
solar wind, the mass-market pigments on the nylon
surface have undoubtedly eroded to oblivion. Dennis

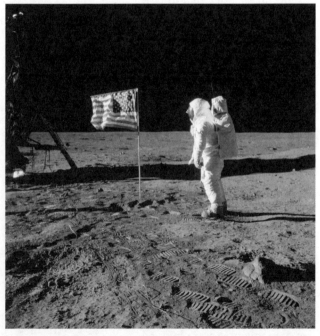

Buzz Aldrin salutes the flag on the Moon's surface, Apollo 11 mission time: 110:10:33.
(Aldrin's fingertips can be seen on the far side of his helmet.)

Lacarrubba, whose New Jersey based flagmaker, Annin, likely sold the flag in question for $5.50, considered in 2008 the effect of thirty-nine years of UV light on even an earthbound flag: "I gotta be honest with you," he reported; "It's gonna be ashes."[54] If any surface remains, it is only as a fallen, dusty square of white.[55]

13. Conclusion

In 1966, ex-army-parachutist and countercultural entrepreneur Stewart Brand drove from a barely-formed Silicon Valley to the political hotbed of Berkeley. Standing under the arches of Sather Gate, he sold white buttons to the thronging students, bearing a simple message in black text. "Why," the button asked, "haven't we seen a picture of the whole Earth yet?" It was Brand's paranoid-yet-credible thesis that, five years into manned spaceflight, and a decade from the first satellites of the International Geophysical Year, a picture of the undivided disk of the Earth was being deliberately withheld from the global public by the US government. In the presence of such a photograph, Brand believed, national and political identity would crumble in the face of our common citizenship of an undivided globe.

As with much in the military-industrial realm, what was seen

52 Ibid.

53 Col. Edwin E. "Buzz" Aldrin, Jr. with Wayne Warga, *Return to Earth* (New York: Random House, 1973), 239. Recent evidence from the Lunar Reconnaissance Orbiter suggests other flags on the moon, or at least their staffs, may still be standing, but suggests confirmation of Aldrin's report of the Apollo 11 site. See Mark Robinson, "Question Answered!" July 27, 2012, website of the Lunar Reconnaissance Orbiter Camera, Arizona State University: http://lroc.sese.asu.edu/posts/537, accessed December 10, 2017, permalink https://web.archive.org/web/20171218061553/http://lroc.sese.asu.edu/posts/537.

54 Tony Reichart, "Finding Apollo," *Air & Space Magazine*, September 2008.

55 Paul D. Spudis, "Faded Flags on the Moon," *Air & Space Magazine*, July 2011; also James Fincannon, "Six Flags on the Moon: What is Their Current Condition?" *Apollo Lunar Surface Journal*, 21 April 2012, https://www.hq.nasa.gov/alsj/ApolloFlags-Condition.html, accessed December 10, 2017, permalink https://web.archive.org/web/20171218064548/https://www.hq.nasa.gov/alsj/ApolloFlags-Condition.html.

as strategy was in fact a tangle of administration and circumstance. Even back then, most cameras sent into space justified their cost through surveillance, and were thus designed, like the satellites controlled from Pine Gap, to magnify the smallest pieces of the globe instead of inspecting it entire. While a composite image from an earth-surveilling satellite, ATS-3, was released in 1967 (and used by Brand for the cover of the first *Whole Earth Catalog*), the first true photograph of the whole earth would await the sunset of Apollo.

This was not seen as initially possible. The Apollo missions, arcing far beyond the earth's surface, were scheduled while the moon was half, or quarter full, the better to throw the dangerous features of potential landing sites into relief on its earthward face. Earth and moon are illuminated, of course, by the same light source, and so when the moon is obscured from the earth, so the earth from the moon. It was only in December of 1972 that increasing mission experience, and lobbying by Senator Gaylor Nelson (who had penned legislation declaring the Earth Day originally proposed by ecologist John McConnell two years earlier), produced the opportunity for such an image. The command module of Apollo 17, *America*, undertook a modified trajectory that allowed the capture—immortally—of the full and illuminated disk of the earth.

The photograph, NASA Image AS17-148-22727, was taken by Harrison Schmitt, the last man, and only civilian, to walk on the moon, using used a 70-millimeter Hasselblad camera with an 80-millimeter Zeiss lens. It is now the most reproduced in history, and quickly replaced a screen-printed version of the ATS-3 image on John McConnell's Earth Day flag.

Appropriately, the only continents it features prominently are Africa—that which empire and mapmakers both have most mistreated, and Antarctica—the

only real *terra nullius*. And yet, like the imperially colored maps to which, in Brand's eyes, it stood as an indictment, it tells its own lies. Massive and solid, the vast sphere of earth is not in fact our home. Indeed, the earth's interior of molten, radioactive magma is as inhospitable to us as outer space. Instead, our natural habitat is a thin curtain of gases—the atmosphere— invisibly clinging to the vast sphere's surface. This is a small place; if this air-ocean's molecules were liquid water instead of gas, it would extend only a few dozen feet above our heads. Which is also why the outpouring of gaseous carbon dioxide—our industrial civilization's most ubiquitous product—has transformed it so much. The result is the ultimate indictment of sovereignty as well. Molecules of air belong to no one, and everyone. They have sustained—even the many millions inside you now—almost everyone who has ever lived, and, we hope, countless more to come. And thanks to the air's

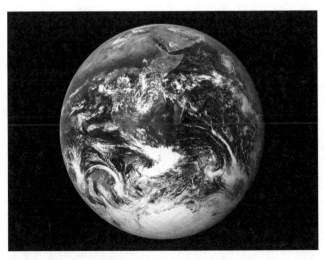

NASA image AS17-148-22727, taken by Harrison Schmitt.

disregard for borders, the calamitous effects of climate change fall most on those nations who have least contributed to it, in the tropics and global south.

In the end, what the detailed modern surveillance of Pine Gap misses is, most profoundly, the scale of the planet and cosmos that it seeks to command. Instantaneous and impossibly detailed, bereft of all but the narrowest gaze, the informational artifacts of today's surveillance state deploy cosmically-scaled infrastructure to serve a profoundly limited vision of our global future: not knowledge, but data. This stands in stark contrast with the outlook of indigenous Australians (including the native Arrente people on whose ancestral land Pine Gap sits), whose civilization existed continuously for 40,000 years alongside the hostile Australian ecology before its devastation by European arrival.[56]

Conflating the accelerating rate of technological change on earth with a mastery of (outer) space defined by technology's use, today's renderings of extra-planetary settlement risk the same myopic gaze. Most of all, we imagine new planetary homes as an escape from the consequences of inhabitation on our current one, and assume that the mastery of a profoundly more hostile planet will save us from our failure to master our assumptions here on earth.[57]

In searching for a justification, that would match the suffering of his and his party's journey into the unknown a century ago, Antarctic pioneer Aspley Cherry-Garrard

[56] Morton Rasmussen et al., "An Aboriginal Australian Genome Reveals Separate Human Dispersals into Asia" *Science* 22 (September 2011) doi: 10.1126/science.1211177.

[57] Musk himself has referred to his Mars schemes as a "backup drive for civilization." Chris Heath, "How Elon Musk Plans on Reinventing the World (and Mars)," *GQ Magazine*, December 2015, permalink https://web.archive.org/web/20180122114219/ https://www.gq.com/story/elon-musk-mars-spacex-tesla-interview?current-Page=all

[58] Cherry-Garrard, *The Worst Journey in the World*, 49.

concludes as follows: "[our goals] were striven for in order that the world may have a little more knowledge, that it may build on what it knows instead of on what it thinks."[58] The most essential legacy of our exploration of the cosmos is likely this perspective on our own, and only, Earth.

TRANSIT SCREENING LOUNGE

A waystation under the US Pavilion rotunda, the Transit Screening Lounge presents a suite of film and video works that raise questions of citizenship through a lens of movement: migration, transgression, transmission, currents, and flows. It investigates the in-between spaces of citizenship— territories of belonging, measured not in inches or acres but in rideshare apps and satellite orbits, rising tides and frequent-flier miles.

Named, in part, for the ubiquitous waiting rooms of international air travel that, with their junkspace aesthetics, govern and regulate millions of bodies in motion. The Transit Screening Lounge features a diverse collection of works that share common ambiguities: blurred boundaries, hidden itineraries, strange passages, gray areas, and alternate histories.

The works in the Transit Screening Lounge elude the specificity of scale and measurement. They neither document the number of migrants in camps and ICE deportees nor sum up US incarceration and urban homelessness rates. Instead, they are distinguished by the way they tell stories through narratives of time and space. This curatorial turn away from didactic or disciplinary messages is founded upon the conviction that imagination and speculation reflect upon experiences and territories that are often difficult to delineate through

traditional architectural means. Modes of citizenship are implied but never directly articulated, gestured toward but never fully captured. Yet each evokes critical conditions formed through brutal political economies of expulsion, deliberate acts of subversion, or collective imagination. Immigrant, outsider, flâneur, fugitive—identities that encapsulate the constant negotiation between these ceaselessly moving bodies and the boundaries that would define them; subjects that refuse to acquiesce to the structural logics of sovereignty.

FRANCES BODOMO
2014

It's July 16, 1969, and the United States is preparing to launch Apollo 11. Thousands of miles away, the Zambia Space Academy is hoping to beat America to the moon. Inspired by true events.

Borrowing the biblical title, *Exodus* addresses the mass flight of people across the world in the wake of war, poverty, and social injustice. Through images of luggage adrift at sea, the video evokes the sense of being uprooted, losing one's identity, and having to fight for one's integrity.

DARK FIBER

DAVID RUETER AND
MARISSA LEE BENEDICT
2015

Tunneling through commercial and industrial fiber-optic networks and traveling in their shadows, *Dark Fiber* follows the course of a single cable, pushing against conventional representations of networks and logistics. The video's montage sequences depict movement between systems and scales as seen in vast landscapes, industrial infrastructure, media apparatuses, art venues, domestic spaces, and imagined worlds.

COSMIC GENERATOR

MIKA ROTTENBERG
2017

Cosmic Generator explores a kaleidoscopic world in which the United States and Mexico are linked by a secret system of tunnels that enable trade among various places and actors. The tunnels lead from the Golden Dragon Restaurant in Mexicali, Mexico, to a 99 Cents Only Store in Calexico, California, each linked to an enormous plastic commodities market in Yiwu, China, in this imaginary network.

WHERE THE CITY CAN'T SEE

LIAM YOUNG
2016

Where the City Can't See is the first narrative fiction film shot entirely with the laser scanning technology used in self-driving vehicle navigation. In a Chinese-owned and controlled Detroit Economic Zone, a group of young auto workers drifts around in a driverless taxi searching for a place they know exists but that their car doesn't recognize. They are part of an underground community in which people adorn themselves in machine-vision camouflage and anti-facial recognition masks to enact escapist fantasies in the city's hidden spaces.

BIOGRAPHIES

**Amanda Williams and
Andres L. Hernandez**

Amanda Williams and Andres L. Hernandez were collaborators on *A Way, Away (Listen While I Say)*, a 2017 design-build commission of the Pulitzer Arts Foundation and the Sam Fox School of Design & Visual Arts at Washington University in St. Louis. They also both serve as members of the exhibition design team for the Obama Presidential Center (Chicago, IL).

Amanda Williams, a visual artist who trained as an architect, lives and works on Chicago's South Side. Her practice often blurs the distinction between art and architecture, and highlights the complexities of the politics of race, place, and value in cities. She is best known for her series, "Color(ed) Theory," in which she painted exteriors of soon-to-be-demolished houses using a culturally charged color palette to mark the pervasiveness of vacancy and blight in black urban communities. Trained as an architect at Cornell University, she is a 2018 USA Ford Fellow, the recipient of a 2017 Joan Mitchell Foundation painting and sculpture grant, an Efroymson Contemporary Arts Fellow, and a 3Arts awardee. She recently had two exhibitions on view at the Museum of Contemporary Art in Chicago and the Art Institute of Chicago. Williams, a Visiting Professor at Cornell University in 2018, frequently lectures on art and design in the public realm.

Through his independent studio-based practice and community-based work with youth and adults, artist, designer, and educator Andres L. Hernandez reimagines the environments we inhabit and explores the potential of spaces for public dialogue and social action. Hernandez is co-founder of the Revival Arts Collective, and founder and director of the Urban Vacancy Research Initiative.

He received a Bachelor of Architecture degree from Cornell University and a Master of Arts from the School of the Art Institute of Chicago, where he is currently Associate Professor in the Department of Art Education. He is also on the faculty of the Graduate Studies program in Art & Design Education at Vermont College of Fine Arts, and was recently a Visiting Assistant Professor in the Graduate School of Architecture & Urban Design at Washington University.

Niall Atkinson

Niall Atkinson is Associate Professor of Architectural History in the Department of Art History at the University of Chicago. He is the author of *The Noisy Renaissance: Sound, Architecture, and Florentine Urban Life* (Penn State University Press, 2016), an excavation of the historical meaning of sound and construction of urban space in Renaissance Florence. His research focuses the experience of space and the reception of architecture in early modern Europe, which has led to several collaborative projects involving the digital reconstruction of the social life and spatial context of Florence in the fifteenth century. His articles have appeared in *I Tatti: Studies in the Italian Renaissance*, *Grey Room*, and *Senses & Society*. His investigation of "Wandering in Rome in the Enlightenment," co-written Susanna Caviglia, is forthcoming in *Word & Image*.

Nick Axel

Nick Axel is an architect, theorist, and editor based in Amsterdam. He is currently Deputy Editor of e-flux architecture. Previously, he was Managing Editor of *Volume* magazine, a researcher at Forensic Architecture, and a resident at DAAR (Decolonizing Architecture Art Residency). Nick studied at the Centre for Research Architecture, Goldsmiths, London,

where he investigated the legal and spatial deregulation of hydraulic fracturing in the United States. Nick has led courses in architecture, theory, and design at Strelka Institute, Design Academy Eindhoven, Royal Academy of Art, The Hague, Bauhaus-Universität Weimar, and The Bartlett School of Architecture.

Adrienne Brown

Adrienne Brown is Associate Professor of English at the University of Chicago. She is the author of two books: *Race and Real Estate* (Oxford, 2015), a volume of essays co-edited with Valerie Smith, and *The Black Skyscraper: Architecture and the Perception of Race* (Johns Hopkins, 2017).

Bill Brown

Bill Brown is Karla Scherer Distinguished Service Professor in American Culture at the University of Chicago. He teaches in the Department of English, the Department of Visual Arts, the Chicago Center for Contemporary Theory, and the College, and he currently serves as the Senior Arts Advisor to the Provost. His books include *The Material Unconscious* (Harvard University Press, 1996), *A Sense of Things* (University of Chicago Press, 2004), and *Other Things* (University of Chicago Press, 2016), and he has been a co-editor of *Critical Inquiry* since 1993. In his current work, "Re-Assemblage (Theory, Practice, Form)," he asks how the artistic practice of assemblage can contribute to assemblage theory across fields and disciplines, from architecture, urbanism, and geography, to sociology and political science.

Frances Bodomo

Frances Bodomo is an award-winning Ghanaian filmmaker. Her two short films *Boneshaker* (2013) and *Afronauts* (2014) premiered at the Sundance Film Festival and went on to play at several other major festivals, including the Berlin International Film Festival, Telluride Film Festival, and SXSW Film Festival. *Afronauts* was also exhibited at the Whitney Museum of American Art as part of the group show *Dreamlands: Immersive Cinema and Art, 1905–2016*. Bodomo is currently developing the feature film version of *Afronauts*.

Ingrid Burrington

Ingrid Burrington is the author of *Networks of New York: An Illustrated Field Guide to Urban Internet Infrastructure* (Melville House, 2016). She works at the Data & Society Research Institute.

Shani Crowe

Shani Crowe is an interdisciplinary artist who uses cultural coiffure, adornment, and beauty ritual as as a tool for healing and connection among people of African descent. She is most known for creating intricate corn-rowed hairstyles, then capturing them as large photographic portraits. Shani received her BFA in film production from Howard University's John H. Johnson School of Communications. Her work and performances have been featured at the Broad in Los Angeles, on Saturday Night Live, in collaboration with Solange Knowles, the Museum of Contemporary African and Diasporan Art (MoCADA), in Brooklyn, NY, the Urban Institute of Contemporary Art, in Grand Rapids, MI, Columbia University, and Soho House Chicago. She is based in Chicago.

Nicholas de Monchaux

Nicholas de Monchaux is Associate Professor of Architecture and Urban Design at the University of California, Berkeley, where he serves as Director of the Berkeley Center for New Media. He is the author of *Spacesuit: Fashioning Apollo* (MIT Press, 2011), an architectural and urban history of the Apollo spacesuit, winner of the Eugene M. Emme Award from the American Astronautical Society and shortlisted for the Art Book Prize. He also wrote *Local Code: 3,659 Proposals about Data, Design, and the Nature of Cities* (Princeton Architectural Press, 2016). He is a partner in the Oakland-based practice Modem. His

work has been exhibited widely, including at the Biennial of the Americas, the Venice Architecture Biennale, the Lisbon Architecture Triennial, SFMOMA, and the Museum of Contemporary Art in Chicago. He is a Fellow of the American Academy in Rome.

Design Earth

Led by Rania Ghosn and El Hadi Jazairy, Design Earth examines the geographies of technological systems—such as energy, trash, water, and agriculture—to open up new aesthetic and political concerns for architecture and urbanism. The design research practice has exhibited its works at the Venice Biennale and other leading architecture and art fairs around the world and has received numerous accolades, including the Young Architects Prize from the Architectural League of New York, the Association of Collegiate Schools of Architecture's Faculty Design Award, and the Jacques Rougerie Foundation's First Prize.

Ghosn and Jazairy each hold Doctor of Design degrees from the Harvard Graduate School of Design, where they founded the journal New Geographies and were the respective editors for NG2: Landscapes of Energy and NG4: Scales of the Earth. They have authored numerous books, including Geographies of Trash (Actar, 2015), Two Cosmograms (SA+P/MIT Press, 2016), and the Graham Foundation grant-supported Geostories (Actar, 2018), as well as recent essays and projects published in Volume, Journal of Architectural Education, San Rocco, Avery Review, Thresholds, Bracket, and Perspecta. Ghosn is Assistant Professor of Architecture and Urbanism at the Massachusetts Institute of Technology's School of Architecture + Planning, and Jazairy is Assistant Professor of Architecture at the University of Michigan's Taubman College of Architecture and Urban Planning and a visiting research scientist at the MIT Center for Advanced Urbanism.

Diller Scofidio + Renfro

Founded in 1981, Diller Scofidio + Renfro (DS+R) is a design studio whose practice spans the fields of architecture, urban design, installation art, multi-media performance, digital media, and print. With a focus on cultural and civic projects, DS+R's work addresses the changing role of institutions and the future of cities.

DS+R has completed two of the largest architecture and planning initiatives in New York City's recent history: the adaptive reuse of an obsolete industrial rail infrastructure into the High Line, a one and a half mile-long public park, and the transformation of Lincoln Center for the Performing Arts' half-century-old campus. The studio is currently engaged in two more projects significant to the city: The Shed, designed in collaboration with Rockwell Group, and the renovation and expansion of the Museum of Modern Art (MoMA). Recent projects include the Centre for Music in London; Zaryadye Park in Moscow; the Museum of Image & Sound on Copacabana Beach in Rio de Janeiro; The Broad, a contemporary art museum in Los Angeles; and the Roy and Diana Vagelos Education Center at Columbia University in New York.

DS+R's independent work includes the Blur Building, a pavilion made of fog on Lake Neuchâtel for the Swiss Expo; EXIT at the Palais de Tokyo in Paris; Charles James: Beyond Fashion at the Metropolitan Museum of Art in New York; Arbores Laetae, an animated micro-park for the Liverpool Biennial; Musings on a Glass Box at the Fondation Cartier pour l'art contemporain in Paris; Pierre Chareau: Modern Architecture and Design at the Jewish Museum in New York, and the upcoming Mile Long Opera, which will take place on the High Line in New York. A major retrospective of DS+R's work was mounted at the Whitney Museum of American Art in New York.

In 1999, Elizabeth Diller and Ricardo Scofidio were named MacArthur Fellows, the first in the field of architecture, and in 2009 they were included in Time magazine's list of the 100

most influential people. Among the awards received by the studio are the Centennial Medal from the American Academy in Rome, the National Design Award from the Smithsonian Institution, and the Brunner Prize from the American Academy of Arts and Letters.

Keller Easterling

Keller Easterling is an architect, writer, and professor at Yale University. Her most recent book, *Extrastatecraft: The Power of Infrastructure Space* (Verso, 2014), examines the potentials for activism latent in global infrastructure networks. Her recent ebook essay, *Medium Design* (Strelka, 2017), rehearses medium thinking as a way to address both spatial and non-spatial problems. Other books include *Subtraction* (Sternberg Press, 2014), which considers building removal or how to put the development machine into reverse; an e-book essay *The Action Is the Form: Victor Hugo's TED Talk* (Strelka Press, 2012); *Enduring Innocence: Global Architecture and its Political Masquerades* (MIT Press, 2005), which researches familiar spatial products in difficult or hyperbolic political situations around the world; *Organization Space: Landscapes, Highways, and Houses in America* (MIT Press, 1999), which applies network theory to a discussion of American infrastructure; and *Call it Home: The House that Private Enterprise Built* (Voyager Company, 1992), a laserdisc/DVD history of US suburbia that she co-authored with Rick Prelinger.

Easterling has also published web installations, such as *Wildcards: A Game of Orgman* and *The Highline: Plotting NYC*. Her research and writing was included in the 2014 Venice Biennale, and she has been exhibited at the Istanbul Design Biennial, the Henry Art Gallery, the Storefront for Art and Architecture, the Rotterdam Biennale, and the Architectural League of New York. She has lectured and published widely in the United States and abroad, contributing to *Domus, Artforum, Assemblage, Cabinet, Domus, e-flux,* *Grey Room, Praxis, Harvard Design Magazine, Log, Praxis,* and *Volume,* among others.

Estudio Teddy Cruz + Fonna Forman

Led by principals Teddy Cruz and Fonna Forman, Estudio Teddy Cruz + Fonna Forman is a research-based political and architectural practice in San Diego, California, that investigates issues of informal urbanization, civic infrastructure, and public culture with a special emphasis on Latin American cities. Blurring conventional boundaries between theory and practice, and transgressing the fields of architecture and urbanism, political theory and urban policy, visual arts and public culture, Cruz and Forman lead a variety of urban research agendas and civic/public interventions in the Tijuana-San Diego border region and beyond. From 2012 to 2013, Cruz and Forman served as special advisors on civic and urban initiatives for the City of San Diego and led the development of its Civic Innovation Lab. Together they founded the UCSD Cross-Border Initiative, as well as the UCSD Community Stations, a platform for engaged research and teaching on poverty and social equity in the border region.

The studio's work has been exhibited widely in leading cultural institutions across the world, including the Museum of Modern Art, New York; the Yerba Buena Center for the Arts, San Francisco; the Cooper Hewitt National Design Museum, New York; Das Haus der Kulturen der Welt, Berlin; the Medellín Museum of Modern Art; M+ Hong Kong and the 2016 Shenzhen Biennial of Urbanism and Architecture, among others. With Helge Mooshammer and Peter Mortenböck, Cruz and Forman co-edited *Informal Market Worlds Reader: The Architecture of Economic Pressure* (nai010, 2015) and have two forthcoming monographs: *Top-Down / Bottom-Up: The Research and Practice of Estudio Teddy Cruz + Fonna Forman* (Hatje Cantz, 2018) and *The Political Equator: Unwalling Citizenship* (forthcoming from Verso).

Iker Gil

Iker Gil is an architect and the director of MAS Studio, an architecture and urban design practice based in Chicago. He is editor-in-chief of the quarterly design journal *MAS Context*, editor of the book *Shanghai Transforming* (Actar, 2008), and curator of several exhibitions, including *BOLD: Alternative Scenarios for Chicago*, part of the inaugural Chicago Architecture Biennial. Iker has received several grants and awards for his work, including the 2010 Emerging Visions Award from the Chicago Architectural Club and grants from The Richard H. Driehaus Foundation and Graham Foundation for Advanced Studies in the Fine Arts. Iker teaches architecture studio courses at the School of the Art Institute of Chicago.

Dan Handel

Dan Handel is an architect and Curator of Design and Architecture at the Israel Museum. His exhibitions include *First the Forests* (Canadian Centre for Architecture, 2012), *Aircraft Carrier* (Venice Biennale, 2012), *Wood: The Cyclical Nature of Materials, Sites and Ideas* (New Institute, 2014), *Yasky* (Tel Aviv Museum, 2016), and *Design Matters* (The Israel Museum, 2017). His writing has appeared in *Frame, Thresholds, San Rocco, Pin-Up, Bracket, Volume*, and *Cabinet*, among others. He is the editor of *Aircraft Carrier* (Hatje Cantz, 2012), *Yasky and Co.* (Tel Aviv Museum, 2016), and *Manifest: A journal of American Architecture and Urbanism*.

Nikolaus Hirsch

Nikolaus Hirsch is a Frankfurt-based architect, editor, and curator. He was the director of Städelschule and Portikus in Frankfurt and currently teaches at Columbia University in New York City. His architectural work includes the Dresden Synagogue (2001), Hinzert Document Center (2006), Cybermohalla Hub (Delhi, 2008–12), an artist residency at The Land (with Rirkrit Tiravanija) and "Museum of Immortality" (Mexico City, 2016). Hirsch curated numerous exhibitions at the Portikus, the Folly project for the Gwangju Biennale (2014), and "Wohnungsfrage" at Haus der Kulturen der Welt in Berlin (2015). Hirsch is the co-founder and editor of the Critical Spatial Practice series at Sternberg Press and e-flux Architecture.

IN-FO.CO

Inventory Form & Content (IN-FO.CO) is an independent design and editorial studio. Working collaboratively across an expansive range of media and scales, IN-FO.CO shapes content, develops form, and produces culture. Founded in Los Angeles by Adam Michaels and Shannon Harvey, IN-FO.CO's work encompasses graphic design, spatial design, strategy, content development, and publishing (including in-house imprint Inventory Press), with a particular focus on art, architecture, education, and cultural institutions.

Laura Kurgan

Laura Kurgan teaches architecture and urban design at the Graduate School of Architecture, Planning and Preservation at Columbia University, where she directs the Center for Spatial Research and the Visual Studies curriculum. She is the author of *Close Up at a Distance: Mapping, Technology, and Politics* (Zone Books, 2013). Her current research focuses on conflict urbanism and critical data visualization.

Ana María León

Ana María León is Assistant Professor at the University of Michigan with appointments in the departments of History of Art, Romance Languages and Literatures, and Architecture. Her research and teaching examines public space and public housing, pedagogy and participatory politics, and the dynamics of the exhibitionary complex. She is part of several collaborations laboring on broadening the reach of architectural history, including the Global Architectural History Teaching Collaborative (GAHTC), the Feminist Art and Architecture Collaborative (FAAC), and Detroit Resists.

Ann Lui

Ann Lui is an Assistant Professor at the School of the Art Institute of Chicago and a registered architect. She is a co-founder of Future Firm, an architectural practice working at the intersections of landscape territory and curatorial experiments, whose work has been exhibited at Storefront for Art & Architecture, the Chicago Architecture Foundation, and the New Museum's Ideas City. She recently co-edited *Public Space? Lost and Found* (SA+P/MIT Press, 2017), a volume on spatial and aesthetic practices in the civic realm.

Mandana Moghaddam

Mandana Moghaddam is an Iranian-Swedish contemporary visual artist whose installation work was exhibited in the 51st Venice Biennale. Following the Iranian Revolution, Moghaddam was granted asylum in Gothenburg, Sweden, where she continues to maintain her studio. Her work, which examines themes such as alienation, communication, and gender, attempts to bridge boundaries, inspire intercultural dialogue, and memorialize often contentious aspects of Iranian life.

Marissa Lee Benedict and David Rueter

Marissa Lee Benedict is a sculptor and writer who currently lectures in visual art. Considering subjects that range from the distillation of algal biodiesel to the extraction of a geologic core sample using a set of gardening tools, her work draws on traditions of American land art to investigate the material conditions of our recently networked world. She earned an MFA in Sculpture from the School of the Art Institute of Chicago.

David Rueter is a visual artist, programmer, and Assistant Professor in Art and Technology at the University of Oregon. Employing video, custom electronics, software, cartography, and performance, Rueter's experiments and interventions confront established technical systems and their philosophical counterparts, opening cracks for radical alternatives and imaginations.

Rueter is a graduate of the School of the Art Institute of Chicago's MFA program in Art and Technology Studies.

Robert Pietrusko

Robert Gerard Pietrusko is Assistant Professor in the departments of Architecture and Landscape Architecture at Harvard University's Graduate School of Design, where his teaching and research focuses on cartographic representation, simulation, and the history of spatial classification schemes. His design work has been exhibited at the MoMA in New York, SFMOMA, and the Storefront for Art & Architecture, among other venues. In 2011, Pietrusko was an artist-in-residence at the ZKM Center for Art and Media in Karlsruhe, Germany.

Mika Rottenberg

Mika Rottenberg lives and works in New York. Through film, architectural installation, and sculpture, she illuminates the connections among seemingly unrelated economies. Collapsing geographies and narratives, Rottenberg weaves together documentary elements with fiction, forming complex allegories about human conditions and global systems. In 2018, Rottenberg is scheduled to present solo shows at the Bregenz Kunsthaus in Austria, the Bass Museum in Miami, and Goldsmiths Centre for Contemporary Art in London.

SCAPE

Founded by landscape architect and educator Kate Orff, SCAPE is an award-winning landscape architecture and urban design practice based in lower Manhattan. SCAPE explores the cultural and physical complexity of urban landscapes and their unique textures, ecologies, programs, and publics. Projects range from a 1,000-square-foot community park in Harlem, to the $60-million federally funded Living Breakwaters project, a comprehensive climate change resilience strategy for the South Shore of Staten Island. The firm has won national and local American Society of Landscape Architects (ASLA)

awards for their built projects, planning, and communications work.

Kate Orff's activist and visionary work on design for climate dynamics has been shared and developed in collaboration with arts institutions, governments, and scholars world-wide. She was named a MacArthur Fellow in 2017. Orff earned a Master in Landscape Architecture degree from the Graduate School of Design at Harvard and currently serves as Director of the Urban Design Program at Columbia University's Graduate School of Architecture, Planning and Preservation. She frequently publishes and is the author of *Toward an Urban Ecology* (Monacelli, 2016), which explores the redefinition of urban ecology as activism; *Petrochemical America* (Aperture Foundation, 2012, co-authored with photographer Richard Misrach); and is co-editor of *Gateway: Visions for an Urban National Park* (Princeton University Press, 2011). Orff's numerous accolades include has been inducted into the National Academy; received the American Academy of Arts and Letters Award in Architecture; was named a United States Artist Fellow; and received the Architectural League of New York's Emerging Voices prize in 2012.

Jennifer Scappettone

Jennifer Scappettone is the author of the critical study *Killing the Moonlight: Modernism in Venice*, and of two cross-genre verse collections, *From Dame Quickly* and *The Republic of Exit 43: Outtakes & Scores from an Archaeology and Pop-Up Opera of the Corporate Dump*. Recent writings can be found in *Asymptote*, *Boston Review*, *boundary2*, *Critical Inquiry*, and *Nuovi argomenti*, and in the collections *The Fate of Difficulty in the Poetry of Our Time*, *Terrain Vague: The Interstitial as Site, Concept, Intervention*, and *The Princeton Encyclopedia of Poetry and Poetics*. She has collaborated on site-specific performance works at locations ranging from a tract of Trajan's aqueduct below the American Academy in Rome and the cloister of the São Bento Monastery in Porto to Fresh Kills Landfill.

Jonathan Solomon

Jonathan Solomon is Associate Professor and Director of Architecture, Interior Architecture, and Designed Objects at the School of the Art Institute of Chicago. His drawings of analytical and counterfactual urban narratives appear in *Cities Without Ground* (ORO, 2012) and *13 Projects for the Sheridan Expressway* (Princeton Architectural Press, 2004). Solomon edits *Forty-Five*, a journal of outside research, and curated the US Pavilion at the 2010 Venice Architecture Biennale. His interests include extra-disciplinarity, post-growth futures, and non-anthro-ponormative design. Solomon received a BA from Columbia University and an MArch from Princeton University and is a licensed architect in the state of Illinois.

Studio Gang

Studio Gang is an international architecture and urban design practice founded by American architect and MacArthur Fellow Jeanne Gang. The Studio works across scales and typolo-gies—from cultural and public buildings, to urban plans and high-rise towers—using a design process that foregrounds the relationships between individuals, communities, and environments. The Studio's interdisciplinary and research-driven approach has produced some of today's most award-winning archi-tecture, such as the Arcus Center for Social Justice Leadership at Kalamazoo College in Kalamazoo, Michigan; Writers Theatre, a professional theater company located in Glencoe, Illinois; two public Boathouses on the Chicago River that provide access to its north and south branches; and Civic Commons, a multi-city project re-envisioning public spaces across the United States. Current projects include an expansion of the American Museum of Natural History in New York City; the new United States Embassy in Brasília, Brazil; and Rescue Company 2, a facility

for FDNY rescue workers in Brooklyn, now under construction.

Intertwined with its built work, Studio Gang develops research and related projects such as publications and exhibitions that push design's ability to create public awareness and change—a practice the Studio calls "actionable idealism." These include Polis Station, an ongoing project exploring how American police stations can be inclusively reimagined to better serve their communities; *Reverse Effect*, an advocacy publication produced to spark a greener future for the Chicago River; and the Garden in the Machine, a proposal for the inner-ring suburb of Cicero, Illinois, developed for the Museum of Modern Art's *Foreclosed: Rehousing the American Dream* exhibition in 2012.

A recipient of the 2013 Cooper Hewitt National Design Award in Architecture and the 2016 Architizer A+ Firm of the Year, Studio Gang's work has been honored and exhibited widely, including at the Venice Architecture Biennale, the Chicago Architecture Biennial, and Miami Art Basel. In 2012 the Studio was the subject of a solo show at the Art Institute of Chicago, *Building: Inside Studio Gang Architects*, accompanied by an exhibition catalogue of the same name. *Reveal*, a 2011 monograph published by Princeton Architectural Press, is the first volume on their work and working process.

Imre Szeman

Imre Szeman in Professor of Communication and Culture Studies at the University of Waterloo. His recent books include *After Oil* (Petrocultures Research Group, 2016), *Companion to Critical and Cultural Theory* (Wiley, 2017, co-editor), *Energy Humanities: An Anthology* (John Hopkins University Press, 2017, co-editor); *Fueling Culture: 100 Words for Energy and the Environment* (Fordham University Press, 2017, co-editor), *Petrocultures: Oil, Politics, Culture* (McGill-Queen's University Press, 2017, co-editor), and the fourth edition of *Popular Culture:*

A User's Guide (Wiley, 2017, co-author). A collection of his essays, *On Petrocultures: Globalization, Culture, Energy: Selected Essays, 2001–2017*, will appear in 2018. He is currently at work on *Transitions: On the Politics of Energy* for MIT Press.

Liam Young

Liam Young lives and works in Los Angeles and London. He is a speculative architect who operates in the spaces between design, fiction, and futures. He is co-founder of Tomorrow's Thoughts Today, an urban futures think tank that explores the local and global implications of new technologies; and co-founder of Unknown Fields, a nomadic research studio that travels on expeditions to chronicle these emerging conditions as they occur on the ground. He has taught at the Architectural Association and Princeton University, and now runs the Master of Arts program in Fiction and Entertainment at SCI-Arc in Los Angeles.

Mimi Zeiger

Mimi Zeiger is a Los Angeles-based critic, editor, curator, and educator. She has curated, contributed to, and collaborated on projects that have been exhibited at the Art Institute of Chicago, the 2012 Venice Architecture Biennale, the New Museum, Storefront for Art and Architecture, pinkcomma gallery, and the AA School. She co-curated *Now, There: Scenes from the Post-Geographic City*, which received the Bronze Dragon award at the 2015 Bi-City Biennale of Urbanism/Architecture, Shenzhen. She teaches in the Media Design Practices MFA program at Art Center College of Design in Pasadena.

PAVILION CREDITS

Commissioners
School of the Art Institute of Chicago
University of Chicago

Curators
Niall Atkinson
Ann Lui
Mimi Zeiger

Associate Curator
Iker Gil

Representative Commissioners
and Co-Directors
Bill Brown, The University of Chicago
Paul Coffey, School of the Art Institute
of Chicago
Bill Michel, The University of Chicago
Jonathan Solomon, School of the Art
Institute of Chicago

Curatorial Advisory Board
Bill Brown
Theaster Gates
Sarah Herda
Mary Jane Jacob
Ollie Palmer
Zoë Ryan
Jonathan Solomon
Jessica Stockholder
Amy Thomas
Yesomi Umolu

Exhibition & Graphic Design
IN-FO.CO

Editorial Partner
e-flux Architecture
Nick Axel, Nikolaus Hirsch,
Anton Vidokle

Project Manager
Samantha Topol

Programming Director, CitizenSHIP
Jerome Chou

Exhibition and Program Coordinator
Fabiola Tosi

Editor
Lucas Freeman

Installation Lead
Levi Murphy

Research Associates
Robert Hayes
Kekeli Sumah
Amanda Wills

Venice Architectural Coordinator
Giacomo Di Thiene, Th&Ma
Architettura

Structural Consulting
Skidmore, Owings & Merrill

Lighting and AV Advisor
Arup

AV Consultant
Jeff Panall

ACKNOWLEDGMENTS

The US Pavilion Commissioners and Curators would like to acknowledge the following individuals for their support and guidance: Elissa Tenny and Craig Barton; Robert Zimmer, Daniel Diermeier, Christine Mehring, and Luis Bettencourt.

Special thanks to Chiara Barbieri. Thank you to Alessandro Possati and Zuecca Project Space, Nora Semel, Alison Buchbinder, and Jill Weinreich for their behind-the-scenes contributions.

This project would not be possible without the help of Andrew Bauld, Jenelle Beaird, Kelly Christian, Mikaya Daniels, Ryan Deemer, Cassandra Dunn, Kendra Foley, Andrea Frank, Sarah H. Gardner, Megan Harris, Scott J. Hendrickson, Ronia Holmes, Troy B. Klyber, Michael Levin, Kate Logan, Cheryl Jessogne, Jeremy Manier, Sharon Marine, Heidi Metcalf, Candace Mueller, Stephanie Oberhausen, Kelly O'Brien, Martina Pizzul, Devarajulu Ravichandran, Lindsey Rogers, Cheryl Russell, Bree Witt, and Chiara Zanandrea.

IMAGE CREDITS

p. 41 Amanda Williams
p. 42 Amanda Williams +
Andres L. Hernandez
p. 43 courtesy the artist
p. 45 Amanda Williams +
Andres L. Hernandez
p. 54 Marshall Brown Projects, Inc.
p. 55 Marshall Brown Projects, Inc.
p. 63 Detroit Publishing Co.,
courtesy the Library of Congress
p. 64 Studio Gang
p. 65 Andrea Morales
pp. 66–67 Studio Gang
p. 77 We the People of Detroit
Community Research Collective
p. 79 UCLA Abolitionist Planning
Group / Institute on Inequality
and Democracy at UCLA Luskin
p. 85 Top: SCAPE Landscape
Architecture
p. 85 Bottom: Joanne Wong Who
and SCAPE Landscape Architecture
pp. 86–87 Andrea Barbanti
p. 89 Cinzia Tibolla
p. 92 Warren Cariou
p. 97 Warren Cariou
p. 100 Warren Cariou
pp. 108–09 Estudio Teddy Cruz +
Fonna Forman
p. 110 Estudio Teddy Cruz +
Fonna Forman
p. 120 Jay Mark Johnson
pp. 128, 131 Courtesy Godard Space
Flight Center
p. 133 The Miriam and Ira D.
Wallach Division of Art, Prints and
Photographs: Photography Collection,
The New York Public Library,
Public Library Digital Collections
p. 150 Michael Waters, courtesy
the photographer
p. 153 Creative Commons
p. 155 Department of the Interior/US
Geological Survey
p. 111 Courtesy Department of the
Interior/US Geological Survey
p. 160 A.W. Allen, "The Chuquicamata
Enterprise—III," Mining and Scientific
Press 123 (July 23, 1921): 120.

p. 164 The Metropolitan Museum
of Art, New York. © Holt-Smithson
Foundation/ Licensed by VAGA,
New York, NY
p. 167 Courtesy the artist and
Galerie Chantal Crousel, Paris.
Photo: Nils Klinger
p. 177–79 Keller Easterling with MANY
p. 181 Keller Easterling with MANY
p. 184 Top and bottom: Advanced
Projects Research Agency
p. 185 David Rumsey Map Collection,
p. 189 Screenshot, Google Maps
p. 195 Facebook
p. 205 Design Earth
p. 207 Design Earth
p. 209 Design Earth
p. 211 Screenshot, Bing Maps
p. 211 Courtesy SpaceX
p. 214 Wikipedia commons
p. 219 US Navy
p. 223 NASA
p. 225 Courtesy Rex Features
p. 230 Image AS11-40-5874,
courtesy NASA
p. 233 Harrison Schmitt, image
AS17-148-22727, courtesy NASA
pp. 238–39 Frances Bodomo
pp. 240–41 Mandana Moghaddam
pp. 242–43 David Rueter and
Marissa Benedict
pp. 244–45 Mika Rottenberg
pp. 246–47 Liam Young

Commissioners

Partners

Mansueto Institute for Urban Innovation	UChicago Arts
Peggy Guggenheim Collection, Venice	Università Ca' Foscari Venezia

Funding provided by the United States Government

 National Endowment for the Arts arts.gov

Editorial Partner	Media Sponsor
e-flux architecture	ARCHITECTURAL RECORD

Presenting

BULLEY & ANDREWS
Building Matters®

Graham Foundation

HDR

The Joyce Foundation

SOM

Leading

THE KRESGE FOUNDATION	**ARUP**

Supporting

The American Institute of Architects	
	COLUMBIA **GSAPP**

Contributing

Blanc Gallery	Brian Lee
Bridgeport Art Center	Busy Beaver Button Co.
Elise Jaffe + Jeffrey Brown	MIT Center for Art, Science & Technology
MIT Department of Architecture	MIT School of Architecture + Planning
Nancy and John DiCiurcio	Patricia and Laurence Booth
Susan and Robert A. Wislow	Zuecca Project Space

Dimensions of Citizenship
is published by
Inventory Press LLC
2379 Glendale Blvd.
Los Angeles, CA 90039
inventorypress.com

This book is the result of curatorial efforts
by Niall Atkinson, Ann Lui, and Mimi
Zeiger, with Iker Gil, and published on the
occasion of the US Pavilion at the Biennale
Architettura 2018, May 26–November 25,
2018, co-commissioned by the School
of the Art Institute of Chicago (SAIC) and
the University of Chicago. Representative
commissioners are Bill Brown, Paul Coffey,
Bill Michel, and Jonathan Solomon.

The essays were co-commissioned by
e-flux Architecture and are available
online at: www.e-flux.com/architecture/
dimensions-of-citizenship

Design: IN-FO.CO

Editors: Nick Axel, Nikolaus Hirsch,
Ann Lui, Mimi Zeiger
Copy editors: Eugenia Bell, Lucas Freeman

Printed and bound in Italy by Contitipocolor

ISBN: 978-1-941753-19-4

Distributed by:
ARTBOOK I D.A.P.
75 Broad Street, Suite 630
New York, NY 10004
artbook.com